Earth Day

JEAN GRIFFITH

PAGE PUBLISHING, INC.
New York, NY

First originally published by Page Publishing, Inc. 2019

ISBN 978-1-64424-945-1 (Paperback)
ISBN 978-1-64424-946-8 (Digital)

Printed in the United States of America

Dedicated to Linnie Marsh Wolfe and the
librarians around the world.

For it is they who toil gathering flax in the fields from
which dreams are spun and woven into reality.

Preface

I ssues generate anxiety in the body politic. This is what political movements are made of. Oftentimes, they lead directly to life-changing historical events. Like the deep roots of a giant tree, issues come together lifting the body politic skyward and an event becomes history. This fact runs true throughout the course of human history through the travail of ages. Colonials opposed to taxation without representation rose up in revolution and broke the shackles of colonialism in America. Free Soilers, Whigs, and disenchanted northern Democrats by 1860 threw their support to Abraham Lincoln after passage of the Kansas-Nebraska Act in the fall of 1854. Middle-class Americans who felt threatened by the big city bosses, political corruption the railroads and robber baron industrialists, and the massive influx of immigrants in the United States at the beginning of the twentieth century created the progressive movement. Political movements are issue-driven. This is a political history examining the tentpole issues that joined Americans to a common cause. So thought-provoking they left an indelible impression etched into the collective consciousness of a people.

The same was true for those who took to the streets for racial equality and Civil Rights and the American Indian Movement led by indigenous peoples who turned to activism the result of a history of broken treaties and reservation governments controlled by subservient brethren. Second-wave feminists rallied behind the banner of gender equality; students took to the streets to march and shut down college campuses to protest the Vietnam War and social injustice. All these Americans had one thing in common: they were inspired by

issues and a burning desire to change their world making it a better place to fulfill their vision. During the 1950s and 1960s, activists believed in causes so much so that they joined together to create a political force that sent tremors throughout the political system. Their activism necessitated reforms. And their voices are often heard by indifferent Americans who listened to their voices too, whether it be in news print or on the radio or a new delivery device television. They too become energized. Oftentimes, they were moved emotionally by what they too deemed to be intolerable. Some were imprisoned. Earth Day on April 22, 1970 was just such an event.

Where to begin. A starting point for a study of the event called Earth Day would be in the ideological origins of environmentalism. Such thoughts form the bedrock of western civilization. Some might look to the ministry of Jesus Christ, the teacher-philosopher who with his disciples wandered through the hills of Judea and along the Sea of Galilee. For it was the Christ who exalted in the beauty of hillsides of wildflowers of Judea so much so he exclaimed according to the gospel of Matthew, "Consider the lilies how they grow: they toil not, neither do they spin: And yet I say unto you, that even Solomon in all his glory was not arrayed like one of these." Following in Christ's example, Saint Francis of Assisi sought solitude in the Italian high country his love of God's creatures shaping the thinking of nature lovers for generations to follow. In Assisi's life and the wild wolf he tamed so the legend goes, we see the beginnings of a distinct environmental ethic identity.[1]

Even President Thomas Jefferson had a deep and abiding affection for the natural world and concern for what might become of it. At one of the president's lavish dinner parties, socialite Margaret Bayard Smith overheard Jefferson, who stated, "How I wish that I possessed the power of a despot." When asked to elaborate further, the president exclaimed, "I wish I was a despot that I might save the noble, the beautiful trees that are daily falling, sacrifices to the cupidity of their owners, or the necessity of the poor." When asked if

[1] Lynn White Jr., "The Historical Roots of Our Ecologic Crises," *Science*, 10 March 1967, vol. 155, no. 3767, p. 1207.

anything could be done to save the old growth forest near the White House, Jefferson stated matter-of-factly, "Only an armed guard could save them. The unnecessary felling of a tree, perhaps the growth of centuries, seems to me a crime little short of murder."[2]

Similar in the way they perceived nature, the American Transcendentalists of the Antebellum period deified nature. Ralph Waldo Emerson and his dear friend, the gentle dreamer Henry David Thoreau, when they gazed upward into the high branches of a giant centenarian oak tree, rowed a John boat down the Merrimac River or strolled through the meadow glens near Concord, Massachusetts, they saw the living god in their natural beauty. Thoreau, who is sometimes referred to as the first environmentalist, disheartened by his generation's disregard for nature exclaimed, "Thank God men cannot as yet fly and lay waste the sky as well as the earth!"[3]

In the early twentieth century, conservation and preservationist formed two wings of what would eventually be modern-day environmentalism. The embodiment of environmental thinking found expression in the mind and life of John Muir, who with conservationist Gifford Pinchot placed conserving and preserving America's natural resources and the country's natural wonders among Progressivism's multifaceted list of reforms. Some might regard Muir's unsuccessful effort to prevent the building of the O'Shaughnessy Dam submerging Hetch-Hetchy Valley near Yosemite a turning point in America's environmental consciousness. A good argument can be made the legal battle led by Muir and his Sierra Club over Hetch-Hetchy Valley is the first great political confrontation in environmental history. That fight was lost.

Another starting point for a study of Earth Day could be Aldo Leopold's *A Sand County Almanac*. More Pinchot than Muir in his thinking early in his career as a forester, Leopold's life story and "land ethic" would experience a rebirth prior to Earth Day. Leopold was a proponent of ecology, the idea that all living things, including

[2] Margaret Bayard Smith, *The First Forty Years of Washington Society*, ed. Gaillard Hunt (New York: Charles Scribner's Sons, 1906), pp. 11–12.

[3] Henry David Thoreau, *The Journal of Henry D. Thoreau*, eds. Bradford Torrey and Francis H. Allen (New York: Dover Publications Inc. 1962), p. 1741.

humans, are connected and interdependent biologically speaking. Before his passing, Leopold had come to embrace Muir's philosophy. By the spring of 1970, many Americans were "thinking like a mountain," the metaphor Leopold used to explain his philosophy of ecology.

Though Hetch-Hetchy was a lost cause, such was not the case with Dinosaur National Monument forty years later. This epic struggle pitted the Bureau Reclamation against that same Sierra Club Muir founded and its executive director David Brower. Thus primarily due to a surge in public opinion on behalf of Brower's organization and his media campaign, a victory for the preservationists and the environmental movement alike.

And no study of the modern environmental movement would be complete without *Silent Spring*. Rachel Carson's book and its influence on those who observed the first Earth Day is incalculable. Though she never lived to see the event she inspired come to pass, Carson's scientific investigation into the toxicity of DDT in the food chain lives on in the federal regulatory standards in place today protecting society from harmful chemicals. Drawing on *Silent Spring* which shone light upon the path for environmentalists historian Adam Rome begins his study of the event in his book *The Genius of Earth Day* at a teach-in on the campus of the University of Michigan in March of 1970.

To be certain it was not issues alone that compelled Americans and people from London to Tengboche in the Himalaya to promote the idea of preserving, restoring, and protecting the natural world from pollution, to sustain life on our planet. No single event or solitary issue explains how Earth Day came to be. The story of the original Earth Day also is about the lives of some of the most remarkable human beings who dedicated themselves to environmentalism. The importance of academia in bringing about the original Earth Day cannot be overstated. For it was their work, their ideas, albeit sometimes flawed, and their research which led to the groundswell of support that lifted the consciousness of people in America. The public depended greatly on the news media whose focused lenses and penetrating prose awakened a people to take action. Television

brought the ABC, CBS, and NBC nightly news into America's living rooms first in black and white then by 1964, in living color. It was the golden age of the glossies such as Look and Life magazine and periodicals such as Time and Newsweek, which were enormously popular at the time and focused the public's attention on polluted America.

It is one thing to write history. It is quite another to have lived it. The original Earth Day occurred my junior year in high school. I witnessed that day through the modern miracle of television watching Walter Cronkite's CBS Special Report that night. And in my case, environmental issues are quite personal. Within a five-hundred-mile radius of the place of my birth there are more than thirty Super Fund cleanup sites. Not far from where I was born, the natural world at the beginning of the twentieth century experienced unregulated mining industry, which occurred with no regard for the environmental consequences or generations of the area's inhabitants which would follow.

Lead and zinc deposits permeate the water and soil in northeastern Oklahoma, Jasper, and St. Francis counties in Missouri. Once discovered, mining companies began dredging and digging deep shaft mines for the minerals, the tailings leaving behind a permanent scare and measurable contamination upon the land. What once had been wooded oaken glens, meadows, and prairies of wild flowers lay covered with contaminated rock, chat, and sand. Lead and zinc mining turned the communities of Picher, Oklahoma, and tiny Treece, Kansas, into ghost towns, the drinking water, and soil so filled with arsenic and cadmium they are unhealthy for human habitation.

There are places in St. Francis County, Missouri, where hardwood forests with abundant wildlife once thrived, which now resemble some dead and distant planet. It's as if the mining companies had raped nature, leaving the victim for dead, the crime occurring without legal repercussions for the perpetrator. Less than an hour's drive from my hometown in Barton County, Missouri, land once rolling farmland is now acre upon acre of huge mountains of solid waste garbage covered by soil for the sake of appearances and to rid the place of the stench. The most notorious Super Fund site is Times

Beach, Missouri. So contaminated with dioxin are the streets of this small village, the people who lived there had to be evacuated. The place where children once played is now a state park.

Similar thoughts of the effects of pollution consumed the minds of modern environmentalists in the spring of 1970. To them, the oil-soaked beaches of Santa Barbara, California, were no different than the video of protestors in streets of Birmingham or crossing the Edmund Petus Bridge in Alabama or newsreels of a Viet Cong ambush of American troops in the Iron Triangle or Tet in Vietnam. And no single event, issue, or person alone explains what happened that day in April of 1970. Rather, it occurred because of an amalgamation of environmental issues which brought concerned Americans together giving the movement structure to create a mighty political movement to celebrate the Earth. To ignore the issues and how they became embedded in the American consciousness is to neglect the reality of how this political event came to pass.

For the America Woody Guthrie sang about in "This Land Is Your Land," which the sixties generation inherited, was fraught with environmental problems. Commercial pilots saw it in the skies above major cities; an environmentalist wrote the obituary of Lake Erie it was so polluted. And consumers had doubts about the food they ate treated with DDT. Air contaminated with not only industrial pollutants but nuclear fallout as well gave pause for concern; waterways filled with pesticides and industrial waste both visible and so toxic they killed fish, the smell so putrid it was nauseating. And an apocalyptic war in Southeast Asia where the United States military was using defoliants on the rain forest to deny an elusive enemy food and sanctuary. An oil spill on the California coast near Santa Barbara happened, which was so unsettling it galvanized public opinion across the country and radicalized many in the environmental movement. If ever an event can be singled out which gave impetus and purpose to the environmental movement's Earth Day activism and the American public's participation in that event, this was it. That oil spill was the environmental movement's Pearl Harbor, its September 11, 2001. That event made the first Earth Day an absolute historical certainty. After Santa Barbara, there would be no turning back.

A museum without walls, this political history is about issues, the topics that made headlines giving structure to a movement and raised the consciousness of the American public and the world. Issues motivate people to take action generating momentous events of which Earth Day is one. These issues were discussed in the home and on college campuses around the country in the streets in Greenwich Village, in Chicago, Atlanta, Georgia, Tucson, Arizona, Santa Monica, California, and inside the Beltway. Without these concerns, the first Earth Day would never have become the cultural phenomena that the world observes today. These issues generated a reform movement so politically potent, a conservative president would make it part of his White House agenda.

It was Arthur Schlesinger Jr. who once said, "The great engine of social change in America has been the determination to close the gap between performance and promise, between the reality and the ideal." The grim reality of environmental degradation made Earth Day an attempt to make progress toward the ideal or that which was possible. For the environmental realities of the United States at midcentury formed the threads of political activism into one formidable movement arousing the American consciousness. Earth Day and those who participated that day lowered or obliterated the social dividing lines of religion, wealth, and social status in a period in American history known for its divisiveness. And this book is also a political history about the activists themselves. Without the journalists, photojournalists, and the protestors themselves, this account of what happened would be incomplete. This is their story.

Chapter 1

The Great Cranberry Scare and Ecocide

B y November of 1962, when Gaylord Nelson won election to represent Wisconsin in the United States Senate, the phrase "environmental pollution" had entered the American vernacular. Three years earlier, with Americans glued to their new black-and-white televisions awaiting news on the Quiz Show scandal and baseball fans paid their respects to Claude "Lefty" Williams implicated in fixing the 1919 World Series, a front-page headline grabbed the public's attention in The New York Times just days before Thanksgiving 1959. Secretary of Health, Education, and Welfare Arthur S. Flemming stepped to the dais warning at a press conference that food and drug agents had detected traces of aminotriazole in the cranberry crop harvested that year in Oregon and Washington state.

Aminotriazole, it was discovered, caused cancer in laboratory animals when exposed to it. With Thanksgiving just days away, housewives fretted on what they planned to serve on the menu for the big meal. This despite assurances from cranberry growers the contaminated Oregon fruit was safe.[4] The first report appeared in The

4 "Some of Cranberry Crop Tainted by a Weed-Killer, US Warns," *The New York Times*, 10 November 1959, sec. 1, pp. 1 and 34. & Bess Furman, "Cranberries

New York Times on November 9, 1959, and in Oregon just prior to that date. Any reference to the possibility of a chemical which caused cancer reverberated throughout American society as a whole. What caused the federal government to act was an obscure add-on to a federal law; traces of aminotriazole in food violated the Delaney amendment of the Food and Drug Act passed by Congress and signed into law by President Franklin Roosevelt. The amendment declared no additive to be considered safe if it caused cancer in laboratory test animals or humans.[5]

The public's reaction to a known carcinogen in the food supply can not be understated. Not since Orson Welles's Mercury Theatre radio broadcast of The War of the Worlds, had there been such a reaction from pundits and the American public. The great cranberry scare of 1959 given the popularity of the fruit near a traditional holiday grabbed American's attention by the shirt collar and apron strings lifting the consciousness of a people to a higher level. Washington Post journalist Milton Viorst in The Nation examined the formidable obstacles facing the Food and Drug Administration in screening the food supply and protecting the public from chemical contamination in this case herbicides used by agriculture to eliminate noxious weeds. Viorst made the case the HEW director had no ulterior motive in warning the public and calling for an investigation. Instead he argued Flemming used his press conference to serve notice on cranberry producers who undoubtedly were guilty of excessive herbicide use, a potential health hazard.

Viorst's article, more importantly, warned of how agribusiness use of chemicals had inconspicuously worked their way into America's food supply affecting unsuspecting consumers. For his outspoken criticism, Viorst would eventually appear on President Richard M. Nixon's enemies list. Nevertheless, at the dawn of the decade of the 1960s, Viorst drew public attention to a problem, "the kind that kills or lays its victims low as dinner goes through the digestive process...

Set for Thanksgiving," *The New York Times*, 20 November 1959, pp. 1 & 19.

5 Mark Ryan Janzen, "The Cranberry Scare of 1959: The Beginning of the End of the Delaney Clause (PhD diss., Texas A&M University, 2010), pp. 50 & 134.

the kind that lies concealed in the diet and spreads its damages over a lifetime."[6]

Viorst went to great lengths to determine where to cast blame. With his thumb on the pulse of the Beltway and public opinion, he identified the cause of the problem. Consumer advocates in the United States Congress lobbied for FDA research funding: the Budget Bureau then "refused to assign the funds to test new products in the chemical pipeline awaiting approval."[7] That and cranberry growers used the herbicide improperly applying it to control weed infestations before the harvest rather than after the fruit's harvesting as proscribed by FDA regulations. Viorst called Flemming's announcement "enforcement by press conference" in recalling the cranberries now on grocery store shelves. Viorst went even further. He called FDA. the "stepchild" of the federal regulatory bureaucracy. Congress "assumed that agricultural products needed little policing, while manufactured drugs and foods were so uniform that sampling was good enough." The reporter drew the obvious conclusion: "This thinking established the 'spot-check' tradition in FDA enforcement." Complicating matters, the Congress and the Eisenhower administration cut the regulatory agency's funding. By the fall of 1959, three hundred FDA inspectors inspected four hundred thousand pill and food manufacturing facilities and at least two hundred thousand food growers nationwide. Viorst cited more evidence: only two inspectors covered an area stretching from Maryland to North Carolina. Their job made more difficult by the lack of adequate laboratories to test the cranberry samples they believed suspect.[8]

Viorst's warning did nothing to dissuade presidential candidates Vice President Richard Nixon and Massachusetts's Senator John F. Kennedy from consuming cranberries on the campaign trail. Campaigning in Wisconsin Rapids, Nixon devoured four bowls of cranberry sauce at a single setting during a photo-op; Kennedy, in aristocratic style, sipped cranberry juice from a glass at a campaign

[6] Milton Viorst, "A Little Poison in Your Food…," *The Nation*, 190 (5 March 1960), p. 200

[7] Ibid., p. 201.

[8] Ibid.

fundraiser in Marshfield, Wisconsin, shadowing Nixon less than an hour's drive from his opponent's campaign stop. This despite Flemming's press conference warning the public to avoid eating the fruit until lab techs had tested samples to determine the fruit's toxicity. Not surprisingly, the FDA's dragnet in the process occurred on an unprecedented scale: Berries from Oregon, Washington state, Massachusetts, and New Jersey were also tested. All regional offices of the FDA bureaucracy reported their findings. Tests on cranberries took place in Atlanta, Georgia, Baltimore, Boston, Chicago, Detroit, St. Louis, and Los Angeles. All total testing occurred in at least seventeen regional offices around the country. And 3 percent of the time, the 1959 cranberry crop tested positive. A total of 325,800 pounds and had to be disposed of. That the sale of canned cranberries plummeted more than 60 percent and raw cranberries nearly 75 percent that fall, reflected the reaction of American consumers.[9] And public opinion sided with Secretary Flemming's decision to pull cranberries from the shelf to be tested.

Letters on behalf of concerned citizens addressed to HEW, primarily housewives, ran overwhelmingly in favor of Flemming's decision by a margin of seven to one. The names and addresses of concerned letter writers were withheld from the public. Of the 295 letters the department received, the majority supported Flemming's decision, expressing gratitude that he had taken action to protect the public; only thirty-nine opposed it. Those supporting Flemming's decision wanted information on other contaminated foods consumers were exposed to. Typical was one health care professional who expressed their gratitude while trying to grasp the enormity of herbicide and chemical contamination in food. The letter read, "Far more important than the use of aminotriazole on cranberries is its use on other crops. We know it has been used on pasture lands, apple and pear orchards, in wheat fields and presumably many other fields. There are a lot of unanswered questions. Is it present in meat of the grazing animals? Is it on pears, apples? Doesn't the average consumer ingest a significantly higher amount of chemicals than anyone real-

9 Janzen, ibid., p. 130.

izes?"[10] Presidential candidates doing a taste tests for the news media to bolster public confidence during the 1960 presidential campaign did not have the intended effect. Fears persisted.

Half a world away in a country most Americans in 1959 had never heard of, the use of herbicides would take centerstage. Like something lifted from the plot of an Ian Fleming spy thriller, the Kennedy administration embarked on a counterinsurgency strategy using herbicides. With the exception of the Reclamation Bureau and Army Corps of Engineers' dam construction in the United States, this was the greatest scheme to alter the natural environment in American history. The thought of herbicides contaminating the food supply was one thing. The thought that the American government with the blessings of the Pentagon putting herbicides to use to fight a Communist insurgency in Vietnam exposing American military personnel and unsuspecting Vietnamese civilians to the hazardous chemicals another. By the end of the decade, every American had been affected in some way by the Vietnam War and the use of defoliants was no longer a secret.

Agent Orange it was called. It had been developed in the laboratory at the University of Chicago by botanist E. J. Kraus and his assistants prior to Pearl Harbor. Kraus was convinced herbicides could be an effective aid to reduce and eradicate the dense jungles on Japanese occupied islands in the South Pacific. Though never used during World War II, Kraus's idea remained in the US military files and held sway in the Pentagon and with certain politicians seeking an advantage over the Japanese military during World War II. Kraus even provided insight into his work in theory in a position paper entitled "Plant Growth Regulators: Possible Uses."[11] Test trials of the chemical 2, 4-D, Agent Orange, by the military in the jungles of Panama and Malaysia proved to be an effective way to defoliate the

[10] "Mail on Cranberry Controversy Said to Support Flemming, 7–1," *The New York Times*, 22 November 1959, p. 74.

[11] David Zierler, *The Invention of Ecocide: Agent Orange, Vietnam, and the Scientists Who Changed the Way We Think about the Environment* (Athens: The University of Georgia Press, 2011), pp. 38–40.

dense jungle of a rainforest. By 1961, the US military had added Agent Orange to the military arsenal.

That same year, Vice President Lyndon Johnson traveled to the Republic of Vietnam to assess the war against the Communist insurgency. The result the creation of the United States Vietnamese Combat and Development and Test Center, at the Army's Chemical Warfare Center near Derrick, Maryland. Dr. James Brown was assigned the task of developing the strategy using herbicides, which would eventually be called Operation Ranch Hand. Brown applied and modified the research of botanist Arthur Galston who had perfected a chemical he labeled triiodo benzoic 2, 3, 5 acid (TIBA). Galston's discovery during World War II induced soybeans to flower earlier improving the plant's reproductive capacity; conversely, when excessive amounts of the chemical were applied, Galston noted, the plants lost their foliage. Based on Galston's findings, botanists at the army research laboratory applied TIBA to plants liberally, causing the same reaction: plants withered and died. The botanists and chemists at the US Army Chemical Corps in Maryland altered Galston's substance, with Brown's approval, adding the initial T to the new mixture trichlorophenoxyacetic acid. The new chemical, 2, 4, 5-T had the desired effect on plant life. An effective herbicide, the new chemical 2, 4, 5-T, Agent Orange as it came to be known, contained dioxin: one of the most lethally toxic substances ever synthesized in a laboratory test tube.[12]

Little if any testing by any federal regulatory agency to determine the toxicity of the chemical and its long-term effects on humans had taken place when in 1961, thousands of gallons of the herbicide identified by color paint stripes on fifty-five gallon drums the colors being blue, pink, white, purple, and orange arrived by merchant ship and cargo plane in Southeast Asia. The chemicals would be used in

[12] Philip Jones Griffith, *Agent Orange: "Collateral Damage" in Vietnam* (London: Trolley Ltd. 2003), p. 164 and Wilbur J. Scott, Vietnam *Veterans Since the War: The Politics of PTSD, Agent Orange, and the National Memorial* (Norman: University of Oklahoma Press, 1993), p. 76 and Jack Doyle, *Trespass Against Us: Dow Chemical & The Toxic Century* (Monroe, Maine: Common Courage Press, 2004), pp. 54–55.

Operation codenamed Hades eventually renamed Operation Ranch Hand, given a new code name to obfuscate the nature of the military's strategy to defoliate thousands of acres of dense jungle. The phrase Ranch Hand seemed more benign, more harmless. Known in Vietnam by the slogan "Only we can prevent forests," a play on the phrase used by the US Forest Service mascot Smokey the Bear, the military would engage in the systematic spraying of dense jungle in Vietnam from the air in Fairchild C-123s, and eventually, Huey helicopters the workhorse of the army air cavalry in Southeast Asia. Ranch Hand's purpose: to deny the Communist National Liberation Front and Viet Minh allies their jungle sanctuary, the dense ground cover and indigenous food supply.

And the results of this ecocide was far-reaching—for nine years, more than nineteen million gallons of (herbicide) fell from the sky over South Vietnam.[13] "The US military command in Vietnam publicly insisted the defoliation program was successful and had little adverse impact on the economy and health of the villagers who came into contact with it."[14] All total, seventy-three million liters almost twenty million gallons covered more than two million acres south of the seventeenth parallel, the dividing line between South Vietnam and the Communist north. Of that amount, 62 percent of the herbicides which fell from the sky contained Agent Orange, its chemical composition consisting of lethal amounts of the afore mentioned... dioxin.[15] Manufactured and sold by Dow Chemical, fifty-five gallon drums of the chemical Agent Orange reached the airfields of Southeast Asia by way of a global pipeline of chemical production. This fact "underscores the common, widespread application of herbicides and other chemicals during the period in which the United States escalated the war in Vietnam and the ways in which a new environmental consciousness would coincide with that war."[16] Not

[13] Edwin Martini, *Agent Orange: History, Science, and the Politics of Uncertainty* (Amherst: University of Massachusetts Press, 2012), p. 2.

[14] Ibid.

[15] Martini, ibid., p. 2.

[16] Jack Doyle, *Trespass Against Us: Dow Chemical and the Toxic Century*. Monroe, Maine: Common Courage Press, 2004, pp. 54–61; ibid., p. 19.

since the Great War had chemical agents been used on the field of military conflict. Vietnam started the practice anew for "in January 1962, Operation Ranch Hand began its formal defoliation operations." Within a matter of months, Rachel Carson's *Silent Spring* had made its debut into the American public's mind, the publication which many claim to be the beginning of the modern environmental movement in America.[17] Carson too was concerned about the excessive use of herbicides.

Covering the escalation of America's military involvement in Southeast Asia, Richard Dudman was one of the first reporters to investigate the use of herbicides breaking the story of Operation Ranch Hand in the St. Louis Post-Dispatch in early 1963. Dudman's ten-part series included the use of the phrase "dirty-war" the strategy implemented by the United States military and their Republic of Vietnam allies. Dudman stated emphatically Operation Ranch Hand had been deployed to deny the Communist insurgency food grown by Vietnamese villagers and would also deprive the enemy of their natural jungle sanctuary from which they ambushed American infantry on patrol.

Dudman's reporting found its way into the office on Capitol Hill of Robert W. Kastenmeier in the House of Representatives. The Wisconsin Democrat went so far as to write a personal letter suggesting President John Kennedy "renounce the use of chemical weapons, especially herbicides, in South Vietnam."[18] Kastenmeier based his argument opposing the use of herbicides on President Franklin Roosevelt's stated policy during World War II in which the United States military in compliance with the Geneva Convention would never use chemical weapons. The rare exception according to the president would be if the Axis powers used them first. Then the US military would retaliate in kind. Dudman's boots-on-the-ground reporting even made it to the desk of Montana Senator Mike

[17] Ibid., p.10.
[18] William A. Buckingham Jr. *The Air Force and Herbicides in Southeast Asia* (Washington, DC: Office of Air Force History United States Air Force, 1982), pp. 81–82.

Mansfield who had the entire series entered into the Congressional Record on March 4 that same year.[19]

To clear the air the South Vietnamese government of Ngo Dinh Diem was advised by the officials in the Kennedy administration stationed in Saigon to hold a press conference the largest media event held in South Vietnam to date. Its purpose: to clarify and promote a better understanding of the need for Operation Ranch Hand and the necessity of American military aide in field operations. At this point in the war, Dudman's reporting in early February 1963 would be indispensable in informing the American people and the world on the use of defoliants in Southeast Asia as well as the political instability of Diem's government. By the early 1970s, Dudman's investigative style of journalism would be subjected to the scrutiny of the Nixon administration, which would have possibly landed him on the president's enemies list. But in early 1962, with Kennedy in the White House, no such threat existed. Dudman's reporting would be crucial in informing the American public about Agent Orange being used as a part of America's military strategy in the war effort in Vietnam.

A few of the reporters' observations are worth noting. Dudman had no illusions as to the despotism of South Vietnamese President Ngo Dinh Diem, who acquiesced to the US strategy of ecocide. Fair and balanced in his journalistic approach, Dudman analyzed Diem's tactics to stem the Communist insurgency in his country, Ranch Hand being one of them. Operation Sunrise forcibly removed Vietnamese peasants from rural agrarian-based areas to militarized villages in Dudman's words, "for the sake of security and surveillance."[20] Observing firsthand the challenges in the early stages of the war, Dudman witnessed American advisers who seemed unable to dissuade Diem from this strategy of "population control." For Operation Sunrise Diem used funds provided him by the United States government. Once relocated Vietnamese civilians, mostly farmers lived a subsistent existence on a small acreage worked as forced laborers

[19] Ibid., p. 82.
[20] Richard Dudman, "Asia's Frontiers of Freedom: Political Reaction a Problem in the Use of 'Dirty' Tactics to Fight Viet Cong Guerrillas," *St. Louis Post-Dispatch*, 6 February 1963, p. 1-B.

located in "agrovilles," massive agrarian settlements. Diem's political opposition were detained in "re-education centers," where between eight thousand and fifteen thousand dissidents lived under constant surveillance. Cruel as it may seem and a clear violation of their civil liberties, ironically, these detainment camps provided a safe haven, a sanctuary for the Vietnamese civilian population by isolating them from the massive air assault from the air by Operation Ranch Hand. Because once released from an aircraft, Agent Orange often drifted in the wind onto unsuspecting villagers, their bodies often exposed to chemical contamination, their crops and livestock damaged or killed inadvertently or intentionally.

Dudman and photojournalist Paul Berg's tour of the Far East began in New York City and took them to Tokyo, Hong Kong, then Saigon, the capitol of South Vietnam. From Saigon the pair traveled to Phenom Penn in Cambodia; Bangkok, Thailand; Vientiane, Laos; New Delhi, India; then back to New York. The headline of Dudman's report from the field dated February 6, 1963, read, "Political Reaction a Problem in Use of 'Dirty Tactics' to Fight Viet Cong Guerrillas" the feature article that exposed Ranch Hand. In Dudman's words, "Details are secret, but it is known that converted United States Air Force planes sweep across the countryside spraying poison from nozzles along their wings to destroy rice fields around insurgent strongholds and to strip the brush from roadsides where the enemy sometimes hides in ambush."[21] Not only did Dudman question the use of defoliants as an ethical, "valid technique of warfare." He made it clear Ranch Hand even at this early date, had yet to prove its effectiveness in killing the thick jungle plant life that provided a sanctuary for the Communist counterinsurgency

Dudman reported in great detail an analysis of how the strategy came to be. Frank J. Walton, head of the public safety division for the Agency for International Development mission in Saigon, outlined a plan to neutralize the Viet Cong. Other techniques included mobile

[21] Richard Dudman, *St. Louis Post-Dispatch*, "Asia's Frontiers of Freedom: Political Reaction a Problem In the Use of 'Dirty Tactics' to Fight Viet Cong Guerrillas," Wednesday, 6 February 1963, p. 1-B, & p. 8, col. 2.

one-man-operated radar to track the enemy, moveable heat sensitive cells to locate hidden insurgents, even the use of trained canine units to track the enemy were in the pipeline. There had even been a plan to defoliate and burn a swath of jungle one mile wide along the Mekong River along the Cambodian border. Such strategies originated in the mind of E. H. Adkins Jr. elaborated on a pamphlet he authored entitled "Control of Population and Material Movement." Adkins, a former FBI agent, based his ideas on the strategy the British military had successfully deployed against a Communist insurgency in Indonesia after the Second World War.[22]

How Ranch Hand became a part of US military strategy is a study in the extremes the United States military would take to enforce the diplomacy of Containment. An extension of George F. Kennan's "The Sources of Soviet Conduct" Containment resulting in the Cold War Domino Theory, was applied to South Vietnam, just another of the dominos which if allowed to fall into the Communist sphere of influence would result in yet more countries in the region the State Department could color red on its global map. That and faith in the notion of the superiority of technology over manpower, boots on the ground, overcoming any adversary on the battlefield. In Vietnam, it began with the first assessment of the Diem regime and its political instability. The man who inspired the lead character in the fictional novel *The Ugly American,* Brigadier General Edward Lansdale began his career in counterintelligence working in the Office of Strategic Services during World War II. Lansdale's assessment of the political instability in Diem's regime made its way to the Pentagon and the desk of Secretary of Defense Robert McNamara and presidential adviser McGeorge Bundy. Lansdale's assessment concurred with that of US ambassador in Saigon Frederick Nolting. Nolting's letter dated December 3, 1961, encouraged McNamara to deploy defoliants though Nolting warned of the adverse publicity should such a strategy become public knowledge.[23] Thus, Ranch Hand commenced.

[22] Ibid.
[23] Buckingham, pp. 26–27.

The operation had four objectives: (1) stripping the Cambodian-Laotian-North Vietnam border of foliage removing the protective cover from Viet Cong reinforcements, (2) defoliating a portion of the Mekong Delta area known as "Zone D" in which the Viet Cong have numerous bases, (3) destroying numerous abandoned manioc groves which the Viet Cong use as food sources, and (4) destroying mangrove swamps in which the Viet Cong took refuge. The scope of the mission would be to spray more than thirty thousand square miles or roughly half of the geographic area of South Vietnam at a cost of slightly less than sixty million dollars.[24] Finally, the plan reached the Oval Office for the president's authorization. John Kennedy approved. It was a go.

Ranch Hand coincided with National Security Action Memorandum 115 dated November 30, 1961, which escalated the war incrementally with an increase in the number of Green Berets in the field to advise the Army of the Republic of Vietnam. The document qualified the use of herbicides stipulating the chemicals be used "in a selective and carefully controlled joint program of defoliant operations in Vietnam starting with the clearance of key [supply] routes and proceeding thereafter to food denial only if the most careful bases of resettlement and alternative food supply has been created."[25]

Admiral Harry Felt, head of naval operations in the Pacific, would command the operation; General Lionel McGarr of the Military Assistance and Advisory group in Vietnam coordinated implementation of the strategy on the ground. Orders for spray missions were approved by US Ambassador Nolting in Saigon; orders were cut by General Paul D. Harkins initially, then by his replacement General William C. Westmoreland, a strong supporter of the use of defoliant strategy, who coincidentally commanded US forces during the

[24] Memorandum and figures cited in Walt W. Rostow, "Summaries of Suggested Courses of Action," no. 19, folder 2, box 202-3, National Security file, John Fitzgerald Kennedy Library, in Lt. Col. T. N. Green. *The Guerrilla and How to Fight Him: Selections from the Marine Corps Gazette.* New York: Praeger, 1962, as quoted in Zierler, p. 61.

[25] Zieler, p. 66.

military build-up during Lyndon Baines Johnson's presidency. Dr. James W. Brown, the biochemist working for the US Army Chemical Corps Biological Laboratories at Fort Detrick, Maryland, oversaw the implementation and effectiveness of Ranch Hand. Stockpiles of the chemical had already arrived in Vietnam stored in fifty-five-gallon color-coded drums at Phan Rang, Da Nang, Phu Cat, and Bien Hoa. There air bases could accommodate C-123 units flying "missions on alternate days with the intervening day used to fly to one of the storage locations to load herbicides for the next mission."[26] On January 7, 1962, six C-123s equipped with specially customized and fitted hourglass spray systems attached to the underside of each aircraft were operational. The first test run occurred in August of 1961; by October 1962, Operation Ranch Hand had expanded to include crops grown by the civilian population in an effort to deprive the Viet Cong of its food supply.

United States ground forces faced the formidable task of fighting an unconventional enemy much different from their task in two world wars. In Vietnam, there were no frontlines. Fighting the elusive Viet Cong and their tenacious ally, the Vietminh, American military commanders underestimated them. Though unknown at the beginning of America's involvement in Southeast Asia, the American military mission resembled a vehicle driving into a mud puddle filled with rainwater: once in the puddle, the weight of the vehicle forced the water out; when the vehicle moved forward out of the puddle, the water ran back into where it had originally puddled in the first place. So it was in the hamlets and villages of the Vietnamese countryside. By day, United States ground forces and ARVN could occupy and seemingly pacify outlying areas removed from their bases of operation. By night, that same area became VC country. The Vietnam War was an unconventional war. To win it, military commanders needed an "unconventional" strategy to deprive the insurgency of ground cover and sustenance oftentimes confiscated from hapless or some-

[26] Buckingham, p.168.

times willing villagers living in the countryside. Hence Operation Ranch Hand.[27]

For nearly ten years, the spraying of defoliants continued unabated. By the spring of 1969, the war in the minds of many Americans seemed to have no end in sight. Now it was Richard Nixon's war. And even though he would begin the de-escalation of the war, the historical record shows there is a great deal of uncertainty as to when the use of herbicides ended, August 20, 1971, being one of the most common dates frequently cited. What is certain is Admiral John McCain's requisition to use Ranch Hand's capabilities in South Vietnam to destroy opium producing poppy fields. The mission: to stem the flow of heroin destined for the illegal narcotics trade in the United States which occurred in June 1971. Another date is certain: Nixon's Secretary of Defense Melvin Laird ordered the removal of all herbicide stockpiles from storage facilities in April of 1972.[28] Prior to that, Ranch Hand flight crews and planes received orders reassigning them to the 310 Tactical Air Squadron on January 28, 1971, for cargo and transport duty.[29] Ranch Hand had come to an end.

Back home, word that the United States military's use of defoliants filtered onto college campuses and out into the streets throughout the country by the mid-1960s. Yale botanist Arthur Galston insisted the United States government knew very little about the environmental safety of defoliants. Galston and biologist Barry Commoner focused their scientific expertise as members of the Association for the Advancement of Science on the ongoing ecocide in the jungles of Vietnam. That and their anti-war activism provided a powerful voice in opposition to Operation Ranch Hand. Ten months after the rock group the Doors released their song "The End," Galston's article in The New Republic appeared in print, a polemic against the use of untested chemicals in warfare. Based on scientific analysis, Galston proclaimed, "Chemicals are being used against forested and agricultural lands in Vietnam as part of US military strategy and tactics."

[27] George C. Herring, *America's Longest War: The United States and Vietnam, 1950–1975* (New York: McGraw-Hill, 2001), 4th ed., p.188.

[28] Ibid., p. 175 & p. 188.

[29] Ibid., p. 175

Unique in the annals of modern warfare, the botanist claimed the use of defoliants to be the first of its kind in modern history: a military strategy novel in kind and massive in scope.

To be objective, Galston presented both sides of the issue quoting Assistant Secretary of State Dixon Donnelley, who explained America's strategy. Dean Rusk's understudy cut directly to the heart of defending the strategy claiming herbicides were being used to defoliate the jungle topography to deny the enemy sanctuary and foodstuffs particularly rice a staple of the Vietnamese diet. Donnelly argued the chemicals were no threat to the civilian population, "to people, animals, soil, or water," stating emphatically the chemicals were "selective" and of no threat to human life and other plants except those "target species." Donnelly neglected to mention the limited testing on laboratory animals or humans using the chemical, nor had any testing occurred when garden crops were contaminated with Agent Orange. As to the term target species, Ranch Hand crews had as much control over where the chemical landed as a golfer has control over where a golf ball lands when hit into a strong crosswind.[30] Ever mindful of public opinion, Donnelly failed to address this grim reality and the potential collateral damage herbicides were capable of. Galston likened Ranch Hand to a massive "experiment" in which the civilian population and US military were unwilling participants, the outcome determined only after the "experiment" had been performed.

The scientist explained, "If these effects are larger, more complex, or otherwise different from what we expected, there is no way of restoring the original conditions." He then provided in his article a brief history of Ranch Hand explaining how it began in 1961 and provided the operation's mission. Its targets: canal banks, riverbanks, the Mekong Delta, the rice basket of Vietnam, and the area surrounding the city of Qui Nhon. He explained how an estimated 1.2 million gallons of 2,4-D and 2, 4, 5-T had been sprayed over nearly a half a million acres of dense jungle, an area the size of the state of

[30] Arthur W. Galston, "Herbicides in Vietnam," *The New Republic*, vol. 157, no. 22, November 25, 1967, p 20.

Massachusetts; he elaborated on how the land area affected by Ranch Hand corresponded to the escalation of the number of ground troops sent to Vietnam by the Johnson administration during the same period. Such an operation required huge amounts of these chemicals; so great was the demand that Business Week magazine reported a shortage of these chemicals in the domestic market by April 1967, Galston reported. The scientist noted when Assistant Secretary of Defense Cyrus Vance was asked by reporters if "arsenic and cyanide," known poisons, were being used in Vietnam, Vance replied, "We are making limited use of them in the southern part of Vietnam but not yet in the north."

Galston went on to caution, "Cacodylic acid, an organic arsenic-containing compound, is being used against elephant grass and rice; both of these are the narrow-leafed type of plant which would be expected to be fairly resistant to the usual formulations of the 2, 4-D type of herbicide."[31]

He calculated the risk to human health as well as the environment of the target areas. Galston claimed two ounces of cacodylic acid derived from 2, 4-D or 2, 4, 5-T could be lethal to humans. Lesser amounts had the potential to induce side effects such as nausea, diarrhea, headaches, muscular pains, weak pulse, and even cause those exposed to lapse into a coma. Based on his scientific research Galston wrote, "All these symptoms flow from the paralysis of capillaries and degeneration of the lining of the intestinal tract known to be induced by arsenic." He identified two lesser known chemicals, Eastern R-245-OS and Formula 40 R, which were currently being sprayed on target areas by the Twelfth Air Command Squadron, printing verbatim the Dow Chemical warning label from the later in his article: Do not contaminate irrigation ditches or water used for domestic purposes. Both chemicals contained a more than two-thirds mixture of 2, 4, 5-T, Agent Orange. To support his argument, Galston borrowed an eyewitness account from Reuters. Reporting from Saigon, this article appeared in print in the Baltimore Sun on January 15, 1967; it read, "Chemical sprays have played havoc with

[31] Ibid., pp. 19–20.

birdlife, destroying vegetation and the insects on which birds feed. Monkey and deer have also been affected," Reuters reported.[32]

Village names have changed since the fall of Vietnam in 1975. That said, Galston tabulated the apocalyptic damage, Ranch Hand had had a part in by providing examples of the destruction caused by unrestricted aerial spraying: A Michelin rubber plantation where trees were dying; the village of Bien How, where banana trees wilted and died; the village of Tan Hiep, where a crop of legumes were damaged in this case by a ground-based Buffalo Turbine spraying defoliant; the village of Thoi An Dong in Phong Phu Province, where a watermelon crop showed signs of withering on the vine; in the hamlet of Can Tho, "papaya, jack fruit, milk fruit, coconut, watermelon, mustard cabbage and beans," a year's supply of food for the poverty-stricken villagers who tilled their small gardens, were ruined by lethal doses of Agent Orange; a rice crop there, a vegetable crop, and fruit trees defoliated and dying here; the garden crops in the villages of Phuce Thai and Ton Tuyen decimated. All these casualties of the aerial onslaught.

Those villages declared "secure" zones by the United States military, they too had incurred serious damage from aerial spraying. Galston estimated the damage in most of the villages affected to be between 40 and 100 percent of the foodstuffs Vietnamese villagers needed to sustain life or to sell at the local open market nearby.[33] A distinguished botanist, Galston based his argument against the use of Agent Orange on the bedrock of scientific fact. He pointed out the risk involved in using chemicals for military purposes in areas inhabited by humans, where they subsisted on agriculture to survive.

Galston warned of not only the potential harm to the people in the target area of this aerial bombardment. He also wrote of the "serious and lasting damage to soil and agriculture, rendering more difficult South Vietnam's recovery from war, regardless of who is the 'victor.'"[34] In Galston's mind, such a scenario made the military outcome irrelevant.

[32] Ibid.
[33] Ibid., 21.
[34] Ibid.

To his way of thinking, there would be no winners in a war that as history would record had become a "quagmire" even before Richard Nixon became president. And as is the case in all wars, in Vietnam, the civilian population suffered the most as a result of ecocide, their crops destroyed their health threatened by a chemical, which would prove to be debilitating at least, deadly at worst by war's end.

Three months before Earth Day, just as the crescendo of anti-war protest reached a fever pitch, Galston submitted another installment of his indictment of the US military's use of defoliants to The New Republic for publication. "Deliberate Destruction of the Environment: What Have We Done to Vietnam?" which included the research of Robert E. Cook and William Haseltine, two of Galston's colleagues. The article included a brief history of Operation Ranch Hand and the chemicals in use, and again, Galston provided more insight into the use of Agent Orange this coming from the person, who more than anyone else was responsible for the development of the chemical in the laboratory. Galston's narrative provided a look into how after World War II the US Department of Agriculture, the Federal Drug Administration, the National Institutes of Health, and US Fish and Wildlife Service approved with limited testing the use of 2, 4-D and 2, 4, 5-T by American farmers. Since being approved as "weed killers," Galston wrote, "By 1965, more than 120 million acres were being sprayed…each year in the United States." Since being certified for commercial use, no comprehensive study by any of the above governmental agencies had been undertaken to determine the chemicals "carcinogenic, mutagenic, or teratogenic properties."[35] By 1970, that had changed.

Ordered by the Pentagon and the National Cancer Institute which Galston supported, tests measuring the herbicide's long-term effects on laboratory rats and mice were made public in December 1969. The classified study had been recommended by the American Association for the Advancement of Science to the Defense

[35] Robert E. Cook, Arthur W. Galston, and William Haseltine, "Deliberate Destruction of the Environment: What Have We Done to Vietnam?" *The New Republic*, vol. 162, no. 2, 10 January 1970, p. 19.

Department. Without question, anti-war sentiment by 1967 the date of Galston's first publication and after the publication of Rachel Carson's *Silent Spring* had played an important part in persuading the AAAS the study was necessary, that Agent Orange was a public health concern.[36] NCI's study sent shock waves throughout the scientific community and the nation as a whole. Female rats and mice that had ingested limited amounts produced offspring with birth defects or showed abnormal physical development the report labeled teratogenesis. As a result, the NCI labeled 2, 4-D "potentially dangerous"; 2, 4, 5-T, Agent Orange, received the classification "probably dangerous." The study read, "Female rats that were fed doses as low as 4.6 milligrams per kilogram of body weight (equivalent to about 1/100 of an ounce for an average woman) bore three times as many abnormal fetuses as control rats." The laboratory findings were irrefutable: clearly these herbicides were potentially teratogenic, with the potential to cause congenital abnormalities in humans.[37]

The collaborative effort was balanced. Galston traveled to Vietnam to see firsthand the devastation caused by Ranch Hand. He and his colleagues interviewed a Vietnamese journalist to confirm the NCI's findings. Vietnamese reporter Viet Bang, writing for the Buddhist publication Chanh Dao, had interviewed local Vietnamese physicians in two hospital maternity wards. Bang's sources indicated an increase in birth defects and a high incidence of fetuses being aborted prematurely; teratogenic babies, those born with malformities, occurred with greater frequency than had previously been observed in these hospitals. Such occurrences were part of hospital medical records, yet the Vietnamese physicians Bang interviewed had been ordered to turn over their files to the South Vietnamese Ministry of Health. There they remained hidden from public scrutiny. Leaving no stone unturned, Galston requested comments from President Richard Nixon's White House Science Adviser Dr. Lee DuBridge. DuBridge responded with assurances the Department of Agriculture had taken the necessary precautions to ban the use of

[36] Ibid., p. 19.
[37] Ibid.

Agent Orange with a convenient caveat "unless the Food and Drug Administration found a basis for establishing a safe legal tolerance." Nevertheless, precautions in the United States did not translate into precautions in Southeast Asia. DuBridge went on insisting Ranch Hand would continue, and the military's "flexible response" would "restrict its use to areas remote from populations." Ranch Hand would continue its strategy, and as Galston indicated, "No change whatever will be made in the military use of 2, 4, 5-T."[38]

Galston concluded his narrative with three key points. First, the chemicals in question had been developed during the World War II era when testing for long-term side effects was limited or nonexistent. He compared the teratogenesis from exposure to Agent Orange to thalidomide, an over-the-counter prescription drug linked to birth defects in the United States and Great Britain. Second, he warned against continuing to use herbicides in the fragile ecosystem of the Southeast Asia rainforest. Then Galston likened defoliants to DDT, which had the potential to kill birds as Rachel Carson demonstrated in her book *Silent Spring*. And finally, the article maintained the use of herbicides was unethical, similar to the use of chemical weapons in modern warfare. Galston warned, "The United States must begin to grasp the concept that belligerents in hostilities share a responsibility for preserving the potential productivity of the area of conflict. Otherwise, our technology may convert even the most fertile area to a desert, with lasting consequences to all mankind."[39]

To say the American public was fixated on the Vietnam War in the winter of 1970, is understating the reality of that time. Casualty numbers projected on television screens during broadcasts of the nightly news was a daily occurrence often narrated by Walter Cronkite, Chet Huntley, and David Brinkley. Environmentalists, in addition to believing the war to be immoral and a violation of international law, also realized the massive defense appropriations for the war in the federal budget could have been used more effectively cleaning up the nation's polluted rivers and Great Lakes and purify-

[38] Ibid., p. 20.
[39] Ibid., p. 21.

ing its smog filled air in the nation's cities. The environmental dev-
astation notwithstanding, the spaying of defoliants on the rainforest
of South Vietnam was a costly undertaking; Operation Ranch Hand
cost nearly sixty million dollars to implement. And it did not go
unnoticed by environmentalists. Minnesota Senator Walter Mondale
made reference in an essay, "Commitment to Survival," to the "man-
grove fields of South Vietnam, made barren for a generation by fifty
thousand tons of herbicides," a reference to Ranch Hand.[40]

Another voice warning of the unrestricted use of defoliants,
originated from the type writer of Wisconsin Senator Gaylord Nelson
given credit for the idea of observing Earth Day. Though without
footnotes or a bibliography, Nelson's book *America's Last Chance
to Preserve the Earth* is a testimonial to that concern. The senator's
words are filled with a sense of urgency on the environmental issues
of that time. On Operation Ranch Hand, Nelson was quite clear.
Nelson believed it had the potential to be an ecological disaster of epic
proportions if the military use of defoliants continued. He claimed,
"Two zoologists made a study of the ecological effects of the Vietnam
War in 1969. They found, in addition to the massive bomb cratering
that is [was] turning much of the Vietnamese countryside into areas
resembling the surface of the moon, that there is [was] heavy dam-
age to areas treated with herbicides, defoliate the trees and plants."
Based on eyewitness accounts from boots-on-the-ground reporting
from the Vietnamese countryside, in Nelson's thinking, irreparable
damage had been done.[41] Nelson cited another example to make his
point. In the area surrounding Dong Nad province just off Highway
1 not far from Bien How evidence of defoliation sorties had taken its
toll, leaving mango groves and surrounding jungle foliage decimated.
Nelson based this statement on reports from the scientific commu-
nity on location: Nelson's sources described "the defoliants as having a
'ghastly effect of denuding the country of growth' and related 'we con-

[40] Environmental Action, ed. (Denis Hayes, National Coordinator), *Earth Day:
The Beginning: A Guide for Survival* (New York: Bantam Books, 1970), p. 43.

[41] Gaylord Nelson, *America's Last Chance to Preserve the Earth*, ed. Country
Beautiful (Waukesha, Wisconsin: Country Beautiful Corporation, 1969), p.
74.

sider the ecological consequences of defoliation very severe.'"[42] The bitter irony is the impact upon human health wrought by Operation Ranch Hand and its impact upon the Vietnamese civilian population and American military personnel exposed to Agent Orange would not be fully known until after the fall of Saigon in April 1975. Even so, with the Vietnam War Moratorium on October 15, 1969, six months prior to Earth Day, Ranch Hand and its mission had made its way into the conversation of environmental activists by April 22, 1970.

Within a few years after Earth Day, related health problems from exposure to agent would become known. Even before the withdrawal of US military manpower in Vietnam, personnel exposed to the herbicide began to complain of health problems, debilitating illnesses, and physical disabilities. How Agent Orange affected those exposed to it can be found in a comment by environmental activist Dr. Barry Commoner. Commoner explained once exposed, defoliants entered the human body in a similar fashion the way DDT contaminated birds. He maintained, "The dioxin contained in Agent Orange could be stored in the body's fatty tissue and at a later date cause cancer or other diseases." Defoliants as a threat to human health made its way into the mainstream by way of a documentary film and a lawsuit brought against the Dow Chemical Company by a Vietnam veteran, one of the costliest class-action lawsuits in American history. Eventually, Monsanto, Diamond Shamrock, and North American Philips, all producers of herbicides used by the military in Vietnam, joined Dow Chemical as co-defendants. The plaintiff Paul Reutershan, suffering from abdominal cancer at the time, is known for his quote during an interview on NBC's Today Show, "I died in Vietnam, but I didn't even know it." Reutershan's lawsuit and the activism on behalf of Vietnam veterans by counselor Maude deVictor in Chicago would raise the environmental consciousness of Americans long after the events of April 22, 1970, had faded into memory.[43]

[42] Ibid.

[43] Wilbur J. Scott, *Vietnam Veterans Since the War: The Politics of PTSD, Agent Orange, and the National Memorial* (Norman: University of Oklahoma, 1993), pp. 87–88.

On behalf of the men who she counseled, deVictor made hundreds of phone calls to the Defense Department, the Veterans Administration in Washington, and Dow Chemical to acquire information on possible side effects caused by exposure to Agent Orange. Frustrated after compiling files on at least two dozen veterans who had either handled the defoliant directly or been exposed to it in the Vietnamese countryside while on patrol, DeVictor sought out Bill Kurtis a television reporter working the beat for WBBM, the CBS affiliate in Chicago handing over to the reporter her files and what little research she had on the subject. Kurtis put together a documentary called "Agent Orange: Vietnam's Deadly Fog," the original broadcast aired on the evening of March 23, 1978. The response from Vietnam veterans and the general public produced shock waves measured in television ratings.

The presentation held no surprises for Arthur Galston, who, for the rest of his professional life, remained in the college classroom teaching bioethics, in a way doing penance for what he undoubtedly had had a hand in bringing about in a hapless, poverty-stricken country in Southeast Asia. Not as an apology but as a moral imperative to the scientific community, Galston submitted an article to the Annals of The New York Academy of Sciences in the early summer of 1972. In it, he included a photographic record produced by a flyover of vast stretches of rainforest, evidence of Operation Ranch Hand's environmental destruction. One photo of a dead mangrove forest from ground level resembled shots taken in France during the Great War, World War I. It depicted an entire forest laid waste to, accentuated by the bomb craters on a pockmarked landscape.

In his narrative Galston called for an end to what he called laissez-faire attitudes of the scientific community he was a part of. He urged scientists and academia as a whole to become involved when a discipline had been appropriated for what he called evil or destructive ends. Despite assurances from Undersecretary of State Dixon Donnelley, Galston called into question the legality of using defoliants under the Geneva Gas Protocol of 1925, approved by the community of nations after the Great War. President Richard Nixon supported ratification of the treaty but insisted on excluding defoliants from the ban on chemi-

cal weapons. For this reason, the Senate Committee on Foreign Affairs objected, and the United States never voted for ratification.[44]

Galston challenged the scientific community to remain in a constant state of vigilance. He listed the reasons for always being alert: (1) he maintained every scientific discovery had the potential to be misused; (2) Galston called upon his fellow scientists to "act on their social responsibilities"; and (3) he insisted when faced with a "perversion" of some innovation, academia must act. Galston cited Ralph Nader, Barry Commoner, and Paul Ehrlich, the latter two educators as examples of academics who had made a difference championing the cause of opposition to ecocide in Vietnam.[45] Galston's article was not an apology. Rather, his narrative summoned scientists to oppose what he referred to as the "perversion of science." Galston's article is nothing more nor nothing less than a moral imperative directed at the scientific community and academia alike to accept their obligation to humanity opposing those forces which might abuse scientific knowledge for immoral or unethical purposes.

So after years of litigation, the US Department of Veterans Affairs relented and began paying Vietnam veterans exposed to defoliants who qualified for benefits. There are fourteen diseases listed as cause for disability payment from the Agent Orange fund. Many disabilities were no doubt the result of some genetic predisposition unrelated to their Vietnam experience. Certainly there were veterans who tested positive for some form of cancer or another disease related to the abuse of opiates which were plentiful in Vietnam, or their illnesses caused from smoking pot, cigarettes, or abusing alcohol or all three in Vietnam. Those were the drugs of choice in "the Nam." Human nature tells us there are always those who will game the system to their advantage given the financial benefits at stake in a federal program such as this. That said, the medical records of the American military personnel returning home from the Great War, World War II, and Korea would reveal the scars of war such as battle fatigue, post-traumatic stress disorder, and disabilities from physical wounds. There were few reported

[44] Arthur W. Galston, "Science and Social Responsibility: A Case History," *Annals of the New York Academy of Sciences,* June 1972: pp. 232–233.

[45] Ibid., p. 235.

health issues such as cases of chloracne, Type 2 diabetes, pancreatic cancer, or other cancers which were diagnosed as war related. Lest we forget this greatest generation produced the baby boom generation, a demographic phenomenon unparalleled in the twentieth century. To dismiss the professional opinions of Dr. Ronald A. Codario, Lennart Hardell, and Dr. Gilbert Boger and other medical professionals is to ignore the obvious: countless numbers of Vietnam veterans after exposure to Agent Orange had serious health problems. In one study, 85 percent of seventy-eight Vietnam veterans exposed to defoliants had health problems; 19 percent of their children had debilitating birth defects; couples reported an abnormally high rate of fertility problems.[46]

What changed? What made Vietnam different? Why was Vietnam an aberration? To ignore the fact that exposure to defoliants in Vietnam caused such maladies is to nullify the professional assessments of countless physicians and the strong scientific evidence that exposure to Agent Orange is the devil in the details. Countless US military personnel serving in Vietnam from January 1962 until the fall of Saigon, thirteen years later who were exposed to defoliants returned home with wounds unrelated to combat and the ravages of war. Exposure to defoliants is the common denominator in most disability claims. It is no coincidence that on April 15, 1970, the Nixon administration banned the sale and distribution of Agent Orange for commercial use in the United States. Seven days later, the whole world celebrated the first Earth Day.[47] As it did then, the dark shadow of the legacy of herbicide use in Vietnam lingers on in America.

[46] Fred A. Wilcox, *Waiting for An Army to Die: The Tragedy of Agent Orange* (New York: Random House, 1983), pp. 114–123 and pp. 195–196.

[47] Edwin Martini, *Agent Orange: History, Science and the Politics of Uncertainty*, p.10.

"I Am Become Death, the Destroyer of Worlds"

Those words were spoken by J. Robert Oppenheimer a short period after the spectacle of the first successful test of an atomic warhead during the summer of 1945 in northwestern New Mexico. A passage from Hindu scripture, those words accurately reveal what the testing of nuclear weapons both on land and sea brought upon not only the United States but the world community at large. World War II had brought human history into the nuclear age. But research and experimentation at Los Alamos, New Mexico, in a government-funded, top-secret operation called the Manhattan Project bore bitter fruit. Though the atomic bombs dropped on the Japanese cities of Hiroshima and Nagasaki ended that great military conflict waged against Imperial Japan, few events have scarred the face of the earth and induced such a paranoia and anxiety in the collective mind of humankind like the dawning of the nuclear age.[48]

President Harry S. Truman did not know at the time that his dispatch to cigar-chewing Major General Curtis LeMay of the Army Air Corps ordering commander Paul Tibbets, flight commander

[48] Julius Robert Oppenheimer, "I Am Become Death, the Destroyer of Worlds," https://youtu.be/lb13ynu3lac.

of the B-29 Enola Gay, to use the ultimate weapon, initiated what would become the most highly contested arms race in human history. When the 4.5-ton atomic warhead nicknamed Little Boy fell to earth and detonated near the Aioi Bridge in Hiroshima unleashing its star shaped concussion and three-hundred-thousand-degree fireball skyward into the heavens, little was known about the Japanese survivors who suffered from effects of atomic radiation. The radiation sickness of the survivors left an indelible mark on military personnel and the civilian population in the United States alike. But another even greater threat became apparent in time: With Hiroshima and Nagasaki, the contamination of the jet stream and the atmosphere by radioactive fallout had began. Also in August 1945, there was little scientific and medical information to suggest atomic radiation was harmful.[49] Nor did any scientific evidence exist which indicated radioactive fallout in the atmosphere to be a threat to human health.

Then it happened. On a routine flight over northeastern Russia in September 1949, a American military reconnaissance flight detected radioactive fallout in the immediate airspace it passed through, positive proof the Soviet Union had detonated a nuclear weapon of its own. And so it was the United States and Soviet Union, each fearing the military capacity of the other, embarked upon a Cold War arms race, a strategic chess match which generated nuclear warhead testing measured in megatonnage. The purpose: one-up-manship, which guaranteed mutually assured destruction should one side strike first. On the tiny atolls of Micronesia in the South Pacific, in the deserts of the American Southwest, and in the barren expanses of frigid Siberia, the superpowers tested no less than two hundred nuclear devices between 1951 and 1963. Military personnel and the scientists who developed these weapons of mass destruction watched through tinted goggles with cotton in their ears crouched in trenches or on sea vessels in some cases barely a mile from ground zero. Military units awaited the all-clear signal to begin military maneu-

[49] Richard L. Miller, *Under the Cloud: The Decades of Nuclear Testing* (New York: The Free Press, 1985), pp. 42–46, and William L. Laurence, "Drama of the Atomic Bomb Found Climax in July 16 Test," *The New York Times*, 26 September 1945, pp. 1 and 16.

vers to determine the feasibility of conventional ground operations in the likelihood of a nuclear war. The civilian population in the United States and abroad were at the mercy of this ongoing escalation of a nuclear arms race. One such example is the fate of a Japanese fishing trawler Lucky Dragon.

The first test of a hydrogen bomb by the United States took place on November 1, 1952, on Eniwetok Atoll, a coral island in the Marshall Island chain. With a megatonnage force eight hundred times more destructive than the bomb which incinerated Hiroshima, the H-bomb, or Super, as it came to be known, codenamed Mike, upon impact lifted a fiery cloud more than fifty-seven thousand feet into the heavens. In his definitive history of the development and testing of American hydrogen bomb weapons program *Dark Sun: The Making of the Hydrogen Bomb*, Richard Rhodes recorded what happened to the fragile atoll as being surreal:

> The fireball had vaporized the entire island, leaving behind a circular crater two hundred feet deep and more than a mile across filled with seawater, a dark blue hole punched into the paler blue of the shallow atoll lagoon. The explosion vaporized and lifted into the air some eighty million tons of solid material that would fall out around the world... It stripped animals and vegetation from the surrounding islands and flashed birds to cinders in midair.[50]

There would be human casualties.

During the late winter of 1954, two years removed from Mike, the United States military embarked upon a series of new tests of this destructive weapon. Operation Castle consisted of five tests of hydrogen-grade warheads, each the equivalent of fifteen tons of TNT. In an instant, test "Bravo vaporized a crater 250 feet deep and 6,500

[50] Richard Rhodes, *Dark Sun: The Making of the Hydrogen Bomb* (New York: Simon & Shuster, 1995), p. 509

feet in diameter out of the atoll rock…" Vaporized coral comprised
of calcium from beneath the ocean's surface, headed skyward up into
the upper atmosphere. The radioactive ash fell back to earth in what
eyewitnesses described as resembling a heavy snowfall. Observing the
weapon's test, a small flotilla of US naval vessels maintaining a posi-
tion thirty miles beyond Bikini Atoll, ground zero. Naval personnel
and marines watched as the massive firestorm measuring "nearly four
miles in diameter" mushroomed upward.[51]

Within the hour after the blast, Geiger readings aboard the
naval vessels began to register dangerous amounts of radioactivity.
Then in an instant, ship captains sounded general quarters, a signal
for personnel on deck to baton down the hatches and go below; spe-
cially designated radiological personnel clothed in special garments
ventured onto the top deck to check for contamination cleanup and
sound the all-clear to shipmates. Meanwhile, crews below deck had
to sweat it out until the signal of all-clear sounded. Specially designed
fire hoses sprayed seawater onto the upper decks to wash off radioac-
tive contamination. But there were those who were not so fortunate.[52]

Less than ninety miles from ground zero, twenty-three Japanese
fishermen went about their daily ritual of setting their lines to catch
fish a mainstay of the Japanese diet. In so doing, they hoped to reel
in the highly prized blue-fin-tuna and other fish. At 3:50 a.m. on
the morning of the Bravo test (codenamed Castle-Bravo) on March
1, 1954, the crew of the Lucky Dragon witnessed what seemed to
them like "the sun rising in the West." Two hours after the bomb's
impact, radioactive coral blasted upward into the South Pacific sky
began to fall to earth again in the form of radioactive ash which
resembled snowfall. Within minutes, the tiny ship and its unsuspect-
ing crew were covered in ash composed of radioactive elements of
uranium and strontium 90, which, in the words of physicist Ralph
Lapp, when coming into contact with the human body, "Sought out
the bone and deposited there would 'live' for a long time" with "a half

[51] Rhodes, p. 187.
[52] Ralph E. Lapp, *The Voyage of the Lucky Dragon: An Extraordinary Sea Story*
(New York: Harper & Brothers Publishers, 1958), p. 159.

life of twenty-eight years, meaning that half its radioactivity would still remain after twenty-eight years had passed."[53]

Within minutes from the moment of contamination, the Japanese crew began to feel the debilitating effects of radioactive poisoning. Alopecia, (excessive hair loss), body blisters, sore eyes, extreme darkening of the skin, and fatigue all pointed to radiation sickness, similar to many of the Japanese survivors following Hiroshima and Nagasaki. Samples of the gray ash later tested positive: The crew had been exposed to high levels of radioactivity. Later, lengthy hospital stays made the front pages of most Japanese newspapers, including the Yomiui Shimbun and others around the world. Tokyo bureau chief for The New York Times Lindsay Parrott reported the Lucky Dragon's fate and the more than two million pounds of contaminated fish in markets, which caused a general panic among Japanese consumers. Parrot's front page headline read, "Nuclear Downpour Hit Ship During Test at Bikini US Inquiry Asked."[54] A colleague's request to edit an edition of the Bulletin of Atomic Scientists brought the plight of the Japanese fishermen to the attention of the rest of the American public and physicist Ralph Lapp who journeyed to Japan three years after the incident to gather facts and tell the true story of what had happened to the Lucky Dragon. Lapp calculated eight thousand square miles of the South Pacific Ocean, including inhabited islands, had been contaminated with lethal radioactive fallout; the blast had dumped "one hundred tons for each square mile" of the area in question.[55] Even more ominous, thousands of pounds of market fish in Japan had to be destroyed due to high levels of radioactive contamination.

Though Lapp argued humanity would survive a nuclear war, he and a cadre of scientists in the United States and the Soviet Union came to oppose the testing and proliferation of nuclear weapons. At the height of the Cold War, Lapp made a plea for sanity in the nuclear arms race by claiming, "In a real sense we are all sacrificed

[53] Ibid., p. 131.

[54] Lindsay Parrot, "Atomic Smasher Sets Record, Japan Gets Radioactive Fish," *The New York Times,* 17 March 1954, p. 1 and 9.

[55] Ibid., p.188.

on the bloody alter of a tyrannical technology."[56] As for the Japanese fishermen, radioman Aikichi Kuboyama's death remains shrouded in mystery beyond the realm of scientific and medical certainty. Though the cause of death listed on the certificate is disorder of the liver, Ralph Lapp surmised had Kuboyama never been exposed to radioactive ash from the Bravo test, "He would never have needed a blood transfusion" the doctors had prescribed to treat his infected liver.[57]

Lapp's book was well-received. By 1958, the number of academics, opinion leaders, and political pundits opposing the nuclear arms race had grown. Reviewing Lapp's book for The New York Times Leonard Engel explained the nuclear device which led to the hospitalization of the Lucky Dragon crew was not a conventional atomic bomb; nor was it a hydrogen weapon. Rather, the Bravo bomb had been proven to be a uranium bomb, a city buster capable of obliterating a city the size of Moscow, London, New York City, or Los Angeles. The bomb had had the equivalent of fifteen million tons of TNT, this according to the Japanese scientific community who had uncovered this important distinction. Of the Lucky Dragon incident, Engel noted, "It helped reveal how powerful and incredibly nasty nuclear weapons have become, and played a part in precipitating the debate over the safety and morality of bomb tests, a debate that still rages four years later."[58] And the crew of the Japanese fishing vessel were not alone.

Two days before the Lucky Dragon returned to its home port of Yaizu, Japan, The New York Times ran a story first reported by the Associated Press about the inhabitants of the Marshall Islands being exposed to intense radiation from Bravo. This despite reassurances from an Atomic Energy Commission spokesman who insisted, "Instruments showed that they [Micronesians] were subjected to some radiation but no ill effects have showed up." The article went

[56] Matthew L. Wald, "R. E. Lapp 87, Physicist in Cold-War Debate on Civil Defense," The New York Times, 10 September 2004, p. C10.

[57] Lapp. The Voyage of the Lucky Dragon, pp. 175–176.

[58] Leonard Engel, review of The Voyage of the Lucky Dragon, by Ralph E. Lapp, The New York Times Book Review vol. LXIII, February 23, 1958, no. 8: p.1.

on to read, "In the more than forty atomic tests conducted so far," there had been no injuries or radiation burns reported. Further investigations by the Times reported otherwise. A United States Marine on duty in Kwajalein, three hundred miles east of Eniwetok, mailed a letter home to his mother in Cincinnati, Ohio. She released the contents to the Associated Press. Marine Corporal Donald Whitaker recalled, "'I was walking back to the barracks…just as it was getting daylight, when all of a sudden the sky lighted up, a bright orange, and remained that way for what seemed like a couple of minutes.'" Whitaker went on to say, "About ten or fifteen minutes later back at the barracks, we heard very loud rumbling that sounded like thunder similar to what the crew of the Lucky Dragon experienced. Then the whole barracks shook as if there had been an earthquake.'[59] Three days later, in a second letter, Whitaker witnessed the following: "'There were two destroyers that pulled in here today bearing natives of one of the Marshall Islands that was seventy-five miles of the blast. They were suffering from various burns and radio-activity [poisoning].'" Whitaker's eyewitness account differs from the official AEC's press release claiming the only person ever injured had been a man near a test at ground zero who had "picked up some radioactive rock and suffered mild burns of the fingers." All total, 236 Micronesians and 28 American citizens had been exposed to radioactive fallout the result of Operation Bravo.[60]

National Security concerns and fear of causing a panic at home led the Atomic Energy Commission to issue misleading press releases for the purpose of damage control. So great was the fear of possible nuclear annihilation and world domination by the Soviet Union, the AEC, President Dwight Eisenhower and his Secretary of State John Foster Dulles resorted to extreme measures including misinformation to make certain that fear never materialized. This implied exposing human beings to lethal levels of radioactive fallout and contaminating the environment in the process.

[59] *The Associated Press* as reported in *The New York Times*, "264 Exposed to Atom Radiation After Nuclear Blast in Pacific," 12 March 1954, p. 1 and 8.
[60] Ibid.

Leonard Engel, a decade earlier, had conjured up the novel *World Aflame: The Russian-American War of 1950*. Though a work of fiction, Engel's book reflected a growing anxiety over the testing and proliferation of nuclear weapons. Engel summed up his impression of Lapp's history of the hapless Japanese trawler by posing the larger question of nuclear weapons proliferation: Should the testing of such weapons be continued, and if so, what precautions should be put in place by the Atomic Energy Commission and the United States government to safeguard civilian populations against the hazards of radioactive fallout in the future? Ralph Lapp and Engel recognized the grim reality of this growing threat to public health. The pendulum of public opinion had begun to shift against testing these weapons of mass destruction and abandoning the nuclear option in the American arsenal which would be used, should the unthinkable happen: a nuclear war with the Soviet Union.

Concerns about radioactive fallout in the environment became common public knowledge. From the medical histories of the survivors of Hiroshima, Nagasaki, and the Lucky Dragon crew, word began to circulate amongst the medical and scientific community and the public at large. These case studies verified the clear and present danger of nuclear radioactive contamination oscillating in the jet stream high in the atmosphere around the earth's surface. Microscopic dust launched high into the atmosphere by nuclear weapon's testing returned to earth in snowfall and rainfall; Geiger counter readings first detected dangerous levels of radioactivity near Huron, South Dakota, on April 28, 1953, followed by Salt Lake City, Utah, Casper, Wyoming, Davenport, Iowa, and Omaha, Nebraska, prompting an investigation by the Atomic Energy Commission.[61]

Responding to the immediate threat to human health, the international community led by the United States AEC, the United Nations Food and Agricultural Organization, the World Health Organization, and the International Atomic Energy Agency convened a formal conference at the Hague in December 1961. One year later,

[61] Richard L. Miller, *Under the Cloud: The Decades of Nuclear Testing* (New York: The Free Press, 1985), pp. 6–7.

the Consumer Union's Director of Public Service Projects released the findings of the Hague conference to the American public and the world. The international gathering confirmed what many Americans and the scientific had suspected for some time: Unacceptable levels of radioactive iodine-131, strontium 90, strontium 89, and cesium 137 now existed in measurable amounts across the United States in every community. The potential for genetic damage and an increased risk for leukemia in human beings was a grim possibility. Radioactive contamination had also made its way into the food chain by way of milk from dairy cattle grazing on contaminated pastures, fruits and vegetables in gardens being dusted with microscopic radioactive dust particles; fallout on grains such as corn and wheat, and fresh food products in open air settings around America.[62]

To allay the American public's anxiety over the issue of the distinct possibility of a nuclear war with the Soviet Union, in the final weeks of 1948, the Truman administration sanctioned the Atomic Energy Commission's publication of *The Effects of Atomic Weapons*. In a nuclear America, preparedness would be the watchword. The purpose of the book: to educate and inform the American people. Preparing the how-to manual would be the University of London's Dr. Samuel Glasstone a respected physical chemist who served as publications editor with many of the same physicists and technicians who had assisted in the development of the bomb in the Manhattan Project. *The Effects of Nuclear Weapons*, which read like a survival manual, was written to inform not only the public but governmental officials as well. The purpose: to prepare for the worst if the detonation of an atomic warhead occurred near your home or in your community. The content explained the difference between a conventional TNT bomb and an atomic weapon in textbook fashion. There was a greater amount of energy released by the nuclear weapon upon impact__a thousand fold greater than a conventional bomb__which also produced greater heat and intensity of light. The potential harmful after effects caused by radiation, which could be lethal, separated

[62] "Fallout in Our Food," *Consumer Reports*, April 1963, vol. 28, p. 191.

the atomic warhead from a conventional bomb used during World War II."[63]

Glasstone included everything in the book, from an explanation of the pathology of radiation sickness to a chapter on physical damage, which went into an in-depth discussion of the projected destruction if nuclear warheads should rain down upon the United States. For environmental activists, their focus was on the low air bursts at Alamogordo, New Mexico, Eniwetok, and Bikini Atolls in the South Pacific. For them, Glasstone's book included the fact that radioactive dust particles measuring from five to three hundred microns in diameter lifted by the mushroom cloud, launching this radioactive contaminated dust into the atmosphere, in the words of Gladstone, like the "dust over the Sahara desert." And the evidence accumulated as weapons tests continued.[64]

Prior to publication, the Atomic Energy Commission had inspected livestock within a fifteen-mile radius of the original Trinity test site not far from Alamogordo, New Mexico. The commissioners observed hair loss and blister-like lessons on cattle there; of those cattle, most soon healed, and no genetic defects in the calf crop were detected in late 1949. However, the commissioners did report the hair of many of the herd exposed to the fallout had turned a grayish color, a clear indication of radiation poisoning. More evidence surfaced after Trinity in Vincennes, Indiana, in August 1945. Water contaminated with fallout had fallen in the Wabash river, a large riverine which drained a watershed in the area.[65] Though the study determined radioactive dust to be a benign threat to human health, this reassurance in no way dissuaded the Earth Day generation of the seriousness of the potential toxicity of nuclear contamination, with thoughts of the survivors of Hiroshima and Nagasaki fresh in their minds. Contaminated air produced by a low air burst generated by the testing of nuclear weapons and the thought of the possibility of an atomic explosion producing microscopic particles with the poten-

[63] Samuel Glasstone et al., *The Effects of Atomic Weapons*, Washington, DC: The Combat Forces Press, 1950, p.1.

[64] Ibid., pp. 271–273.

[65] Ibid.

tial to produce clouds which generated rainfall did nothing to calm fears of an anxious public. Neither did the conclusion of the study which revealed conclusive evidence even reinforced-concrete frame buildings located more than five thousand feet from ground zero in Hiroshima and Nagasaki remained relatively intact and unscathed. Such reassurances did nothing to discourage political activism opposing nuclear weapons testing during the late fifties and sixties.

Soon, the New York Times reporter who witnessed the Trinity Test published *Dawn Over Zero: The Story of the Atomic Bomb* in 1953. William Laurence's book preceded Robert Jungk's *Brighter Than a Thousand Suns: A History of the Atomic Scientists* in 1956. To claim the nuclear threat consumed and dominated the imagination of the American people in those times would be an understatement. For twenty years beginning in August 1945, more than five hundred films of dubious quality were produced by the dream machine in Hollywood, California, and in Japan, featuring the mutated forces of the natural world made so by radioactive nuclear fallout.

Whether they be movies featuring prehistoric dinosaurs or giant insects, such films played in movie houses around the country, eventually finding their way onto the silver screen in Asia and Europe. Radiation caused Tarantula, The Deadly Mantis, and The Black Scorpion to morph into monstrous size beyond belief. Plots as predictable as the popular westerns of the time included humans acting heroically to subdue these forces of nature and, in so doing, saving America and the world from catastrophe and annihilation. Darwinian in principle, preposterous to the point of being surreal, "The Beast From 20,000 Fathoms" and "It Came From Beneath the Sea" featured a prehistoric-like creature and monstrous octopus respectively, the latter invading the West Coast and stalking the streets of San Francisco; both returned to the living because of nuclear weapons testing. But of all the mutants which appeared on film, most noteworthy was a Mesozoic beast summoned from the depths of the Pacific Ocean by the detonation of a hydrogen bomb.[66]

[66] Robert A. Jacobs, *The Dragon's Tail: Americans Face the Atomic Age* (Amherst: University of Massachusetts Press, 2010), pp. 334–339.

The creature's name: Godzilla. And the first film featuring this monster, "Godzilla, King of the Monsters," featured the beast terrorizing the streets of Tokyo with his gargantuan size, a radioactive tail, and fire-breathing nostrils, inspiring countless spin-offs in which Godzilla would, in time, do battle with another genetically mutant creature King Kong. By the middle of the 1960s, Godzilla was not alone. Genetically altered creatures made so by nuclear accidents were as common in American culture as the new Ford Mustang, American Bandstand, and bouffant hairdo. Aliens from the far reaches of the galaxy in movies always seemed to set up their base of operations beneath nuclear weapon's test sites. "Killers from Space" and "This Island Earth" typified this genre. An entire generation of American children matured under the spell of this Hollywood science fiction. Many would came to embrace the spirit of the first Earth Day.

Films of a far more serious tone produced for an adult audience included "Fail Safe," "Seven Days in May," "On the Beach," "Planet of the Apes," and Stanley Kubrick's classic "Dr. Strange Love." All plots featured the threat of a nuclear holocaust. In Kubrick's film, Major T. J. "King" Kong, played by Slim Pickens, rides an atomic bomb rodeo-style from the bomb bay of a B-52 to ground zero somewhere deep inside the Soviet Union presumably Moscow. "Dr. Strange Love," featuring Peter Sellers and George C. Scott, satirizes the theory of General Curtis LeMay and many members of the Joint-Chiefs-of-Staff in the Kennedy White House that a nuclear war based on mutual assured destruction, the preposterous idea that such a war was winnable. This despite the fact most of the scientific community involved in creating these weapons of mass destruction had assured the world in the event of such a likelihood, there would be no winners.

Realizing this fact and knowing a thing or two about military intelligence, author Ian Fleming produce a series of popular novels based on this premise. Of the first six films based on Fleming's imaginary character James Bond Agent 007, four included plots in which nuclear weapons or nuclear energy of some kind in the hands of an evil, megalomaniac character would be catastrophic to humanity. One such character, Emilio Largo, an agent doing the bidding of the

international crime syndicate SPECTRE, hijacks two nuclear bombs demanding a ransom of one hundred million pounds sterling in uncut diamonds from the North Atlantic Treaty Organization. Refusal to meet his demand would result in Largo and his undersea army detonating the bombs somewhere in the United States or Europe. Special Agent Bond infiltrates Largo's base of operations, learns of Largo's plan, and saves Miami, Florida, Largo's target from destruction. The movie Thunderball reinforced the threat of a nuclear disaster and the threat posed by nuclear weapons to civilization. One episode of The Twilight Zone filmed in 1962 features Burgess Meredith, a lowly bank teller, the sole survivor of a hydrogen bomb blast. His character, Henry Bemis, a man with a nagging wife who forbids him to read, contemplates suicide. Then he discovers the local library and charts a reading schedule for his entire life, a dream come true, only to break his glasses concluding the episode. "Time Enough at Last," a tale of the horrors of nuclear weapons, ends in absolute terror with Bemis unable to fulfill his lifelong fantasy.

American culture and Saturday matinees are one thing, educating America's children about the nuclear weapons threat another. Many of those who celebrated the first Earth Day knew of children in some cities on the East coast who were required to wear dog tags to identify their bodies should a nuclear war occur. The Federal Civil Defense Administration produced and distributed to public schools around the country a film entitled "Duck and Cover." Its purpose: "to teach children how to survive a nuclear attack without adult assistance." In the film, elementary school children were instructed on the proper way to "duck and cover" in hallways next to inner school building walls, to take cover under cafeteria tables and desks and how to use their hands properly to prevent serious head injuries.[67] In the same vein, Encyclopedia Britannica Films produced "Atomic Alert," instructing schoolchildren on how to best prepare for atomic warfare. In an educational setting where children were supposed to feel safe, "the fact that both films were shown to children in their classrooms served to give these messages a chilling authoritativeness." The

[67] Ibid., p. 102.

psychological effects of such drills and films cannot be measured. Given the trusting nature of small children, the impact of watching such films and the "duck and cover" routine were profound.[68]

An activist in the Students for a Democratic Society, Todd Gitlin reflected upon the psychological effects of children who had to endure the constant threat of World War III. Nuclear war did not discriminate; in a nuclear war between the United States and the Soviet Union, social status and wealth were meaningless. Gitlin recalled routine drills in grade school, and the psychological conditions gave cause for "the first American generation compelled from infancy to fear not only war but the end of days."[69] "Duck and cover" drills in school classrooms where children cowered beneath metal and particle board desks were practiced oftentimes to the eerie wale of a civil defense siren. Embedded in the collective imagination, the threat of nuclear annihilation left a lasting impression. Not until well after the first Earth Day did the "all clear" warning sound in the minds of an entire generation of children and their parents. Gitlin reminds us of the way things were by explaining, "Whether or not we believed that hiding under a school desk or in a hallway was really going to protect us from the furies of an atomic blast, we could never quite take for granted that the world we had been born into was destined to endure."[70] In retrospect, the greatest casualty of the Cold War for the United States was that of the lost innocence of its children. For the generation which came of age during those times, the possibility of nuclear war during the decade of the fifties caused great anxiety and was a pernicious distraction threatening their future in much the same way the war in Southeast Asia would in time.

Imagination in the minds of impressionable children of mutually assured destruction is immeasurable. Hard scientific empirical evidence of a real nuclear weapon's is irrefutable. A mainstream publication, Consumer Reports confirmed in its September and October issues of 1962 numerous reports of whole milk contaminated by

[68] Ibid., p. 106.

[69] Todd Gitlin, *The Sixties: Years of Hope, Days of Rage* (New York: Bantam Books, 1993), p. 22.

[70] Ibid., p.23.

radioactive idodine-131 produced by nuclear weapon's fallout had surfaced as early as the previous July. Public health officials reported "hot milk" had been detected in Salt Lake City, Utah. Short-term solutions such as dry-lotting dairy herds and transferring in bulk the tainted milk to facilities where it could be processed into powdered milk and cheese were measures taken to allow the radioactive contamination to "decay" before it reached consumers in waxed cardboard and glass containers in grocery stores. Compounding the crises, Consumer Reports confirmed the same nightmare in Utah had surfaced also in Minnesota, Iowa, Kansas, and Missouri; state health officials in each state had taken action to prevent iodine-131 from contaminating their milk supply in vain. Minnesota compensated dairy farmers financially to dry-lot their dairy herds during scheduled nuclear weapon's testing.[71]

Six months later, the Consumer Reports followed up on its reporting of the previous fall with an article, "Fallout in our Food." It declared emphatically, "It is therefore clear that the iodine-131 in our diet during the second half of last year was from the 1962 tests by the US and the USSR." It identified other sources of contamination, the lethal radioactive isotopes strontium 90, strontium 89, and cesium 137, which when digested acted in a similar fashion to calcium by bonding with "bone and remains there for many years, and may therefore cause leukemia or bone cancer in some people..." CR identified traces of strontium 90 and strontium 89 in products made from wheat such as breads and pastries, calculating them to be roughly 6 percent of the contaminants of the total diet. Milk was another matter. The percentage of the two isotopes in milk contributed more than 80 percent of the contamination in the daily average American diet.[72] CR rated the amount of strontium in the diets of America's cities, singling out Little Rock, Atlanta, New Orleans, Duluth, Portland, Oregon, and Knoxville, Tennessee, as venues averaging levels of the radioactive isotope between 50 percent and 300

[71] "More States act on Iodine-131 in Milk," *Consumer Reports*, October 1962, vol. 27, p. 478.
[72] "Fallout in Our Food," *Consumer Reports*, April 1963, vol. 28, p.190 & 191.

percent. Consumer Reports listed thirty of America's largest metropolitan areas where high levels of radioactive fallout was found in the diets of the people living there.[73]

Consumer Union scientists analyzed the daily diets of a typical teenager in those same cities in various regions in the continental United States. Milk, cereal products, and other food samples from the food pyramid, totaling twenty-one meals including snacks were included in the study. Testing was also performed on foods typically consumed by infants in four of the thirty cities. The CU indicated traces of cesium 137 had a half-life of at least thirty years and had the potential to cause genetic defects in children. CU test results were then compared to minimum allowable standards set by the Federal Radiation Council. The investigation noted the correlation between the frequency of nuclear weapons testing and the spike upward in levels of radioactive fallout contamination between 1961 and 1962. Their conclusion: contamination increased upward when weapon's tests increased in frequency. For Americans concerned with their health and their children's health, with strontium and cesium in the air they breathed, there existed a greater probability of leukemia and birth defects. The official FRC statement read, "Any radiation exposure of the population involves some risk, the magnitude of which increases with the exposure."[74]

As to the source of this life-threatening "Fallout in Our Food?" most of it originated in the Nevada desert, sixty-five miles northwest of the gambling capital of America, Las Vegas. At Yucca Flat, scores of nuclear grade weapon's tests, both above and below ground, occurred there between October 1951 and April 1970 with ominous implications for the American landscape. One such test received publicity in Life magazine, a mainstream coffee-table publication.

At approximately 5:10 a.m. on May 15, 1955, military technicians dropped a nuclear device the equivalent of thirty-five thousand tons of TNT from a steel tower. Civil defense officials had planned this test, which included a simulated town built with military mus-

[73] Ibid., p.193.
[74] Ibid., p. 192.

cle and appropriations from the civil defense fund. The imitation town complete with wooden and masonry structures, automobiles, even canned soup and mannequins positioned like real people going about their daily routine were intended to educate civil defense personnel to "see the effects of atomic attack on the normal surroundings in which Americans work, play and live."[75]

Eight miles from ground-zero, civil defense workers observed the blast through tinted googles from Media Hill. Life reported, "The mushroom cloud reached a height of about forty thousand feet, a frosty white cap forming on its top as it moved into the cold upper atmosphere." Ominously, the magazine read, "There the winds began to disperse it." Life's reporter mounted cameras near the makeshift buildings, where mannequins stood motionless as the concussion from the blast hit them. Time-lapse photographs recorded the devastation; Life published the color photos showing moment of impact.[76] The blast set fire to the houses more than four thousand feet from impact; houses constructed of brick exploded, their roofs ripped from the main structure like kites from a string in a strong wind. At the 2.4 second mark, a greenish tint smeared the celluloid film, indicating the effects of gamma radiation contamination; that same moment, a dust cloud blurred the film, indicative of the massive amount of dust particles in the air. All this captured by Life's photojournalist at the scene and robotic photographic technology. Both the real-time film footage and Loomis Dean's photographic artistry left an indelible impression on Life's readership. To even contemplate the unthinkable reality of planning to survive a nuclear holocaust left many Americans thinking of ways to abandon the nuclear arms race and drop out of the Cold War altogether. Such thinking permeated American society.

Such sensational journalism solidly grounded in fact became public knowledge. It sold magazines consumed by the general public, raising the specter of nuclear annihilation both at home and abroad.

[75] "Close Up To the Blast," *Life*, vol. 38, no. 22, 30 May 1955, pp. 39–42, and "Victims at Yucca Flat," *Life*, vol. 38, no. 20, 16 May 1955, p. 58.

[76] Ibid.

Of those scientists who worked on the Manhattan Project, most came to oppose the proliferation of nuclear weapons. Most also supported regulating them by some international governing body, the United Nations foremost among that number. Though he identified with those opposing the proliferation of nuclear weapons and banning the bomb, British philosopher Bertrand Russell refused to allow political pundits to label him and what he stood for. President Truman's decision to use the ultimate weapon on Hiroshima and Nagasaki left Russell's mind in a state of confused agitation as it did many academics initially. A stint as guest lecturer at Princeton University helped spread his convictions of antimilitarism and nuclear disarmament to the United States.

With the onset of the Cold War and subsequent nuclear arms race between the United States and the Soviet Union, the subsequent future of Eastern Europe, and in time, East Berlin in the balance, the philosopher began to focus his energy on prohibiting the testing, the proliferation, and the dissemination of knowledge about how to build the bomb. By the time Russell became resolved to this way of thinking, George Kennan, the architect of Truman's containment policy, had also come out publicly in favor of deescalating the East–West nuclear threat. Coincidentally, Russell joined and became actively involved in the Campaign for Nuclear Disarmament in January 1958. Serving as the organization's first president, Russell went on to write *Common Sense and Nuclear Warfare*, expressing his thoughts on the subject and making a case to end once and for all the testing and proliferation of nuclear weapons.[77]

The first official meeting of the CND took place on February 17, 1958. Within a matter of weeks, chapters of the organization had spread throughout Great Britain. Despite factionalism between those who insisted upon passive resistance and others who embraced the need for civil disobedience, Russell perceived the CND as a necessary means to add converts to the cause of abolishing nuclear weapons. After the first meeting in the winter of 1958, the CND organized

[77] Bertrand Russell, *The Autobiography of Bertrand Russell* (New York: Simon and Shuster, 1969), p. 139.

protest marches in London and elsewhere around the country, the first of which occurred that same year. Such protest marches became an annual ritual, which Russell claimed degenerated "into something of a yearly picnic." Even so the CND proved to be an important political instrument for generating the kind of publicity which focused on the nuclear threat both in Great Britain and abroad.[78]

A turning point for the nuclear disarmament movement in the United States happened when Russell met American Ralph Schoenman. Both men had committed themselves to political activism; both shared an affinity for the Campaign for Nuclear Disarmament. Convinced civil disobedience to be the means by which the movement could achieve its goals, it was Schoenman who persuaded the philosopher Russell to embrace such activism as a means to raise public nuclear consciousness among the general population. By the early spring of 1958, CND in England had planned a peaceful march from Trafalgar Square in London to Great Britain's Aldermaston nuclear weapons facility fifty-two miles away. It was during this march that Gerald Holtom, a textile designer, unfurled his cloth banner featuring an eclectic variation of two naval flag distress signals. The Aldermaston march was the first time the peace symbol captured the public's attention. The date was April 4, 1958. Ten days later, on April 14, the peace symbol made its debut in the United States, featured in a an edition of Life magazine.[79]

Though the subject of debate, the first appearance in public of the peace symbol occured at a gathering of Women Strike for Peace, a protest movement organized by in thousands of women in more than fifty American cities in opposition to nuclear weapons which occured on November 1, 1961. WSP superimposed Holtom's peace symbol creation in a white dove on an American flag. Ironically, WSP membership committed themselves to political activism, not only opposing the deployment of nuclear warheads but also "their detonation in the atmosphere," and were gravely concerned by the saber rattling

[78] Ibid., p.141.

[79] Ken Kolsbun and Mike Sweeney, *Peace: The Biography of a Symbol* (Washington, DC: National Geographic Society, 2008), p. 41.

by both the United States and the Soviet Union after construction of the Berlin Wall.[80] Holtom's iconic symbol would be ubiquitous from the late 1950s through Earth Day in the spring of 1970. It could be seen on banners during the civil rights marches, brandished by those opposed to the Vietnam War, at Woodstock, and even worn by American troops in the jungles of Vietnam as a badge of honor. Antinuclear anxiety spread rapidly.

In the United States, the most important political organization opposing nuclear weapons proliferation was SANE, an acronym for the National Committee for a Sane Nuclear Policy. In 1957, two weeks before the Thanksgiving holiday, SANE promoted their cause with a one-page spread in The New York Times. In bold print, the headline read, "We Are Facing a Danger Unlike Any Danger that Has Ever Existed…" SANE challenged the public, accusing America of abdicating its moral obligation as a world leader. SANE questioned American values, accusing the newspaper's readership of excessive materialism. The ad stated the obvious: Americans had an obsession for "bigger incomes, bigger television screens, and bigger cars," a cheap substitute for freedom from the fear of mutually assured nuclear destruction. SANE warned, "In our possession and in the possession of the Russians are more than enough nuclear explosives to put an end to the life of man on earth."[81] Those signing the SANE advertisement read like a who's who of academia, religion, the arts, celebrity, and America's political leadership. Among the names were Oscar Hammerstein II, Dr. Erich Fromm, Norman Cousins, Roger N. Baldwin, Lewis Mumford, Norman Thomas, the Reverend George B. Ford, Rabbi Edward F. Klein, Eleanor Roosevelt, and Dr. Paul Dotty Chairman of the Federation of American Scientists.[82]

By 1960, SANE's membership had spread to more than one hundred chapters nationwide with a membership of more than twenty thousand. Their number included celebrities Janet Leigh, Tony Curtis, Anthony Quinn, Jack Lemmon, Shirley MacLaine, Gregory

[80] Ibid., p. 64.
[81] National Committee for a Sane Nuclear Policy, The New York Times, 15 November 1957, p. 3.
[82] Ibid.

Peck, and Marlon Brando. The national spokesmen for the organization were socialist Norman Thomas and Saturday Review editor in chief, Norman Cousins.[83] SANE's gathering in Madison Square Garden during the spring of 1960 would mark a turning point in the American antinuclear movement. A foreshadowing of the Earth Day to come, the New York City event drew a capacity crowd who listened to speeches by Eleanor Roosevelt, Walter Reuther, Thomas, and Cousins. After the convention adjourned, entertainer Harry Belafonte accompanied several thousand protestors on a march to the United Nations to air their grievances.[84]

Ban the Bomb activism in the United States took on a variety of outward political personas and sizes. The factors that energized this political phenomena varied:

1. Its members realized the impact of the testing of nuclear weapons in Nevada and the South Pacific.
2. They felt threatened by the health risks nuclear fallout posed not only for Americans but the international community as well.
3. Most opposed nuclear weapons which they believed threatened world peace.
4. Lastly, many joined the movement out of a sense of camaraderie with the anti-nuclear protestors in the United Kingdom and elsewhere, particularly Japan.

Theirs was a relatively peaceful political movement, free of acts of civil disobedience so typical of most of the portest against the Vietnam War. An exception would be the Committee for Nonviolent Action, which in 1959 in a protest against the deployment of intercontinental ballistic missiles in Omaha, Nebraska, there were arrests and incarcerations by law enforcement. Another exception was a protest initiated by Mary Sharmat and Janice Smith when the two young

[83] Lawrence S. Wittner, *Resisting the Bomb: A History of the World Nuclear Disarmament Movement, 1954–1970* (Stanford, California: Stanford University Press, 1997), p. 246.

[84] Ibid.

mothers refused to participate in civil defense drills in New York City. In total, the New York City Police Department made twenty-six arrests even as young women defiantly pushed baby carriages down city streets as the "take shelter" sirens blared.[85]

More typical was the aforementioned noteworthy organization Women Strike for Peace. Gender-based WSP lobbied Congress with letters, marched with placards around the White House, printed substantive quantities of antinuclear literature, and even sponsored a delegation to Geneva, Switzerland, where the Women's International League for Peace and Freedom held a disarmament conference, which included Coretta Scott King in the summer of 1962. Generating even more sensational publicity, WSP emphasized the threat to children's health requesting young mothers save their child's teeth for testing to determine the level of strontium 90 contamination. The group called for a boycott of milk if President John Fitzgerald Kennedy continued to support atmospheric nuclear weapons testing.[86] Similar sentiment permeated college campuses around the country.

Another anti-nukes organization, the Student Peace Union, was organized in Chicago in the winter of 1959 by the American Friends Service. It exemplified the diversity of the movement. Comprised of Socialists and pacifists representing at least seven midwestern college campuses, the SPU met in Nyack, New York, announcing to the media that war can no longer be successfully used to settle international disputes and that neither human freedom nor the human race itself can endure in a world committed to militarism.[87] Increasing in numbers to more than five thousand students on over one hundred college campuses around the country, the SPU represented the core values of the Ban-the-Bomb movement. SPU even picketed the Kennedy White House. Similar to SANE, the SPU organized protest meetings and held antinuclear seminars similar to the Earth Day teach-ins; gatherings featured celebrity speakers, promoted circulating petitions, and campaigned openly on college campuses to

85 Ibid., 249–250.
86 Ibid., p.251.
87 Ibid., p. 253.

raise the awareness of the dangers of nuclear fallout from weapons testing.[88]

And there were incidents. In the darkness of night on January 17, 1966, near Palomares, Spain, a B-52 bomber laden with four hydrogen bombs collided with a KC-135 refueling tanker during a routine exercise. Though none of the four bombs had been armed, two shattered into pieces emitting plutonium-grade dust into the atmosphere at the crash site. A single microgram, one-millionth of a gram can cause great harm to the human respiratory system if inhaled. The bombs outer exterior shells had cracked and released roughly seven pounds of weapons-grade plutonium contaminating the entire crash area. Air Force personnel scoured the countryside searching through the cactus covered rocky terrain with no protective gear or breathing apparatus to protect them from life-threatening nuclear particulate matter. The New York Times reporter Dave Philips recalled the furor created by the disaster: "Accounts of the crash became front-page news in Europe and the United States. American officials immediately tried to cover-up the accident and down play the risk. They blocked off the village and denied nuclear weapons or radiation were involved in the crash."[89]

Two days later near Jacksonville, Florida, a nuclear-tipped missile accidentally dropped several feet, hitting the deck of the missile frigate, the USS Luce. The surface-to-air missile, Terrier, as it was called, caused no serious damage. Even so, the Mayport Naval Air

[88] Ibid., p. 254.

[89] United Press International, "US Said to Hunt Lost Device," *The New York Times*, 20 January 1966, p. 1 and p. 9. United Press International, "GIs Hunt Atom / device at Bomber Crash in Spain," *New York Herald Tribune,* 20 January 1966, p. 1 and p. 6, Dave Philips and Raphael Minder, "In Sick Airmen, Echo of 66 Nuclear Crash," *The New York Times*, 20 June 2016, p. 1 and p. 12 and Ralph Minder, "An Air Force Bomber Crash Leaves Scars in Spain," *The New York Times*, 21 June 2016, p. A4 and A9. (See *The New York Times* video documentary online: "Decades Later, Sickness Among Airmen After a Hydrogen Bomb.") 19 June 2016.

Station remained at a heightened state of alert with sections of the base closed for security reasons.[90]

Serious incidents for certain. But these pale into insignificance compared to what transpired on May 22, 1957, near downtown Albuquerque, New Mexico. Little known before Earth Day in 1970, it happened on a routine flight from Biggs Air Force base in Texas to Kirtland Field near Albuquerque. A solitary B-36 carrying a forty-two-thousand-pound hydrogen bomb had a breach of protocol which would in time shock the entire nation. How it happened is in dispute, but somehow, the H-Bomb was released from its secure hold in the jet falling to the ground and landing somewhere on the campus of the University of New Mexico. The "broken arrow," as the military referred to such mishaps, did not detonate; the only damage left behind after the stray H-Bomb crashed to the ground was a sizable crater killing a cow that happened to be grazing nearby. Details were not known until a local newspaper sued under the Freedom of Information Act in 1986. Even so, Air Force personnel spread news of the incident by word of mouth. Fortunately, the city itself remained intact instead of being blown into oblivion, its citizens unharmed.[91]

The threat remained, which increased the level of the public's anxiety. The nuclear weapon's monopoly held by the United States and the Soviet Union did not last. By 1964, Great Britain and France had joined the nuclear community of nations. Ominously, on October 16, 1964, the Chinese Communist government of Mao Tse Tung successfully tested an atomic device at Lop Nur in Outer Mongolia in the barn salt flats of the Train Basin. Three years later, in March, Red China flexed its nuclear muscle by detonating another atomic bomb; the test broadcast by a Tokyo television station for the entire world to see. Three months later, on June 17, Chinese technicians successfully tested its first hydrogen weapon. The Super, unleashed a destructive force the equivalent of several million tons of TNT launching tons of radioactive dust into the stratosphere. By

[90] Associated Press, "Device Dropped Aboard Ship," *The New York Times,* 20 June 1966, p. 9.

[91] Les Adler, "Albuquerque's Near-Doomsday," *Albuquerque Tribune,* 20 January 1994, p. C1.

June 1967, the five nuclear powers had tested more than 483 atomic or hydrogen grade warheads above ground. The geographic area and air affected was global in scale. Distractions such as Rudi Gernreich's topless bathing suit and the arrest of nineteen-year-old model Toni Lee Shelly who dared wear Gernreich's fashion creation on the beach at Lake Michigan in Chicago, dominated the news cycle only momentarily. The global threat of nuclear weapons and their side effects left a deeper imprint upon the American consciousness.

And the threat of radiation contamination of the air, food, and soil would not be the only thought in the minds of the American people. By 1961, the United States and Soviets had begun deploying ICBMs, intercontinental ballistic missiles with the capacity to guarantee mutually assured destruction in both countries. The V-2 missile system developed by Wernher Von Braun and the Nazis during World War II was the engineering paradigm. Eastern European physicists and engineers had, by 1960, perfected surface-to-surface rockets capable of lifting multiple nuclear warheads aloft to targets deep inside the Soviet Union, more than 5,500 miles from the eastern shore of the United States. These giant, wingless artillery ranged in size from the Matador, Jupiter, and Thor Intermediate Range Ballistic Missiles (IRBMs) to the Atlas and Titan ICBMs, capable of delivering multiple nuclear warheads nine thousand miles with deadly accuracy.[92] In a dangerous game of one-upmanship, the Soviets countered with the mainstay of the Soviet ICBM arsenal, the R-7 and improved R-7A. These formidable weapons had a range of more than five thousand miles, carrying a nuclear payload of three tons.

Such developments did nothing to rid American society of the anxiety over the nuclear threat. East Germany's decision to build the Berlin Wall in that divided city in August of 1961 and the Cuban missile crises the following year were grim reminders of a world divided over political ideology which could lead to war. Fortunately for humanity, the Kennedy administration, in no small part due to Soviet Premier Nikita Krushchev's better judgement and the diplo-

[92] Neil Sheehan, *A Fiery Peace in a Cold War: Bernard Schriever and the Ultimate Weapon* (New York: Random House, 2009), pp. 173 & 178–179 and 265–266.

matic acumen of the president's younger brother, Robert, America and the world could breathe a sigh of relief once the thirteen-day Cuban Missile Crises passed. In hindsight, the Cuban dilemma did do a great deal to lessen Cold War tensions. A phone line between the Kremlin in Moscow and the White House installed to facilitate communication was a good first step. That and negotiations between Khrushchev and Kennedy led to the signing of the first Nuclear Test-Ban Treaty in August 1963, just months before Kennedy's assassination in Dallas, Texas.

The anxiety and fear wrought by the threat of nuclear contamination created by atomic weapon's testing was real. So real it was deeply imbedded within the subconscious of the minds of the millions of Americans who celebrated the first Earth Day. Such apprehension motivated Sheila Hoffman, wife of Abbie Hoffman, to become actively involved in the Campaign for Nuclear Disarmament, comprised of those inspired by the example of Bertrand Russell. In the winter of 1960, it would be Sheila who received notoriety in the couple's hometown of Worcester, Massachusetts, by protesting there outside city hall against the proliferation of nuclear arms carrying a large sign inscribed with the words "O Sleepers Awake!" as she pushed her infant son Andrew in a stroller.[93] Aware of the threat posed to human health by nuclear-grade weapons' testing at Yucca Flat in Nevada, biologist Barry Commoner, with other academics and community activists, formed the group St. Louis Committee for Nuclear Information. With the help of other scientists such as Linus Pauling and Herman Muller, Commoner's organization campaigned for an end to aboveground testing. Environmental historian Philip Shabecoff points out, "The atmospheric testing of atomic devices was one of the newer issues around which the modern environmental movement rallied."[94]

Elation and jubilation after the first successful test of a nuclear bomb at Alamagordo, New Mexico, had changed to anxiety and fear.

[93] Jonah Raskin, *For the Hell of It: The Life and Times of Abbie Hoffman* (Berkeley: University of California Press, 1996), p. 41.

[94] Philip Shabecoff, *A Fierce Green Fire: The American Environmental Movement* (New York: Hill and Wang, 1993), p. 98.

There among the cottonwood trees and Yucca plants on terra-cotta-colored ground at 5:30 Mountain Time, New York Times's reporter William Laurence stood alongside Harvard physical chemist George B. Kistiakowsky in a slit trench three feet deep in total darkness and witnessed the first test of the atomic bomb. It was Kistiakowsky who prophetically best described what he had witnessed to Laurence. In the chemist's words, "'I am sure that at the end of the world, in the last millisecond of the earth's existence, the last man will see what we saw!'" In the minds of environmentalists, on April 22, 1970, those words had become a sobering, real possibility.[95]

[95] William I. Lawrence, "Drama of the Atomic Bomb Found Climax in New Mexico," *The New York Times*, vol. XCV, column 2, 26 September 1945, p. 16.

Chapter 3

One Huge, Teeming Anthill

In 1962, the United Nations Statistical Yearbook tabulated the total world population to be more than three billion, increasing incrementally at a rate of fifty-five million per year. Statisticians and demographers with the world-governing body projected by the year 1970 more than 3.7 billion would be inhabiting the earth's surface, each one partaking of the planet's capacity to support life. UN demographers estimated a total world population of six billion by the year 2000. Accordingly, the birth rate would increase incrementally population density to twenty-two persons per square mile in 1962, slightly less than twenty-three, the number projected by demographers the previous year. The year 1962 would be a watershed date in world population growth. For that year marked the beginning of a growing gap between a declining death rate and a tremendous spike upward in the world birth rate, both occurring simultaneously. The following year, for the first time in recorded history, the combined population of the Americas totaled 441 million, exceeding the population of Europe, excluding the Soviet Union.[96]

Of all the issues, the Earth's growing population numbers would be the most controversial environmentalists would face after World

[96] United Nations, *United Nations Statistical Yearbook, 1962* (New York: United Nations, 1963), p. 41.

War II. The majority of activists celebrating the first Earth Day in the spring of 1970 would live up to the label neo-Malthusians, a name attributed to an Englishman of the Enlightenment who raised the specter of overpopulation in the waning years of the eighteenth century.

Born in Surrey County, England, Thomas Robert Malthus was a man of the Enlightenment, a period of insatiable intellectual and scientific inquiry. It was a time when the ideas of Diderot, Bacon, Voltaire, Locke, and Montesquieu became known. Malthus's book *An Essay on the Principle of Population as It Affects the Future of Improvement of Society* argued food production could not keep pace with humanity's capacity to reproduce itself. In those times, disease, famine, pestilence, and natural disasters served to check human population expansion; Malthus believed war, a man-made disaster, served as a positive check on overpopulation. But by the 1960s, the frequency of such forces had lessened significantly. Through technological progress and laboratory miracles such as vaccines, civilization had overcome such deterrents to population growth. Hence the concern of intellectuals, the scientific community, and of course, environmentalists alike, who focused on overpopulation, believing it to be a social problem. By 1962, the world had become a smaller place indeed. Environmentalists came to believe population growth threatened not only their quality of life but their survival as well.

In the years immediately following the Second World War, Henry Fairfield Oborn Jr. warned of overpopulation. Osborn was born in Princeton, New Jersey, dabbled in eugenics, and eventually aspired professionally to the presidency of the New York Zoological Society. He became the first American essayist to go on record warning world population growth threatened human survival. In his book *Our Plundered Planet*, Osborn warned anthropocentric behavior threatened nature and the natural world. Osborn assessed world population numbers in a chapter entitled "The Geologic Force: Man." Beginning his study in the base year of 1630, Osborn calculated the world's population had risen from 400 million to 1.6 billion, grow-

ing at an annual rate of 1 percent per annum.[97] Malthusian in tone, Osborn based his book on scant evidence. Even so, he used his intuitive intellect to warn technological advancements and improvements in health care in Western civilization had contributed to a rapid increase in population numbers in the twentieth century.

Osborn's numbers on the acreage necessary for agriculture of a given region to support the human population inhabiting it were approximations not grounded in solid demographic statistics. Even so, Osborn determined the growing world population after World War II to be "the greatest problem facing humanity today…"[98] *Our Plundered Planet* served as a wake-up call to the postwar generation and to those who would deny this just as the leaders and peoples of vanished nations have failed to recognize this truth in the past. Osborn articulated much of what would by the spring of 1970 become a groundswell of the sentiments expressed by protestors on Earth Day. He reasoned, "Almost every purpose and activity of modern life takes precedence over the one most basic purpose of all, namely of conserving the living resources of the earth."[99] To focus the public's attention on the issue of global population expansion, Osborn put together a collection of essays offering different perspectives on the subject. *Our Crowded Planet: Essays on the Pressured of Population* appeared in print fourteen years after his original book. The compilation of articles included the thoughts of Henry Steele Commager, naturalist Joseph Wood Crutch, British biologists Sir Julian Sorell Huxley, Japanese journalist Chikao Honda, University of Michigan biologist Marston Bates, British conservationist Frank Fraser Darling, and the grandson of Charles Darwin, Galton Darwin. A physicist, Darwin's descendant's essay is most interesting. Never mind the proclivity and pro-creationist tendencies of his famous grandfather, Darwin's words echoed that of the neo-Malthusian point of view at that time.

Quoting directly from his grandfather's *The Origin of Species*, Galton Darwin's submission to Osborn's collaborative effort reflected

[97] Fairfield Osborn, *Our Plundered Planet* (Boston: Little, Brown and Company, 1948), pp. 39–40.

[98] Ibid., p. 41.

[99] Ibid., p. 196.

the sentiments of the other erudite academics who contributed. To his way of thinking, "Even slow-breeding man has doubled [the population] in twenty-five years, and at this rate, in a few thousand years, there would literally not be standing room [on earth] for his progeny..."[100] Darwin continued to make several thought provoking points. Darwin, like Malthus, believed world population growth would exceed the earth's carrying capacity to produce food to sustain it. Darwin interjected something he referred to as the "Malthusian balance": population numbers juxtaposed to humanity's quality of life. Darwin identified the greatest obstacle to curbing the trend of rising population around the world and particularly Western civilization; he called it "love of freedom." Because of this libertarian philosophy, Darwin reasoned efforts to restrict, curtail, and suppress population growth would be difficult. In his closing argument, he declared, "there would be an instability in the process in that if half the world accepted limitation, while the other half refused, all too soon the limiters would be in a minority, and in the end, the nonlimiters could dominate the world."[101]

Even historian Henry Steele Commager, one of the more prolific writers of the twentieth century, weighed in with his thoughts on the subject. Writing at a time when the less industrialized countries referred to as Third World or undeveloped surged onto the stage of world affairs emboldened by a new intangible, a spirit of nationalism after World War II, Commager identified Asia, Africa, and Latin America as all undergoing a population explosion. He readily added China to his list of hot spots in which a dramatic upward spike in population numbers had ignited a war with India at the time. Prophetically, Commager argued Arabic states' population numbers could put pressure on the newly created state of Israel and what remained of the European colonial presence in the Middle East. This new spirit of nationalism, combined with the rising tide of popula-

[100] Charles G. Darwin, "The Law of Population Increases," ed. Fairfield Osborn (Garden City, New York: Doubleday & Company, 1962), p. 29.
[101] Ibid., p. 25.

tion growth, could lead to political instability and even war as was the case in the conflict between China and India.[102]

Of all the essays, perhaps the most relevant was Mahammedali C. Chagla's, the one-time Indian ambassador to the United States. An academic with an Oxford education, Chagla's contribution to Osborn's monograph came at a time when the population of India was exploding. As a result, the government of the former British colony struggled with the burden of feeding an ever-growing population. Chagla placed the blame on colonization, arguing exploitation by white Anglos had laid the foundation for what India now experienced. Two global wars had given rise to intense nationalism and the idea of "self-determination" amongst the exploited peoples of the world; this in turn had led to an effort to raise the quality of life by the governments of these emerging nation states previously taken for granted, their fates determined by the immutable "law of nature." Improvements in health care had resulted in an upward spike in the birth rates in these Third World or undeveloped countries, which Chagla considered revolutionary. Inherent in the title of his brief contribution to Osborn's book, "India's Dilemma," he explained the increase in India's birth rate corresponded to an equally dramatic decline in the country's death rate. Improvements in medical care, sanitation awareness, and new treatments for disease, the antibiotic, penicillin being foremost among those, had led to an astronomical increase in the country's population. This, Chagla noted, left India and its government facing as he put it, "a dark and dismal future for millions…poverty and unemployment, political discontent and unrest."[103]

Citing India's population at 430 million people and rising daily in 1961, the former vice-chancellor of Bombay University called for continued improvements in health care for children and the general populace combined with an intensified campaign by the government to promote family planning. These improvements he claimed would

[102] Henry Steele Commager, "Overpopulation and the New Nations," ed. Fairfield Osborn (Garden City, New York: Doubleday & Company, 1962), pp. 117–121.

[103] Mahommedall C. Chagla, "India's Dilemma," ed. Fairfield Osborn (Garden City, New York: Doubleday & Company, 1962), pp. 161–162.

alleviate overpopulation and determine India's destiny. He listed two factors which would dictate birth control's success in India: first, the government's commitment to promote the idea to the people and gender attitudes claiming Indian women would be willing "to cooperate in any planned drive for birth control or family planning."[104]

The former diplomat called upon his audience in the world community to cooperate and to provide financial assistance for India, appealing to what he referred to as "a roused conscience which feels the same urgency of fighting this fell disease, because it is a sickness from which mankind is suffering as it does with regard to cancer or a thousand and one other ailments to which human flesh is heir."[105] Based on personal experience and what he had witnessed in India living there, he came to the conclusion neither gender nor Hinduism would interfere with the government's attempt to promote family planning to curtail population growth in his country. Though insensitive, the words disease and sickness in describing overpopulation, shows the severity of the problem India faced in 1962. India at that time teetered on the brink of famine and starvation. Chagla's thoughts focus on the disease and sickness words merely reflected the sentiments of a majority of neo-Malthusians and his love of country.

Another academic similar to Chagla, Osborn included the thoughts of Harvard attorney and nuclear disarmament advocate Grenville Clark in his collection of essays. Clark's contribution "Population Pressures and Peace" made a strong case that overpopulation and armed conflict around the world were interrelated. Stemming rapidly growing population numbers would be imperative for world peace to Clark's way of thinking. He laid out a six-point plan to keep the peace:

1. Universal and complete disarmament enforced by an international police force comprised of military units drawn from the world community.
2. He called for the military force to be voluntary.

[104] Ibid., pp. 162–163.
[105] Ibid., 163.

3. A world court system with the authority to convene tribunals and pass sentences on offenders.
4. World law-making and executive agencies to prevent war.
5. A world authority to address the disparity of wealth around the world.
6. And finally, an effective world revenue system to finance enforcement and essential international institutions.[106]

Clark, like Commager, envisioned unrestricted population growth as a threat to political stability. Left unchecked it could result in acute, debilitating poverty. This in turn would inevitably lead to "international tension" and the possibility of intermittent wars which would breakout on a global scale. Though never referring to it by name, reading Clark's thoughts on the subject at the time brings to mind the mission and purpose which gave rise to the United Nations, which in 1961 had assumed a greater role in bringing Clark's worldview closer to reality. With the publication of Osborn's collection of essays, a seismic shift in the thinking on the issue of population is apparent among academics and the intelligentsia. To a lesser extent, it also marked the beginning of a gradual shift in the thinking of the American public. Osborn's *Our Plundered Planet* reached a broader audience. Nonetheless, the thoughts in his collection of essays would in time filter down to the bedrock of public opinion, which over time would elicit a response which would be a part of the thinking of most activists who participated in the original Earth Day.

Almost at the very moment Fairfield Osborn expressed his concerns on the issue, ornithologist William Vogt would add his thinking to the debate on population growth. Stricken with polio at an early age, Vogt organized a campaign to restrict a federal effort to drain wetlands, an essential habitat which birds depended upon to nest and for food. Vogt saw firsthand what human encroachment such as housing and commercial development had done to this habitat, destroying marshes the habitat for so many living things. This

[106] Grenville Clark, "Population Pressures and Peace," ed. Fairfield Osborn (Garden City, New York: Doubleday & Company, 1962), pp. 124-125.

stirred within him a "new ecological vision," an epiphany common in so many visionaries. Altering his perspective on conservation and resource depletion, Vogt became the first environmentalist to use the phrase "carrying capacity," the potential of any land mass or region necessary to produce food and water for humans inhabiting the area. In other words, Vogt recognized any region in the world had as he described it, "limitations on the number of human societies it could support."[107]

Vogt's book *Road to Survival* is regarded as a watershed in the discourse on the issue of overpopulation. Vogt's book was quite popular, its message resonating with a broad audience. Adding credibility to his argument for population control, Vogt contrived a mathematical equation: one could calculate "carrying capacity" of a given inhabited land mass by dividing the environmental resistance into the "biotic potential" of the area in question. Biotic potential represented the land's capacity to produce "shelter, for clothing, and especially for food"; the environmental resistance represented the "limitations" placed on the land mass in question, factoring in quality of soil, climate, terrain, and the like. Vogt stressed the imperative of balance between humanity's ever-expanding numbers and the physical environment. Vogt prophesied that if an imbalance occurred between the two, "it is probable that at least three-quarters of the human race will be wiped out."[108]

Vogt believed the world population numbers had reached the breaking point. Given the demographical numbers at the time, anyone living in the post–World War II era might have come to the same conclusion. World population numbers had exceeded the "carrying capacity" of arable land based on Vogt's observations. He began one passage with a Chinese proverb: "One hill cannot shelter two tigers." Then Vogt provided his audience with carrying capacity examples from nature itself: the mountain lion that needs a hunting area of

[107] Thomas Robertson, *The Malthusian Moment: Global Population Growth and the Birth of American Environmentalism* (New Brunswick, New Jersey: Rutgers University Press, 2012), pp. 40–41 and 47.

[108] William Vogt, *Road to Survival* (New York: William Sloane Associates, 1948), pp. 16–17.

roughly forty square miles to survive, a deer that requires forty acres of graze increasing to more than three hundred acres to thrive on the high plains of New Mexico.

Providing a glimpse into the past, Vogt reviewed the history of western civilization. Neolithic peoples were occupied with the day-to-day struggle for survival using stone tools with no concern for the natural world they inhabited. Colonial farmers in the new world prior to the American Revolution toiled in such an abundance of natural resources and wild game, they seldom gave carrying capacity of the land they lived upon a second thought. But with the dawn of the modern age, everything changed.[109] The Industrial Revolution, first in England then the rest of Europe, then crossing the Atlantic to the New World, had precipitated a dramatic increase in population numbers. Vogt dismissed the notion of an "agricultural revolution," leading to an increase in grain production feeding a world on the verge of starvation. Quite to the contrary. Vogt held steadfast to the idea "environmental resistances" had actually drastically reduced the amount of land suitable for farming and agricultural production. True though one farmer in 1947 produced more edible commodities than ever before; artificial, chemical fertilizers and improvements in agri-technology, a trend that continues even today had made that possible. Nonetheless, basing his argument on personal observations and demographic research, Vogt reasoned, while "one man under an improved technology, might be able to farm a full section [of land] this would not bring into being more sections of agricultural land nor raise or even maintain productivity on other acres."[110] Arable acreage, land which could be farmed was finite. Once the equation exceeded carrying capacity of a given region of the world, those who inhabited it and humanity as a whole would find the equation of sustaining life difficult, if not impossible, to balance.

Vogt's ideas were provocative. *Road to Survival* became a national best seller, causing a debate and renewed public interest in overpopulation, signaling a Malthusian reawakening, particularly in

[109] Ibid., p. 41.
[110] Ibid., p. 42.

the United States. Vogt commended Chile in South America for having "one of the greatest national assets…perhaps the greatest asset is its high death rate."[111] His reasoning being Chile had yet to exceed the carrying capacity of its tillable land. Chile was the exception. Vogt condemned Central America and South American countries painting with a broad brush arguing they had exceeded their carrying capacity because of an exploding birth rate. Vogt, like Osborn, focused on the consequence of unchecked population growth; both made the case Earth was on borrowed time, which would result in "deforestation, desertification, and the extinction of wildlife." Even without nuclear war, humanity had become a "geological force," as Osborn put it. Humanity had begun to lay waste to its only home: Earth. To both men, the current rate of population growth even in 1948 was unsustainable and would lead to ruin.[112]

Our Plundered Planet and *Road to Survival* found a receptive audience in a post war generation void of television and the 24 hour cable news cycle. Both were published in 1948: Osborn's book in March; Vogt's book in August. Osborn's book alone endured through eight editions printed in a dozen languages. Vogt's book made it as a Book-of-the-Month selection which reached more than a half a million readers. Reader's Digest even released a condensed edition to its audience of 15 million subscribers; *Road to Survival* also reached a world-wide audience having been translated into more than a half dozen languages. Both writers lent moral support to each other writing letters of encouragement; both benefited immensely from the advice of Aldo Leopold, a kindred spirit. Vogt's book, the more influential of the two, "became the blueprint for today's environmental movement" providing inspiration for Rachel Carson and Paul Ehrlich[1]. Environmental

[1] Charles C. Mann, *The Wizard and the Prophet: Two Remarkable Scientists and Their Dueling Visions to Shape Tomorrow's World* (New York: Alfred A. Knopf, 2018), p. 87.

[111] Ibid., 186.

[112] Fairfield Osborn, *Our Plundered Planet*, pp. 29–30, 38, and 44–45 and William Vogt, *Road to Survival* as quoted in Matthew Connelly, *Fatal Misconception: The Struggle to Control World Population* (Cambridge: Harvard University Press, 2008), p. 128.

historian Gregory Cushman goes even further commending Vogt's book by writing, "No single figure was more influential in framing Malthusian overpopulation as an ecological problem—an idea that became one of the pillars of the modern environmental thought." More significantly as it relates to Earth Day, Vogt's book made its way onto the book shelves and reading lists and as a required textbook of no less than two dozen college campuses around the country.[2]

By the sixties, the thought of planet Earth growing smaller and smaller with every human birth consumed the thoughts of most environmentalists. Mention to any of those who protested on Earth Day in 1970 the names Osborn and Vogt, and chances are you would have received a blank stare. Even so the seed sown by Osborn and Vogt fell on the fertile soil and began to germinate. Awareness of the overpopulation of the planet and the idea of too many people came from Henry R. Luce's magazine Time. Perhaps acting on the advice of his wife, Claire Booth Luce, a convert to the environmental cause, publisher James Linen assigned his reporters at the magazine to visit forty-eight countries around the world. Their job, to investigate the issue of overpopulation. Among their number were Herman Nickel, Alexander Campbell, and the distinguished Stanley Karnow. One correspondent, Jayme Dantas, traveled by jeep into the Amazon River basin, deep into the greatest rainforest on the planet west of Rio de Janeiro to verify a rumor of a couple with thirty-six biological children. The cover story began in shocking fashion. A population clock on top of the Commerce Department building in the nation's capitol "flashed every eleven seconds to mark the birth of another American. If a 'world population clock' existed, it would have been flashing three times a second," Time reported.[113]

Astonishingly based on census data from the United Nations among other sources, according to the magazine every year, India alone produced enough live births to populate New York City;

[2] Gregory T. Cushman, *Guano and the Opening of the Pacific World: A global Ecological History* (New York: Cambridge University Press, 2014) p. 190 as quoted in Mann, *The Wizard and the Prophet, p. 492.*

[113] Robert C. Christopher and Thomas Griffith, "Population: The Numbers Game," *Time,* 11 January 1960, p. 19.

maternity wards in mainland China in one year delivered enough infants to populate Canada. Time's four-thousand-word article went to press complete with demographic charts showing world population growth in Asia, South America, Africa, and the continent of Europe contrasting and comparing population numbers with the United States. On-site reporters captured the sweat, the abject poverty, and desperation of the sweltering shantytowns around the globe. The final draft by Robert Christopher and Thomas Griffith could be found on newsstands, on kiosks, and in every public library in the country that subscribed. The authors dropped the name of Fairfield Osborn to lend their narrative authority.[114]

Woven within the narrative were a plethora of facts. Certain scientific breakthroughs had extended human longevity something the article called "death control." The death rate had been reduced significantly around the world. Scientific innovations such as Edward Jenner's smallpox inoculation combined with other miracle vaccines to provide humanity with better health. That combined with improved living conditions, particularly sanitation, had resulted in a population explosion in the modern age. This exceeded, in the minds of Time's reporters, the planet's agricultural production capacity of edible plant and animal protein. Also, the transference of scientific know-how to prolong life from generation to generation had only exasperated the problem, sending birth rates into the demographic stratosphere. An expenditure of a paltry fourteen cents, American currency, per person spent on child vaccines and medical technology, resulted in a payback of a 50 percent decline in the death rate in Central America, Africa and Asia after World War II. So population numbers climbed upward even though birth numbers remained constant the article pointed out.[115]

On the island of Ceylon, now Sri Lanka, the pesticide DDT had been used to great effect in reducing cases of malaria, which precipitously had increased the population by one-third. Objectively, Time's reporters pointed out how unreliable Malthusian gloom and doom

[114] Ibid.
[115] Ibid.

prophecies had played over two centuries. The article noted the vast regions of the Earth still virtually uninhabited; they explained how world food production could be increased substantially without adding a single acre of farmland to land in agricultural production by using hybrid seed and commercial fertilizers to increase yields. Also, DDT still in use could reduce crop loss preventing insect infestations. Nonetheless, demographic experts and sociologists who studied trends in population growth stressed "death control must be offset by birth control" a somewhat novel concept in 1960.[116]

And Time's cover story parsed out the current world population dilemma to increase public awareness. Reporters interviewed Pakistan's military ruler, who prophesied, "If our population continues to increase as rapidly as it is doing…we will soon have nothing to eat and will all become cannibals." From the Far East the island of Formosa, with a birth rate of one thousand per day, college administrator Chiang Monlin cautioned, "'Here it is like breathing into a small paper bag, something will burst." With a rising standard of living made possible by conspicuous consumption, the Western news media had inadvertently made it possible for undeveloped countries to see the possibilities of a higher standard of living for their families. The relatively new delivery device television had led to what Time's reporters called a "revolution of expectations."[117]

Time's reporters took on the thorny issue of birth control one of the motives behind their investigation. Roman Catholic bishops released a statement in late 1959 stating their opposition to federal funding for birth control in the developing world. Casting its investigative net far and wide, Time determined birth control had had little, if any, impact in reducing birth rates around the globe. Where Roman Catholicism predominated, contraception was forbidden. In India, Ghandi had made his thinking on contraception clear by preaching, "Union [intercourse] is a crime when desire for progeny is absent." A Pakistani man interview for the piece said, "A man must have children or he is not a man." Similar sentiment predominated in

[116] Ibid., pp. 19–20.
[117] Ibid., p. 20.

the dominant patriarchal culture in Arabic countries in the Middle East where children were believed to be "a gift of Allah," where an adult woman without children was perceived as "an object of pity."[118]

In Red China, with a runaway population of more than 680 million in 1960, Communist party bosses vacillated between the necessity for a viable workforce and the reality of growing enough food to feed their people. In 1956, the Chinese government had promoted birth control, encouraging women to use all the latest intrauterine devices to the most popular of preventing pregnancy: apothecaries who prescribed arcane herbal concoctions and live tadpoles. Nonetheless, the report concluded "in 1958, Red China's bosses quietly dropped birth control," advocating "the gospel according to Karl Marx: an increase in population is always an increase in capital."[119] Reporters noted the obvious. In developing countries, having many children had become ingrained in cultures and the people's ethnicities, the production of progeny oftentimes the result of necessity. Particularly in agrarian societies, "in lands where death comes early and often, those who with extra hands in the fields fear to have few children."[120]

And since the days of Thomas Malthus, regulating population had accumulated a history all its own. France during the early nineteenth century witnessed a population decrease due to a Napoleonic decree imposing mandatory land inheritance on heirs. Hence, French peasants had fewer children. A similar law in Indonesia had actually resulted in a rise in population numbers. In Benito Mussolini's Italy, an order dictating Italian families increase in size fell on deaf ears. No population increase occurred. Japanese physicians performed a million legal abortions annually, and Puerto Rican women agreed to voluntary sterilization, the "la operacion" they called it. In both Japan and on the island of Puerto Rico, there had been a gradual decrease in the birth rate. Though Time claimed the dramatic decrease on both islands, had occurred voluntarily because of education, that and

[118] Ibid., pp. 20–21.
[119] Ibid., p. 21.
[120] Ibid.

their people came to realize fewer hungry mouths to feed in your family translated into "economic well-being."[121]

Similar to Vogt's book, the Time cover story sold well. But as popular as both were, they did not compare to the popularity of Paul Ralph Ehrlich's *The Population Bomb* released in 1968, two decades after Vogt's book hit bookstore shelves, generating environmental anxiety throughout American society. Ehrlich may have been familiar with Osborn's book and Vogt's book and found inspiration in the Time cover story on overpopulation. Whatever the case, Ehrlich's futurology was a sobering shot of espresso, a wake-up call for people to face the reality of an overcrowded "spaceship Earth," as he called the planet. Ehrlich, a Stanford entomologist, had had an epiphany one evening in a taxi cab driving through the streets filled with teeming multitudes in Delhi, India, his family in tow. In that sweltering, overcrowded, poverty-stricken city Ehrlich had a vision of two worlds: one comprised of the developing countries such as India, Africa, and Latin America suffering from illiteracy and economic stagnation, the other a world consisting of what he called the overdeveloped countries which included the Western democracies, Eurasia, and Japan. The latter indulged in what economist Thorstein Veblin called conspicuous consumption, the practice of binging on "a disproportion amount of the world's resources and in so doing contributing to environmental pollution."[122]

Ehrlich's book prophesied the apocalypse, the end of times, with the world he lived in plunging headlong toward the abyss of disease, pestilence, hunger, and war precipitated by world food shortages brought on by too many hungry mouths to feed, too little land to grow food upon, and too little space to live in.[123]

He warned of the toxicity of pesticides, calling the use of chlorinated hydrocarbons a "worldwide problem." Ehrlich labeled the use of pesticides for agriculture cost-prohibitive, advising homemakers to be educated in recognizing certain acceptable levels of crop dam-

[121] Ibid.

[122] Paul R. Ehrlich, *The Population Bomb* (Cutchogue, New York: Buccaneer Books, 1971), pp. 7–8.

[123] Ibid., pp. 24–25.

age caused by pests claiming the unsightly appearance of fruits and vegetables to be far less an inconvenience than the risk of pesticide poisoning. That and the impact DDT, for example, did to fragile ecosystems, especially wildlife, which Ehrlich called pesticide horror stories. He referred to the use of chemicals to eradicate insects "a record of ecological stupidity without parallel."[124] Nearly twenty years before Dr. James Hansen made his theory of global climate change known, Ehrlich identified carbon dioxide as harmful, writing, "All of the junk we dump into the atmosphere, all of the dust, all of the carbon dioxide, have effects on the temperature balance of the Earth."[125] Resorting to hyperbole to get the public's attention, he referred to the Earth's atmosphere as a "garbage dump." He pointed out climate change might lead to a drastic decrease in agricultural production, a sector of the world economy already hard-pressed to feed humanity.

Then Ehrlich included a passage in his book, which might have been lifted from the body of Al Gore's documentary An Inconvenient Truth, writing, "With a few degrees of heating, the Greenland and Antarctic ice caps would melt, perhaps raising ocean levels 250 feet. Gondola to the Empire State Building anyone?"[126]

After sounding the death knell of Lake Erie and launching into a lengthy discourse on the deteriorating quality of America's streams, rivers, lakes, and drinking water, Ehrlich explained why he had neglected to pay tribute to the conservationist's cause. Listing the various causes conservationists had fought for such as preservation of the redwood forests, the carrier pigeon, the California condor on the verge of extinction, the auk, the American buffalo, the California grizzly, and the Carolina parakeet, Ehrlich exclaimed the conservationist's fight to preserve the natural world was lost. All their efforts would prove to be in vain for two reasons:

1. Nature was no match for the onslaught of overpopulation.

[124] Ibid., p. 34.
[125] Ibid., p. 38.
[126] Ibid., p. 39.

2. Most Americans, in Ehrlich's words, "don't give a damn."

The American people were divided into two groups: those who cared compassionately about the preservation of the natural world and the aesthetics of nature and those who would carelessly destroy it. Paul Ehrlich tied virtually all environmental problems to overpopulation in his book.[127] A significant increase in population numbers translated into growing more food in a given country necessitating the use of more pesticides; more people subsequently meant more water pollution and more air pollution given the significant increase in combustible engine exhaust. And most importantly, more people took up living space, the area which people inhabited. The spatial element of what Ehrlich touched upon cannot be underestimated. In his mind and the thinking of those who participated in the first Earth Day, this threat seemed to be a real possibility.

After teasing the imagination with three likely scenarios if numbers went unchecked, Ehrlich examined the progress of programs to bring the world's population under control. He singled out family planning calling it "inadequate." Conversely, he claimed Zero Population Growth and the Association for Voluntary Sterilization positive developments moving in the right direction. Ehrlich called for the states and the federal government to reform abortion laws, a cause second-wave feminists championed before the United States Court ruled in Roe v. Wade. A realist, he referred to population control at the international level as "dismal." Calling the actions taken by the governments of India, Pakistan, and Chile "sources of hope," Ehrlich applauded Sweden for assisting underdeveloped countries in aiding them in procuring the means of birth control. As for the United States, the entomologist characterized efforts by the leading country of the free world as "disgraceful." Ehrlich bluntly put it this way: "It is ironic that some Latin American politicians have accused the United States of attempting to pressure them into population control programs. If only it were true!"[128]

[127] Ibid., p. 43.
[128] Ibid., pp. 88–90.

Religion was paramount. The bedrock of Latin American culture, the Catholic Church deserved to be held accountable, and on the issue of Rome's pronouncements on the issue of birth control, Ehrlich did not mince words. Realizing how sensitive the issue is, he approached it scientifically in his narrative. In the crosshairs of his passionate plea for population control was the Papal Encyclical of 1968, prohibiting the use of birth control devices, Ehrlich believed to be morally wrong and unrealistic. In this instance, he weighed carefully quality of life against the abject poverty he had witnessed in India the site of his first epiphany in 1966.[129] The Green Revolution, a scientific breakthrough that improved the yields of certain grain crops, Ehrlich likened it to an addictive drug with humanity the incurable addict. More food could not alleviate the misery caused by poverty, the result of population excesses to Ehrlich's way of thinking. Over the long haul, population control was the only viable solution.[130]

His book gave not only the author considerable public exposure but also the cause inspired many to advocacy. The need for people and their governments to act according to Ehrlich, "seems to be filtering through to the public consciousness, at least in the US, thanks largely to increased coverage in the media."[131] When *The Population Bomb* first hit the shelves of bookstores in 1968, it received little notice from academia and the general public. Nonetheless, by April of 1970, Paul Ehrlich claimed the mantel of environmental superstar achieving celebrity status as the message in his book reverberated throughout the United States and the world. The seemingly mild-mannered scientist appeared as a guest on the Johnny Carson Show; and that fall after the book's release, Ehrlich hit the college lecture circuit, speaking to standing-room-only crowds, promoting his crusade. Meanwhile, book sales skyrocketed to a top slot on The New York Times best seller list joining Erich Segal's popular romance

[129] Ibid., pp. 136–138.
[130] Ibid., pp. 98–101.
[131] Ibid., p. 88.

novel Love Story, which later became a film starring Ali McGraw and Ryan O'Neal.

Just as significant, Ehrlich's book inspired a grassroots political organization to gain traction. Five days before April 22, 1970, Life magazine featured a cover story which read "A Thoughtful New Student Cause: Crusade Against Too Many People." By then, Zero Population Growth had 102 chapters in thirty states most on college campuses around the country. Promoting family planning advocating restricting the number of children to two, ZPG had begun on the campus of Yale University following the release of Ehrlich's book. The political organization demanded, "Abortion reform, legalization of birth control, and changes in welfare regulations and tax exemptions for children."[132] And Ehrlich's message drew others to his cause in academia. Dr. Thomas Eisner, who had a vasectomy like Ehrlich who inspired him, readily accepted the ZPG challenge after field trips to study butterflies convinced him overcrowding threatened the habitat of that which he studied. Eisner with two Ehrlich converts conducted a scientific study of student's attitudes at Cornell University. Of the 1,059 students who took their survey more than half wanted a traditional family of at least three children; there existed among those surveyed misconceptions or a total lack of understanding about human sterilization methods and birth control devices.[133] Like Ehrlich, the organization linked unchecked population growth to societal problems such as "pollution, violence, loss of values and of individual privacy." In a concerted effort to change this thinking and awaken the American people, ZPG hired a lobbyist to carry its message to the nation's capitol, organized a commission in California which focused on population growth and pollution controls, and initiated a campaign to educate the American people on the excesses of overpopulation in general.[134]

Student activists passed out literature, organized demonstrations, and involved themselves in educating their fellow students

[132] Ralph Graves, ed., "A New Movement Challenges the US to Stop Growing: ZPG," Life, vol. 68, no. 14, 17 April 1970, p. 31.

[133] Ibid., p. 33.

[134] Ibid., pp. 31 and 33.

around the country prior to the first Earth Day. The Life cover story featured the photography of Arthur Rickerby and Tom Prideaux's review of the Broadway rock musical Hair, a popular counterculture antiwar statement at the time. (Rickerby's photojournalism of Ehrlich at the lectern speaking and ZPG student activists passing out leaflets is photography at its best.) With this feature in a mainstream media publication like Life, the issue Ehrlich raised reached a broad readership, perhaps millions of average Americans. Like Time's feature story, such journalism left a lasting impression on American public's consciousness. By the spring of 1970, environmental activists encouraged funding for planned parenthood and promoted the practice of using a technological breakthrough in birth control: the pill.

ZPG was an outgrowth of the environmental movement which sensed an impending Malthusian-like crises, which seemed at the time to be imminent. Paul Ehrlich being one notable exception, most academics remained above the fray when it came to commentary on sensitive issues such as human sexuality, population, abortion, and voluntary sterilization. Not as noteworthy as Paul Ehrlich but just as outspoken, was biologist Wayne H. Davis, who inspired by the Stanford scientist's example, took to a popular media outlet in early 1970. His polemic published in The New Republic, "Overpopulated America: Our Affluence Rests on a Crumbling Foundation" went beyond the pale of the reserved, dignified silent academic. Davis's narrative shattered the academic stereotype.

In words imparting a sense of urgency, Davis's commentary is indicative of an increasing awareness, a rising consciousness on the part of an educator whose words spoke for the environmental movement as a whole. Davis argued the Earth had reached a population breaking point which was unsustainable. Accusing Americans of overconsumption, Davis calculated the average American would pollute three million gallons of water during their natural lives, consume more than twenty thousand gallons of poisonous leaded gasoline, on average, and consume more than twenty-five thousand gallons of cow's milk per person during their lifetime. Davis compared American consumers to their counterparts in India defining it in his article as the "Indian equivalent." He explained, "The average number of Indian

citizens required to have the same detrimental effect on the land's ability to support life as...the average American."[135] To put it bluntly, the rate of expansion of the American economy and the consumption of its people could not continue. America's carrying capacity had reached the breaking point. An environmental disaster would occur unless the American people ended their conspicuous consumption binge.

Davis warned if current trends continued in economic growth and increasing population numbers, the standard of living in the United States would implode. In Davis's words, "If our numbers continue to rise, our standard of living will fall so sharply that by the year 2000, any surviving Americans might consider today's average Asian to be well off." Davis went even further warning, "Our children's destructive effects on their environment will decline as they sink ever lower into poverty."[136] With Americans consuming at a faster rate and more of everything than the average Hindu in India, Davis predicted American civilization was on the verge of collapse. Davis's polemic included a solution. First, the United States had to achieve zero population growth. This would include birth control education and family planning stemming the trend toward larger families which would reduce consumption. The two remedies would work in tandem, and America's standard of living would stabilize.

Like many activists, Davis blamed the excesses of American affluence for the country's environmental problems. Calling for a drastic reduction in the trend in American culture to develop land, which resulted in urban sprawl, Davis even went so far as to argue economic expansion measured in the nation's gross domestic product could not continue indefinitely in a world in which natural resources were finite. At the very core of the biologist's commentary was population growth, which he insisted must be reduced by birth control or abortion. Davis went so far as to demand the federal government take action to "establish a system to put severe economic pressure on

[135] Wayne H. Davis, "Overpopulated America: Our Affluence Rests on a Crumbling Foundation," *The New Republic*, 10 January 1970, p. 14.
[136] Ibid., p. 14.

those who produce children and reward those who do not. This can be done within our system of taxes and welfare."[137]

Davis praised African American sharecroppers in the Mississippi Delta and conversely condemned white middle-class Americans and their elected political representatives, whom he referred to as "affluent destroyers." In Davis's perfect world, the American people "must halt land destruction." He wrote, "We must abandon the view of land and minerals as private property to be exploited in any way economically feasible for private financial gain." "Land and minerals," Davis declared, "are resources upon which the very survival of the nation depends, and their use must be planned in the best interest of the people."[138] Similar to many activists in the Students for a Democratic Society and the civil rights movement, Davis blamed the "establishment" for dividing the American people. Davis preached, "Blessed be the starving blacks of Mississippi and their outdoor privies, for they are ecological sound, and they shall inherit a nation."[139]

A biologist by trade, Wayne Davis spent more than thirty years teaching human ecology at the University of Kentucky in Lexington. He had a deep respect and appreciation for the natural world around him and studied ornithology. One biographical anecdote speaks volumes about the man and the path he pursued after the original Earth Day in April 1970. As an ornithologist, Davis knew of the bluebird, known for their tiny orange-white breasts and bright blue wings that fluttered among tree limbs. The birds had a tendency to nest in rotting fence posts set on farmland in their natural habitat in Kentucky. The bird did not thrive there before the American Revolution but were drawn to the blue grass state following farm settlements as pioneers moved west attracted by the fence posts. Urbanization and suburban sprawl had transformed the Kentucky landscape, with asphalt, steel, and concrete replacing farmers' homesteads. The blue birds all but disappeared; sightings were rare by the spring of 1970.[140]

[137] Ibid., p. 15.

[138] Ibid.

[139] Ibid.

[140] Andy Mead, "Wayne Davis: A Legacy in Flight," *Lexington Herald-Leader*, 7 April 1970, www.kentucky.com/opinion/op-ed/article 143450579. Hymn:

Singlehandedly, in the similar way Johnny Appleseed had improved the Ohio River Valley, Wayne Davis took it upon himself to bring back the bluebird to Kentucky. He experimented with various bird houses, trying all sorts of material, but eventually settled on the aging wood planks from fencing on UK's Coldstream Farm, an experimental station in the university system. "He had the most success with the one he made out of old oak plank fencing from UK's Coldstream Farm. He built them in the basement of his house."[141] With hammer and nails in hand, Davis hung more than three thousand bird houses along Kentucky's Mountain Parkway along Interstates 64 and 75 in state. The bluebirds returned and flourished. An iconoclast to the end, Davis condemned Republicans, Ronald Reagan, and even God the latter condemnation leading to his expulsion from the Boy Scouts as a child.[142] So when you see those tiny birds flitting about among the tree limbs in Kentucky's wild places, thank Wayne Davis. Henry David Thoreau would approve.

Other academics joined Wayne Davis in studying and analyzing population trends before Earth Day. Brothers William and Paul Paddock published *Famine, 1975,* a book prophesying doom for an overpopulated world, in particular India, in 1967. Theories abounded as to how a dramatic increase in world population numbers would impact upon human behavior. Ideas ranging from the probable to the bazaar had appeared in print before Earth Day. Along those lines, British ethnologist William Boy Stratten Russell and his wife, Claire, published an article in a journal, collaborating on the title "The Sardine Syndrome." In it, the couple made an attempt at explaining the causes of "human aggression which caused violent crime, riots and war."[143] From their study of primates in rainforests on three continents, the Russells inferred, "Every time the human civilized populations seriously outran their resources, they

paper-based edition *Lexington Herald-Leader,* 9 April 2017, p. 5C.

[141] Ibid.

[142] Ibid.

[143] Bernard Weinraub, "2 Britons Discern a 'Sardine Syndrome,' Linking Recent Violence to the Pressure of Overpopulation," *The New York Times,* Sunday 16 August 1970, sec. L, p. 53.

entered a population crises, marked by very acute social tensions, leading to extensive, unrestrained violence and stress, the collapse of the population under epidemics and the decline and fall of many a civilization…"[144]

And with the Soviet Union and Communist Red China vying for influence in developing countries around the globe during the Cold War, America's political leadership took notice. The first official statement on the issue of excessive population growth came out of the Draper Committee, which had been ordered to assess the problem by the Eisenhower administration in 1958. President Dwight Eisenhower had created the committee to audit foreign aide expenditures and its effectiveness. General William Draper made the committee's findings public in an article published in National Parks Magazine in 1966. Overpopulation posed a threat to global political stability Draper warned. He and the committee calculated, "Food production was increasing 1 percent a year, but populations were climbing at twice that rate. The result was widespread hunger and malnutrition. India…faced 'the prospect of real famine this fall' and the likelihood of 'mass starvation.'"[145] The Eisenhower administration did nothing to address Draper's concerns. His successor John Fitzgerald Kennedy highlighted the problems of third-world poverty, but he too did little about population growth. After the tragedy in Dallas, Texas, on November 22, 1963, President Lyndon Baines Johnson took up the issue of overpopulation both at home and abroad placing it at the top of his White House priorities. Realizing poverty and hunger as the children of overpopulation, Johnson perceived the potential of the problem to be the cause of political unrest and instability in the Third World. In such a way the issue of overpopulation became attached to the Cold War, the global chess match pitting the United States against the Soviet Union and Red China for ideological

[144] Ibid.

[145] William Draper, "Parks or More People?" *National Parks Magazine* 40, April 1966, pp. 10–13, as quoted in Thomas Robertson, *The Malthusian Moment: Global Population Growth and the Birth of American Environmentalism* (New Brunswick, New Jersey: Rutgers University Press, 2012), p. 86.

and political influence around the world.[146] Environmental historian Thomas Robertson effectively makes a strong case the issue of over-population became a part of America's Cold War strategy.

It would be India where the Johnson administration would focus the diplomatic and economic might of the United States to stave off a crisis of Malthusian proportions. The Bihar drought had depleted two successive rice crops there leaving the Indian government pros-trate unable to feed the country's millions. The president's advisers projected if action was not taken, seventy million people could die of starvation after the rice crop had failed twice. In one of the most highly publicized events of the twentieth century, Johnson and his aides devised a relief effort, the largest since the Marshall Plan after the Second World War. By the spring of 1966, two American mer-chant vessels carrying wheat and corn were arriving daily in belea-guered India. The relief effort lasted two years. Environmental histo-rian Thomas Robertson writes, "American grain was the main source of sustenance for over sixty million Indians. Roughly one quarter of the annual US wheat crop went there."[147] Rain returned breaking the drought and what became known as the Green Revolution nourished Inida's hungry masses. Nonetheless, the Bihar drought and subse-quent famine left a lasting impression on the minds of the American people.

Johnson also was the architect of the first concerted effort to promote family-planning centers in the United States and abroad. Federal funding for both increased dramatically. Taking a proac-tive approach to the issue, he said, "These programs were a mix of Malthusianism and modernization: they recognized the problems of rapid population growth and resource shortages, but they also stressed the progress that could be attained by overcoming obsolete cultural traditions with technological solutions—in this case birth control."[148]

[146] Ibid. Thomas Robertson, *The Malthusian Moment: Global Population Growth and the Birth of American Environmentalism*, pp. 99–101.

[147] Robertson, pp. 99–100,

[148] Secretary of Agriculture Orville Freeman to LBJ, 23 November 1964, USDA Subject Files, 1964, Reports, Box 1, Lyndon B. Johnson Presidential Library as quoted in Robertson, pp. 101–102.

Environmental activists viewed the problem in more personal terms. Their concerns included population growth and its impact on depleting natural resources, polluting and using America's water supply, its contribution to solid waste accumulation, abject poverty, and the possibility of starvation on a global scale. All these factors and diminishing space in a world, which seemed to grow smaller by the day, gave momentum to the environmental movement. Those activists were keenly aware and pleased when in the spring of 1965 the United States Supreme Court handed down its landmark ruling Griswold v. Connecticut, striking down a state statute which made it unlawful for women to use oral contraceptives. In effect, the High Court legalized the sale and use of the pill. Neo-Malthusians believed it to be a silver bullet, a quick and effective fix in their efforts to curb runaway overpopulation numbers on a global scale, and in doing so reducing poverty and its close relatives starvation and environmental degradation.

Nonetheless to many, it was not enough. No less a voice in the journalistic profession than James Reston weighed in on Johnson's population control agenda. Reston joined The New York Times's staff in London the same day Nazi Panzer divisions smashed across the border in Poland in 1939. Reston, a witness to history, saw the devastation wrought by the Luftwaffe during the Battle of Britain as it happened. His reputation as a journalist was impeccable, earning him the respect of colleagues and making him a role model for young apprentice newspaper reporters, many of whom he mentored personally. Reston made the case that attitudes toward birth control had changed by the summer of 1966. Even the mood in Congress had changed. The House had passed the Food for Freedom Act appropriating tax dollars for food to be shared with developing nations in Latin America, Africa, and the Far East. Reston noted how the legislative branch using federal dollars had purchased grain for impoverished countries and had also provided funding for countries to "set up birth control clinics" for women in need.[149]

[149] James Reston, "Washington: The Politics of Birth Control," *The New York Times*, Friday, 10 June 1966, p. 44.

Similar to the neo-Malthusians, Reston saw scientific innovation such as the pill, intra-uterine devices, and technological progress as solutions to runaway population growth. The dean of American journalism applauded groups such as the Sexuality Information and Education Council, the Population Council and Zero Population Growth. As a stern college professor lectures students, he addressed the entire nation in his editorial by saying, "Nothing short of a vast new effort by all governments in the world is likely to bring this urgent problem up to the proper level of public concern."[150] He called "sexual energy" a greater threat to humanity than "atomic energy," aware of the political activism directed at the proliferation and testing of nuclear weapons. Reston calculated the world's population had taken a mere ten thousand years to reach 250 million people. By the ascension to the throne of the Tudor Queen Elizabeth I, the number had doubled to five hundred million in just 1,600 years. Reston grappled with the enormity of the population explosion worldwide in a tone of exasperation, concluding his editorial with scorn for the government's efforts at dealing with the issue. "In the face of these projections even the progress made in Washington since Eisenhower seems almost ridiculous."[151]

Another voice in the growing crescendo of concern and consternation over the issue was microbiologist Garett Hardin. Borrowing from Medieval European history, Hardin used the commons, a term referring to open land shared by the peasantry to graze their livestock. Disputing the classic economist Adam Smith's notion of an "invisible hand" and the notion that human beings act in the "public interest," Hardin used his parable of the commons. Instead of acting in a spirit of altruism, for the good of all, the peasant begins to think only of self-interest. One animal grazing the commons is followed by another and then another, "and another, and another… But this is the conclusion reached by each and every rational herdsman sharing a commons. Therein is the tragedy. Each man is locked into a system that compels him to increase his herd without limit in a world that is limited." Hardin prophesied, "Freedom

[150] Ibid.
[151] Ibid.

in a commons brings ruin to all!"[152] With regard for the world's run-away population, Hardin called for an end to the theory of laissez-faire by the federal government and the world community.[153]

Publicity generated by media coverage of this issue did not go unnoticed by Lyndon Johnson's successor Richard Milhous Nixon. The thirty-seventh president issued an executive directive creating the National Commission on Population Growth and the American Future. The commission released the findings of its investigation in 1972. Its conclusion: "In the long run, no substantial benefits will result from further growth in the nation's population, rather that the gradual stabilization of our population would contribute significantly to the nation's ability to solve its problems."[154] Though there had been no recommendation as to family size or how to go about solving the problem, from the moment the commission released its report, Nixon began distancing himself from the study he had commissioned. Nixon condemned abortion and a minor's access to birth control, in particular the pill. Reading the tea leaves, did the president sense the impending fallout on the issue of abortion? The United States Supreme Court had yet to hand down its ruling in Roe v. Wade, which would in time send seismographic shock waves throughout American society, transform-ing the Republican Party into a formidable political force by 1980. Historian Thomas Robertson believes the NCPGAF report marked the beginning of the "pro-family" movement presidential candidate Ronald Reagan and Republicans would capitalize on to great effect during the 1980s. It would be difficult to make a case to the contrary.

Realistically, some Americans would have known of Nixon's commission and its recommendations. Many would not. One thing is certain. The legal right to an abortion energized social conservatives and the pro-life movement, a political force to be reckoned with after

[152] Garrett Hardin, "The Tragedy of the Commons," *Science*, 13 December 1968, vol. 162, issue 3859, p. 1244.

[153] Ibid., p. 1243.

[154] Commission on Population Control and the American Future, *Population Growth and the American Future* (Washington, DC: Government Printing Office, 1972) as quoted in Thomas Robertson, *The Malthusian Moment*, p. 185.

the controversial Court ruling Roe v. Wade in January 1973. Factor in that by the summer of 1972 the Nixon administration found itself micromanaging the malignancy called Watergate, grown from what one Nixon scholar calls the bitter soil of his own vindictiveness. In any case, overpopulation and the Malthusian point of view had had its intended effect leaving an impression on the mind of the president and the American public as a whole. Seemingly by ignoring the findings of John Rockefeller III's commission, the president defied his better judgement on the issue relying on his political instincts. This, however, is beyond the realm of historical debate: the Nixon White House released news of the commission and its objective on March 16, 1970, anticipating Earth Day the following month.[155]

A member of an elite social class, Rockefeller was just one of many of the movers and shakers in American society who were of like mind on this issue. Two weeks before the Vietnam War Moratorium in October 1969, a meeting convened at the Carnegie Endowment International Center at 345 East Forty-Eighth Street in New York City. In the midst of a strike by garbagemen in the city, with the putrid odor of uncollected refuse filling the air, the National Conference on Conservation and the Association for Voluntary Sterilization, a first of its kind, represented two diverse groups who had discovered common ground upon which they could agree. There conservationists and neo-Malthusians met to discuss "solutions to population problems." The Audubon Society and the National Wildlife Federation represented conservationists; their concern was loss of habitat, the wild places which supported wildlife. In seminar fashion, with flashbulb cameras popping, the gathering examined "the relationship of the population explosion to pollution, overcrowding, urban deterioration and environmental destruction..."[156] Heading a distinguished list of speakers on the docket, keynote speaker Paul Ehrlich defined the daunting task

[155] Jack Rosenthal, "Nixon Signs Bill Creating Commission on Population," *The New York Times*, Thursday, 2 October 1969, p. 49.

[156] Bayard Webster, "Overpopulation Unites 2 Groups," *The New York Times*, Thursday, 2 October 1969, p. 49.

[3] Stephanie Mills, "The Future is a Cruel Hoax," in *Student Address at Mills College Commencement Exercises*, Sunday 1 June 1969, p. 2 Labadie

facing the gathering. Standing at the lectern, the celebrity author said, "Every year, there are seventy million more people to feed and house, and that yearly number will increase during the next decades. Only a fool would think that we are going to be able to supply food and other amenities for a population increase of seventy to one hundred million people each year for the next thirty years." Aware of the familial tradition in the United States and around the world of couples producing multiple biological children, Ehrlich summed up the problem using a contemporary analogy. Solving the problem of reducing population numbers, "makes going to the moon a childish prank by comparison," a reference to the Apollo 11 lunar landing the previous summer.[157]

By the spring of 1969 when she was named class valedictorian, Stephanie Mills had read *The Population Bomb* and heard Paul Ehrlich speak. To measure the impact of Ehrlich's thoughts and the focus of public attention to the issue we need look no further than Stephanie Mills. A student at small Mills College in the bay area, Mills had come to believe as Buccaneer Books advertised Ehrlich's book, "overpopulation is now the dominant problem in all our personal, national, and international planning." Embarking upon her journey into adult life as a student, Mills took a defiant stand in her valedictory address to the more than 1,000 gathered at her graduating ceremony at Mills College. Quoting from Thomas Robert Malthus and Ehrlich, she addressed the issue. The first and most obvious was with the world's population standing at roughly 3.5 billion in 1969, the planet was close to maxing out its carrying capacity limit. Then she accused humanity of being apathetic, naïve, and outright hostile toward the issue of birth control; she criticized Pope Paul the Sixth's encyclical which prohibited the Catholic faithful from using contraceptives. And finally she questioned "what kind of world my children would grow up in.'" Then she made a statement which would capture not only the attention of her audience but the national news

Collection, Stephanie Mills papers, boxes 8 & 9, 1965-2006(https://iris.lob. umich.edu/aeon.dl?Sessiion ID=U134423680JActiion=10 & F...)

[157] Ibid.

media as well: "'I am terribly saddened by the fact that the most humane thing for me to do is to have no children at all.'"[3]

Within the week word of her graduation speech had circulated in newspapers up and down the west coast. Peggy Skorpinski's interview in the San Francisco Chronicle and Barbara Morgan's Oakland Tribune "World of Women" interview appeared in print on June 5. The St. Paul, Minnesota newspaper printed an excerpt from Mill's speech as early as June 2 the same day the Los Angeles Times carried the story. One week later on June 8, the Los Angeles newspaper even printed and excerpt from her speech on its editorial page. In York, Pennsylvania the local Gazette and Daily picked up the story as newspapers in the bay area ran it on June 3. That same day even Stephanie Mills's hometown paper The Arizona Republic ran the commencement address. Typical was reporter Judy Nicol's headline the Los Angeles Times borrowed from the Chicago Tribune: "Stephanie Renounces Motherhood: A Valedictorian Sticks to Word." Nicol's lead sentence less than two months after Earth Day, "it had been a year since Stephanie Mills renounced motherhood at the age of 20."[4]

Mills had no misanthropic tendencies, confiding to Peggy Skorpinski she had "no plans to marry until [age] 30'" when you know who you are." She had even considered adopting children explaining to Skorpinski "'I find children so easy to love it doesn't matter.'"[5] Word of the hazel eyed, photogenic coed's speech created a media sensation spreading across the land even to the copy of The New York Times. Mills College received numerous requests for copies of her speech; she was interviewed by television and countless newspaper reporters.[6] Mills eventually edited Earth Times, Rolling Stone's environmental spin-off and authored five books on the subject of environmental issues.

Four conclusions can be drawn from this phenomenon. First Mills's speech represented a break from the time-honored tradition

4 Ibid., Judy Nicol, "A Valedictorian Sticks to Word," Los Angeles Times, 14 June 1970. Sec E, p.2.
5 Ibid., Peggy Skorpinski, "A Valedictorian Views the World." San Francisco Chronicle, 5 June 1969, p. 22.
6 Ibid.

of the New American Woman as a wife and mother to the non-traditional roles preferred by Second Wave feminists. Then here is an example of a student applying theory or that which is taught in the classroom into practice, in Mills's case to her life. Third, her speech is indicative of how the issue of an overpopulated world had become a part of the environmental agenda before Earth Day and the importance of the media coverage during the 1960s. and finally, the media frenzy caused by her speech demonstrates the widespread idealism of her generation at the time. For like the crossroads in the Robert Frost poem, in life Stephanie Mills "took the one less traveled by."

Chapter 4

Silent Spring

W estern civilization has produced volumes of literature, which has elevated the human consciousness, and in so doing bringing into the market place of public opinion the ideas, which have moved humanity forward into the light. Galileo's *Dialogue Concerning the Two Chief World Spheres*, John Locke's *Two Treatises of Government*, Mary Wollstonecraft's *A Vindication of the Rights of Woman*, Charles Darwin's *On the Origin of Species*, and Harriet Beecher Stowe's *Uncle Tom's Cabin*, all are among that number. Another is Rachel Carson's *Silent Spring*. For with its publication came a debate about the efficacy of chemical pesticides in the food supply. Here a sharper focus was placed upon modern technology and its impact upon nature in general. Carson's book left an indelible impression upon her generation and generations yet unborn. *Silent Spring* is just such a book.

Her journey from humble beginnings as a child to the pantheon of environmental icons merits retelling here. Born under the shadows of the Allegheny Mountains, Carson came into this world during the Gilded Age amidst an ongoing national debate between conservationists, utilitarians, and preservationists or naturalists. Strolling through the wooded glens in the Allegheny Valley near her birthplace in Springdale, Pennsylvania, as a child with her little dog Candy accompanied by her mother, Maria, she could see the smoke and smell the stench from the American Glue Factory. There horses,

no longer of any use to their owners, broken and lame, were slaughtered. Living not far from the Carson's homestead, the memories of that factory must have left a lasting impression upon the child. "Passers-by could watch old horses file up a covered wooden ramp to their death. The smell of tankage, fertilizer made from horse parts, was so rank that along with mosquitoes that bred in the swampland near the riverbank called the Bottoms, it prevented Springdale's 1,200 residents from sitting on their porches in the evening."[158] Her father, Robert, had a difficult time earning a living for a growing family. Neither her father or her mother finished high school, which instilled within their daughter the imperative that she must earn an education a difficult task given the modest financial circumstances of her father.[159] With the opportunity public education afforded her, Rachel excelled in the classroom, earning high marks on her grade cards. As a child, she developed a love for words and literature. That, combined with her mother, who with Rachel by her side at a young age exposed her daughter to the natural world on long walks through the countryside around Springdale. This nurtured and cultivated a love of nature that would always remain a part of her as Rachel matured into a young woman.

After graduating from high school with honors in the spring of 1925, Rachel gained admission and enrolled in the Pennsylvania College for Women located in a Pittsburg suburb in the fall that same year. Her scholarship fell short of paying for her education, leaving her parents with no choice but to mortgage the family's Springdale home to make up for the short fall. Like so many college students, Rachel declared a major in English, which she believed would prepare her for life as a writer. That ambition and her life's passion all changed when the young college student enrolled in a biology class and fell under the spell of biologist Ms. Mary Scott Skinker, who had high academic standards. As so often happens in college, the other

[158] Eliza Griswold, "The Wild Side of Silent Spring," *The New York Times Magazine,* Sunday 23, September 2012, p. 38.

[159] William Souder, *On a Farther Shore: The Life and Legacy of Rachel Carson* (New York: Crown Publishers, 2012), pp. 24–25. And Linda Lear, *Rachel Carson: Witness for Nature* (New York: Henry Holt and Company, 1997), pp. 12–13.

girls avoided Ms. Skinker' class and her challenging pedagogy. "But Miss Skinker changed Rachel Carson's life."[160] During her junior year in college, Rachel informed Skinker of her decision to change her major to biology. It would prove to be a watershed moment in her life. Completing her degree requirements, she graduated from PCW in the spring of 1929. Five months later, the American stock market crashed, bringing with it financial ruin and despair throughout the United States and the world.

Life for Rachel during the Great Depression was surprisingly stable and the exception given the magnitude of the financial crises. She gained admission to the Johns Hopkins University, finding work as a research assistant working in various laboratories. Among them, Raymond Pearl's Institute for Biological Research in the School of Hygiene and Public Health. She also taught as an adjunct in the classroom at Johns Hopkins to pay expenses. Networking through Mary Skinker and using her already impressive resume, Rachel passed the civil service examination acquiring a job as a field aide working for the US Bureau of Fisheries in October 1935. Her job consisted of writing program material for radio aired as "Romance Under the Waters" heard over the Columbia Broadcasting System's air waves. Most likely through Skinker, Carson had the opportunity to meet Elmer Higgins, head of the US Bureau of Fisheries, Division of Scientific Inquiry, a part of the Department of Commerce. Prior to Germany's invasion of Poland on September 1, 1939, the Bureau merged with the Department of Interior under New Dealer Harold Ickes. In addition to Rachel's responsibilities in the Bureau of Fisheries, she occupied her time writing articles for the Baltimore Sun and the Richmond Times-Dispatch, her focus wildlife preservation and conservation issues.[161]

Working under Higgins proved to be another transformative experience in Carson's life. For it exposed her to the first-rate research laboratory at Woods Hole, Massachusetts, on Cape Cod. Aboard the research vessels Fish Hawk and the much more elaborate Albatross,

[160] Ibid., Souder pp. 31–35 and Lear pp. 35–37.
[161] Ibid., Souder, pp. 52–54 and Lear, pp. 62–63 and 78–80.

researchers could go virtually anywhere in the world. Carson's research at Woods Hole left a lasting impression upon her as a scientist and a writer. Excursions aboard the research vessels exposed her to a cornucopia of sea life as nets dipped into the ocean's depths oftentimes dredging up that which remained unseen on the ocean's surface. Carson biographer William Souder writes, "Mixed in with rocks and shells was a profusion of species crustaceans and seaweeds, invertebrates, and small fish, an embassy of living things she had never seen before, from a place she was just beginning to imagine."[162] Doing research did not come easy for Carson though she persevered during her two month stay at Woods Hole. That which she benefitted from most was the experience living near the sea itself, the exposure to the diversity of aquatic life, the smell and feeling of sea breeze in her face. Here was another world, a strange and wonderful place beckoning her to peer into its depths.

And it stimulated her imagination like nothing before in her young life. "The great variety of life in the sea impressed upon Carson that every living thing belonged to a larger diverse community of life that was sustained by interdependence and perpetuated across the vastness of time. Of all the lessons she'd learned well, this was the one she learned best."[163] Nearly a decade before Carson's experience at Woods Hole, Aldo Leopold had had the same epiphany, envisioning a "community of life" in nature while working for the US Forest Service eradicating the wolf population on the Kaibab plateau in northern Arizona. There Leopold came to realize the wolf he had been paid to eradicate, played an integral role in sustaining the deer population of the Kaibab and said so in a chapter in his book *A Sand County Almanac*. In "Thinking Like a Mountain," he examined something he referred to as the "land ethic." Leopold's ecological commentary left a lasting impression on a generation of environmentalists including Rachel Carson. Only one book rivals *A Sand*

[162] Souder, p. 44.
[163] Ibid.

County Almanac's influence on the Earth Day generation: that book is Carson's *Silent Spring*.[164]

Only two individuals had more of an influence upon her life greater than Mary Skinker and Elmer Higgins as a writer. The first was British author Henry Williamson, the second a fellow Brit by the name of Richard Jeffries. Both had a unique writing style; both authored books on nature. Carson was familiar with Williamson, a confident and friend of Thomas Edward Lawrence whose life's story inspired the biography Lawrence of Arabia. He influenced her the most. Williamson's nature study *Tarka the Otter* views the world through the eyes of a charming mammal found wild in freshwater wilderness. But he is better known for *Salar the Salmon*, a book which brings to life one of the prize game fish in the author's home Shallowford in extreme northeast Devonshire on the southeastern coast of England. Williamson, an avid fisherman, anthropomorphized the salmon creating one of the most memorable readings of the 1930s; it appeared in print in the United States during the summer of 1936.

In the spring of 1938, Carson made a request to Atlantic Monthly asking the editor for permission to review Williamson's newest offering, *Goodbye, West Country*. Exemplary of a genre known as ruralism, the book reflected on Shallowford and the places in nature in the area which Williamson had familiarity with. Atlantic granted Carson her wish. This despite the fact Henry Williamson, a member of the British Union of Fascists, had attended a Nuremberg rally featuring a speech by Adolf Hitler.[165] Carson's first great breakthrough in the literary world came with the release of her first book *Under the Sea-Wind* just weeks before the Japanese attack on Pearl Harbor. Encouraged by Dutch author Hendrik Van Loon and Simon and Schuster's Quincy Howe, Carson compiled her Woods Hole experiences and love of aquatic life toiling diligently until November 1941 when the manuscript was ready for the printer's ink. Though literary critics admired Carson's book, "*Under the Sea-Wind* sold slowly

[164] Souder, pp. 124–126.
[165] Ibid., Souder, pp. 59–67 and Lear, pp. 90–92 and 103–104.

at first then hardly at all. Toward the end of January, [her book] had sold fewer than 1,300 copies, and weekly totals had dropped to only a handful."[166] She rationalized claiming the World War had hurt sales. Meanwhile, her mentor Mary Skinker confided in a letter to her former student, "'The world tonight is depressing…and thoughts of friends in danger serve but to increase a sense of despair over the inevitable period of years we must face before we know anything resembling peace or security."[167]

Undeterred, Carson published again. A decade had passed by the time she found an agent who put their client's interests first. Author Marie Rodell went about the task, negotiating a contract with Oxford University Press, which never materialized. Then Rodell approached Paul Brooks, the chief editor of Houghton Mifflin press, by putting a copy of *Under the Sea-Wind* on his desk. Brooks was impressed. Two fortuitous occurrences made Carson's next project a resounding success: Carson first applied for a grant totaling more than two thousand dollars from the Eugene F. Saxton Memorial Trust which she put to good use buying time to write, and in the spring of 1950, she changed the title of her new book from "Return to the Sea" to *The Sea Around Us*, the words she borrowed from the lyrics of a poem by T. S. Elliot's "The Dry Salvages." Through a connection she made at The New Yorker magazine, Rodell arranged with Edith Oliver for the outlet to publish ten chapters of *The Sea Around Us*. Editor in chief William Shawn approved the project and published it as a serial.[168]

The transformative effect the magazine series had upon Carson's literary career cannot be underestimated. Ten chapters placed her writing in the hearts and minds of an elite social class in America, the movers and shakers, the intelligencia, a group of opinion leaders whose thoughts and words carried weight with thousands of their peers. Literary critics praised the book in what one Carson biographer calls "universal critical acclaim." Her face appeared on the front

[166] Souder, p. 93 and Lear, p. 105.
[167] Souder, p. 94.
[168] Souder, pp. 135–143, and Lear, pp. 152–177.

page of the Saturday Review of Literature. And the public followed suit. By August of 1951, the book had made The New York Times best seller list rising to number two; one month later, *The Sea Around Us* had risen to number one, holding the top spot "for the rest of the year and far into the next, setting new records for the most consecutive weeks atop the list."[169]

Buoyed by the financial rewards reaped from book sales, Carson embarked on a tour of the east coast traveling from Maine to the Florida Keys. The facts and research findings would contribute material to a narrative she titled *The Edge of the Sea*. One month after it hit bookstore shelves, her book appeared at number eight on the best seller list competing with Anne Morrow Lindberg's *Gift From the Sea* and Walter Lord's history of the Titanic tragedy for the top spot. To capitalize on Carson's momentum as an author, Marie Rodell negotiated a contract with the CBS television network for Carson to write a script for the series Omnibus. As only she could, Carson explained the complexities of the atmosphere specifically clouds; the show aired on a Sunday in March of 1956. Four months later, Carson submitted an article to Woman's Home Companion, a coffee table glossy which appealed to housewives. The title "Help Your Child to Wonder," explained the importance of instilling in young children the importance of investigating the natural world. Rodell also negotiated a contract with RKO Studio's Irwin Allen to produce a documentary based on *The Sea Around Us*.[170]

Though Rachel Carson had achieved celebrity status she would save her best for last. In a short time, the publicity generated by her last offering's message would resonate from main street America to the halls of the United States Congress and the Oval Office in the White House. Many regard it to be the defining moment, the watershed in American environmental history. In her book, she challenged the notion that American society could enjoy better living through chemistry. As Philip Shabecoff writes, by the time of her book's publication, "Environmentalism in the United States had become a pow-

[169] Souder, p. 159 and Lear, pp. 207–208 and 237–240.
[170] Ibid.

der keg ready to explode. With *Silent Spring*, Rachel Carson lit the fuse."[171]

There is a misconception that dichlorodiphenyltrichloroethane's effectiveness was discovered by student chemist Othmar Zeidler in a laboratory in Strasbourg, Germany, in the last years of the nineteenth century. DDT, the acronym for the chemical compound and brand label for the synthetic chemical, was just one of hundreds of chemicals produced in the laboratory, where Zeidler happened to be working on his PhD. Zeidler merely made a notation using the acronym jotting down notes in his journal to earn his degree. The dubious distinction for inventing DDT belongs to Swiss chemist Paul Muller of Basle. After discovering the concoction in his laboratory in 1938, Muller tested it to determine its effectiveness as an insecticide by fogging first the clothes moth, then the common house fly, followed by some mosquitoes. Coincidentally, DDT dustings saved the Swiss potato crop that same year eliciting praise from Geigy Company officials as a "miracle insecticide."[172]

During World War II, the chemical's effectiveness in preventing and eradicating lice infestations—among American troops and the victims of the Nazi concentration camp system—was widely known by war's end. Typhus, one of the dreaded killers of the day, carried by lice had spread throughout Europe, infesting American troops returning from Europe at the time. To rid the American army of the infestation, the military turned to DDT, and by March 1945, one month before Adolf Hitler committed suicide, more than a quarter of a million troops and European civilians by the thousands had received a dusting of the white powder. Publicity generated by further application by the military on the battlefield and experimentation by officials of the US Department of Agriculture during the war led to governmental approval of DDT for sale to the general public in September 1945. Seizing upon the opportunity to eradicate insects which infested their crops, American farmers and commercial

[171] Philip Shabecoff, *A Fierce Green Fire: The American Environmental Movement* (New York: Hill and Wang, 1993), p. 110.

[172] Souder, pp. 238; Eliza Griswold, "The Wild Life of 'Silent Spring,'" *The New York Times*, Sunday, 13 September 2012 (*New York Times Magazine*), p. 39.

agricultural interests turned to DDT as the weapon of choice in the seemingly endless struggle against countless destructive insects. That DDT could save valuable crops of grain, fruits, and vegetables, and in so doing, increasing profit margins stimulated sales of the substance for chemical companies.[173]

Carson's interest in the potential harmful effects of pesticides, and DDT in particular, is a familiar story in environmental historiography. Much of her interest stemmed from a lawsuit filed in federal court by a citizen's group on Long Island seeking an injunction to prevent the federal government from the wholesale spraying of DDT to eradicate the gypsy moth. The plaintiffs claimed such spraying had had a devastating impact upon nontargeted species, particularly the songbird population in the target area. Carson received encouragement to investigate the harmful effects of pesticides by one of the plaintiffs, a Marjorie Spock, who informed the now famous author of the lawsuit's progress; Carson also corresponded with The New Yorker's Elwyn Brooks White, a frequent contributor to the popular magazine. White, better known for his writing manual *The Elements of Style*, suggested Carson investigate the use of pesticides further. Carson agreed. In such a way, the foremost nature writer in America unintentionally turned her attention to environmental advocacy.[174]

Clearly, all indications point to Carson believing commercial pesticides, particularly DDT, had the potential to be harmful to wildlife and human health by January 1958. A letter from Beatrice Trum Hunter to the editorial page of the Boston Herald resonated with Olga Owens Huckins, who had worked as the literary editor at the Boston Post. Huckins and her husband, Stuart, lived on a small acreage of undeveloped land near Duxbury, Massachusetts. Their property provided habitat for a large population of songbirds. Huckins knew of Carson having reviewed her book *The Sea Around Us* for the Post. The Huckins' property had been the target of Massachusetts' state officials who had sprayed to eradicate mosquitoes near the property with a mixture of DDT and fuel oil. Basing her argument

[173] Lear, p. 305 and Souder, pp. 244–247.
[174] Souder, pp. 274–276.

on visual evidence, Huckins authored her own editorial, mailing it to the Boston Herald, which Carson read. The Hunter letter and Huckins's friendship persuaded Carson to act: she phoned the US Congress and the Department of Health, Education, and Welfare, urging both to investigate the harmful effects of pesticides. Their indifference then silence only stimulated Carson's curiosity.

On her own initiative, Carson uncovered an unnamed source in the Food and Drug Administration who indicated a certain baby food manufacturer had put a hold on a specific vegetable used in making its products. The vegetable in question had tested positive for pesticide contamination.[175] That and the many friends who encouraged her gave Carson the motivation to research the issue of pesticide poisoning. What emerged from her effort would change the course of the environmental movement and the momentum of history.

Compiling research, she cast her net wide, contacting those in the scientific community who in time would prove to be one of her most valuable sources. She began her book with a style that placed her audience in an imaginary small farming community then interjected something she described as "a strange blight," which left the community in the same way it would have been if an evil spell had been cast upon every living thing. Its human inhabitants fell ill, unable to explain what afflicted them; farm animals inexplicably died, and the oddest phenomenon of all, the songbirds disappeared, leaving the springtime air "without voices" during mating season. In her macabre vision, it was one in which "on the mornings that had once throbbed with the dawn chorus of robins, catbirds, doves, jays, wrens, and scores of other song birds. There was now no sound; only silence lay over the fields and woods and marsh."[176] And not just this town but every community in America had had an evil spell cast upon it. Reading her introduction she titled "A Fable for Tomorrow," it is no surprise *Silent Spring* remained atop The New York Times for more than two years. With the possible exception of

[175] Lear, pp. 313–315.

[176] Rachel Carson, *Silent Spring* (New York: Houghton Mifflin Company, 2002), p. 2.

Paul Ehrlich's *The Population Bomb*, no scientific-based book before or since captured the imagination of the American public the way Rachel Carson's book did during the fall of 1962.

Drawing an analogy using radioactive fallout from nuclear weapons' testing, as we have seen a hazardous threat at the time, and pesticides proved to be an appropriate beginning for her to make her case. Like radioactive contamination, pesticides' harmful side effects surfaced well after initial contact and ingestion by the host had taken place. And in the case of nuclear contamination by the time *Silent Spring* reached bookstore shelves, its harmful effects were widely known. Given the book's popularity such a literary device was a stroke of genius. Then Carson methodically examined the chemicals in question molecule by molecule: chlordane, heptachlor, DDT, aldrin, endrin and dieldrin the latter when tested, measuring fifty times more toxic than the more widely used hydrocarbon DDT. Carson made the case "chemists' ingenuity" in the laboratory had surpassed the "biological knowledge" of the long-term effects of these concoctions upon living things. The second category Carson analyzed in her book, the organic phosphates parathion and malathion, she labeled "the most poisonous chemicals in the world."[177] Though hydrocarbons differed from organic phosphates in their molecular structure, one fact remained a constant: all warranted the skull-and-crossbones designation of poison. All had the potential to be lethal if a living host came into contact with them.

Carson addressed this "new kind of fallout," a not-so-subtle reference to nuclear contamination and their potential to pollute community drinking water. To support her assertion, she used the congressional testimony of the Massachusetts Institute of Technology's Rolf Eliassen. Eliassen went on to found Stanford University's environmental engineering program; his words under oath added a sense of the unknown to the consequences of mixing pesticides with other chemicals which flowed into city reservoirs and underground aquifers. The truth of the matter was in 1962, the scientific community

[177] Rachel Carson, *Silent Spring* (New York: Houghton Mifflin Company, 2002), pp. 24–31.

had not determined the effects of pesticides upon humans or wild-life when they seeped into fresh water below ground in the aquifers around the United States. Carson cited examples of fish analyzed in the laboratory in Pennsylvania to Muscle Shoals and reservoirs in the Tennessee Valley. Fish tested positive for agricultural pesticide residue runoff, which had contaminated streams and rivers. The result: large fish kills and damage to aquatic ecosystems.[178]

Carson believed there could be nothing more alluring and disconcerting in the public's mind than the thought of potentially lethal chemicals leaching into the water supply contaminating the underground aquifers, which held the very water necessary to sustain life on Earth. "Except for what enters streams directly as rain or surface runoff, all the running water of the Earth's surface was at one time groundwater. And so, in a very real and frightening sense, pollution of the groundwater is pollution of water everywhere."[179] To make her case, she provided an example. Not far from Denver, Colorado, the Rocky Mountain Arsenal operated by the Army Chemical Corps had rented the facility to an oil company, which had manufactured insecticides during World War II. Farmers in the area had complained of livestock sickened for which local veterinarians had no explanation. Once healthy plant life began to wither and die and grain crops failed; federal and state authorities investigated in 1959 and determined farm wells had been contaminated with a mixture of toxic chemicals: "Chlorides, chlorates, salts of phosphonic acid, fluorides, and arsenic had been discharged from the Rocky Mountain Arsenal into holding ponds during the years of its operation."[180] Carson calculated it had taken almost a decade for the chemicals to leach from the holding ponds to the nearest farm three miles away. State and federal officials were at a loss as to how to go about containing a life-threatening monster created by human ingenuity. The facility, once a storage facility for lethal nerve gas, was in time added to the Environmental Protection Agency's Super Fund cleanup list and is

[178] Ibid., pp. 40–41.
[179] Ibid., p. 42.
[180] Ibid., p. 43.

today a wildlife refuge. *Silent Spring* also addressed the defoliants a potential source of pollution which was being used by Operation Ranch Hand at the time of the book's publication.

Not surprisingly, most of *Silent Spring* is dedicated to how chemicals threatened wildlife, birds, and aquatic life. That evidence which pointed to certain chemicals impacting negatively on wildlife, by implication, also could potentially threaten human beings. One example is the western grebe. An aquatic bird that thrives in the trans-Mississippi region, the birds sustained a drastic reduction in its numbers due to the spraying of DDD, a chemical cousin of the more highly publicized DDT. Spraying intended to eradicate the Chaoborus astictopus, a bothersome relative of the mosquito, turned deadly for the grebe. Insect eradication was ordered to accommodate anglers who frequented Clear Lake, California, a popular fishing destination. The aerial assault, which included the toxic elixir DDD, devastated the grebe population near the lake, which fed on the targeted insect and small fish alike. Grebe numbers plummeted from more than two thousand birds shortly after World War II when the spraying began, to only sixty birds on the entire lake in 1960. And Carson rhetorically added more potential victims of the eradication program by reasoning, "But what of the opposite end of the food chain—the human being who, in probable ignorance of all this sequence of events, has rigged his fishing tackle, caught a string of fish from the waters of Clear Lake, and taken them home to fry for his supper? What could a heavy dose of DDD, or perhaps repeated doses, do to him?"[181]

Here, Carson brought her readership face-to-face with the unpleasant reality of the seriousness of the issue: in an attempt to accommodate sportsmen, fish and game officials had exposed human beings to a potentially lethal chemical, not to mention the fact the lake itself provided drinking water for the community nearby. She summoned up no less an authority than Dr. W. C. Hueper of the National Cancer Institute, who cautioned, "The danger of cancer hazards from the consumption of contaminated drinking water will

[181] Ibid., pp. 46–49.

grow considerably within the foreseeable future." She provided her reader with a study carried out in the Netherlands during the 1950s, which demonstrated conclusively, "Cities receiving their drinking water from rivers had a higher death rate from cancer than did those whose water came from sources presumably less susceptible to pollution such as wells."[182] Here intended comparison using the grebe and the average American was obvious: If one succumbed to pesticide poisoning, so could the other.

One producer of canned baby foods had had problems purchasing fruits and vegetables which tested free of pesticide contamination. Chemical analysis of sweet potatoes grown in California and South Carolina tested positive for benzene hexachloride. Conscientious about the quality of its products mothers purchased to feed infants, the baby food manufacturer had to contract with other growers at a considerable financial loss. Even hops in the Pacific Northwest grown for brewing beer withered and died on the vine when heptachlor had been applied to a crop to rid it of the strawberry root weevil; pesticide residue lingered in the target fields for years hops growers left with the unenviable task of seeking restitution in the courts.[183]

But Carson reserved her most convincing condemnation for the "insect-control programs" around the country. Whether at the local, state, or federal level in Carson's third-person narrative, such eradication programs had morphed into a Frankenstein monster. One such program involved the Michigan Department of Agriculture. Its intended target: the Japanese beetle, popillia japonica, an invasive insect, which destroys domestic plants and fruit. A stowaway on plants imported from Japan during World War I, the insect spread into states west of the Mississippi River. By the time Dwight D. Eisenhower had been elected president for a second term, the infected states took action "in the name of beetle control." Despite reassurances by the supervisor in charge of the Federal Aviation operation in the Detroit, Michigan, area that the aerial spraying of the pesticide aldrin was safe, the chemical fell from the sky "like snow," contam-

[182] Ibid., p. 50.
[183] Ibid., pp. 59–61.

inating humans and wildlife alike. Cats and dogs became ill; birds fell from the sky in neighborhood yards dead or debilitated, their nervous systems damaged so they could not fly; residents flooded Detroit hospitals complaining of, "nausea, vomiting, chills, fever, extreme fatigue and coughing."[184]

Away from heavily populated Detroit, in rural Illinois the same result. In the small town of Donovan, through applications of aldrin, the wildlife was decimated: "The robins had been wiped out, as had the grackles, starlings, and brown thrashers." Game birds such as quail and pheasant, once plentiful, all but disappeared. "Pheasant hunting, which had been good in these areas in former years, was virtually abandoned as unrewarding."[185] Ornithologists, concerned citizens, and members of the scientific community witnessed and recorded how birds reacted to the spraying of pesticides. One such example, a solitary meadowlark near Sheldon, Illinois, was typical: "Although it lacked muscular coordination and could not fly or stand, it continued to beat its wings and clutch with its toes while lying on its side. Its beak was held open and breathing was labored."[186] This example of a solitary bird distressed played upon the sensibilities and compassion of Carson's audience. Then she implicated all who read her narrative appealing to their emotional sensitivities with this line of questioning: "By acquiescing in an act that can cause such suffering to a living creature, who among us is not diminished as a human being?"[187]

The scope of her research was boundless. Carson consulted the National Audubon Society, her old employer the US Fish and Wildlife Service, natural museum curators, even the Superintendent of Forestry, leaving no stone unturned in her search for facts to support her argument. And therein lies the greatness of her book: it combines thorough scientific research within a compelling story which informs. Which explains the books popularity as well. An example is the chapter "And No Birds Sing," in which Carson tells of how the

[184] Ibid., pp. 89–91.
[185] Ibid., p. 95.
[186] Ibid., p. 99.
[187] Ibid., p. 100.

state of Michigan attempted to eradicate Dutch elm disease, an epidemic which killed hundreds of the popular shade trees in residential areas. It seems a fungus carried by the elm bark beetle had infected the elm, a source of shade in many neighborhoods. The arboreal disease made its way onto the campus of Michigan State University by 1954, where ornithologist George Wallace, a professor on campus, began to observe the effects of DDT sprayed to kill the bark beetle. Wallace noticed "dead and dying robins on campus" thereafter and began to investigate. Quite by chance, Wallace mentored John Mehner, a graduate student whose doctoral work examined trends in robin populations.[188] In the spring of 1954, the university and the city of East Lansing commenced a systematic spraying of DDT to eradicate the insects and in so doing the fungus which infected the elm. Mehner noticed nothing unusual that year, but in successive years, the robin's numbers diminished on campus to the point three years later he counted only a solitary bird at a time when hundreds should have been on campus to nest.[189]

A clue which would eventually solve the mysterious disappearance of the robins surfaced in the laboratory of Dr. Roy Barker doing collaborative research at the University of Illinois, Urbana. Barker determined the robins' fate linked to organic matter such as leaves and bark contaminated with DDT which fell to earth, decayed, decomposed, and then was digested by earthworms. Earthworms were then eaten by robins, which explained their deaths. Wallace found excessive amounts of DDT in the earthworms' intestines he examined; some died, but others survived only to be transformed into "'biological magnifiers' of the poison."[190] Then Wallace uncovered something "more sinister" in his investigation. Toxic concentrations of DDT were detected in the testes and ovaries of adult robins; sterile, the birds failed to reproduce young. Carson produced numbers. Roughly forty-five species of birds depended upon earthworms in their diets, and she came to the logical conclusion: "Already there

[188] Ibid., p. 106.
[189] Ibid., p. 108
[190] Ibid.

are disturbing records of heavy mortality among more than 20 other species of ground-feeding birds whose food—worms, ants, grubs, or other soil organisms—has been poisoned."[191] Carson reported in 1956, the Cranbrook Institute of Science requested local residents to bring dead birds they believed to be poisoned to the institute to be examined. The response was overwhelming. Three years later, the institute had collected more than a thousand poisoned birds, so many the institute could no longer hold their number in the facility's deep-freeze depository.[192]

In the same chapter which described the plight of the robins in Michigan, Carson noted the decline in the number of birds of prey. Observations and counts of banded birds by naturalists east of the Mississippi River noticed a significant decline in the number of young eaglets. She relied on documentation compiled by Maurice Brown, the principle ornithological authority of the Hawk Mountain Sanctuary in southeastern Pennsylvania under the shadows of the Appalachian range. Brown confirmed the worst: the American bald eagle numbers had declined inexplicably. During the Great Depression, when Hawk Mountain had been designated a sanctuary "from 1935 to 1939, 40 percent of the eagles observed were yearlings, easily identified by their uniformly dark plumage." But beginning in the years following World War II, young eagles comprised 20 percent of the total number until the year 1957, when eaglets comprised only 3 percent of the total.[193] Not surprisingly, those years immediately following the war corresponded with an increase in the use of DDT as an agricultural insecticide. Ingesting fish, a mainstay of the eagle diet, which had consumed DDT residue which flowed in rainwater into river estuaries and streams had dire consequences for the adult birds.

Subsequently the eagle and peregrine falcon laid eggs with thin shells, the result of a chemical imbalance from ingesting the fish contaminated with insecticide. This made the eggs susceptible

[191] Ibid., p. 110.
[192] Ibid., p. 109.
[193] Ibid., pp. 119–120.

to breakage before hatching, resulting in the depletion of the number of young birds during the nesting season. So devastating was this chemical phenomena which led to their diminished numbers the American bald eagle and the peregrine were determined to be endangered. Fortunately, with the banning of DDT in 1972, this biological trend reversed itself. The birds' numbers rebounded to the point both species began to thrive again in the wild. The birds numbers increased in wilderness areas where their ancestors had lived for millennia.

Perhaps her greatest literary triumph, the chapter "Rivers of Death," told of the devastation brought upon the eastern salmon, which spawned in the Miramichi River moving in mass from the coastal waters of the Atlantic Ocean off the coast of New Brunswick, Canada. Here in poetic prose Carson explained how the Canadian authorities used a DDT emulsion to rid the pine forests of the spruce budworm, which had attacked the coniferous forests of eastern Canada. She recounted the literally millions of acres of pinewood forests which had been sprayed with DDT, "to save the balsams, the mainstay of the pulp and paper industry."[194] Unfortunately, Canadian conservation authorities failed to consider the collateral damage incurred by the indiscriminate spraying of the pesticide over such a wide area. For the fingerling salmon of the Miramichi, the late spring of 1954 turned deadly. That spring, the river received a massage dosage of the pesticide; at a rate of eight ounces per acre, DDT made its way through the skies from aircraft onto the river's watershed, which received the full brunt of the poison, killing the intended target, the budworm larva. Unintended, the spray also eradicated insects, the blackly, mayfly, and caddis fly larva, dietary mainstays of young salmon and trout.

Biologists of the Fisheries Research Board of Canada investigated. They deduced without food to sustain themselves, thousands of the young salmon had died, their carcasses littering upper streams of the Miramichi where their parents had given them life. The spraying stopped. The salmon recovered. Even so, Carson reasoned,

[194] Ibid., pp. 130–131.

"Against such a background, the future of the salmon fisheries in New Brunswick may well depend on finding a substitute for drenching the forests with DDT."[195]

Even more sobering in "Rumblings of an Avalanche," Carson applied Darwinian theory in convincing fashion to persuade her audience of the implications of society's newfound faith in "chemocidal" eradication of the insect world. As the weakest insects succumb to the poison, those which survive live to breed again and again multiplying with each new generation, building up a genetic tolerance or immunity to the recommended dosage of the once effective poison. Just as plentiful in numbers as before, the heartier, stronger more virulent generation of insects confronts humanity, now forced to increase the dosage in order to increase the pesticide's effectiveness. Such escalation leads to a vicious cycle with seemingly no foreseeable resolution. This idea of "chemical biocide" is an integral part of Rachel Carson's purpose in *Silent Spring*.[196]

Before it went on sale on September 27, 1962, to the general public, the book first received notoriety in a three-part serialization in New Yorker magazine. Beginning on June 16, then June 23, and June 30, opinion leaders and the public got their first exposure to Carson's case against excessive pesticide use. That fall, Lorus and Margery Milne reviewed her book in the New York Times's book review section under the heading "There's Poison All Around Us Now." The public's reaction was astounding. It shocked the general public, lifting the level of environmental consciousness to a heretofore unseen level in American culture. Correspondingly, sales of *Silent Spring* placed it on The New York Times best seller list for months, joining Truman Capote's *In Cold Blood* and Joy Adams's *Born Free* as one of the most popular books of the sixties. But by writing a cautionary account of the dangers of chemicals, Rachel Carson also stepped into the Coliseum with the lions of the business community whose livelihoods depended upon sales of pesticides. A rebuttal would be forthcoming.

[195] Ibid., pp.131–135.
[196] Ibid., pp. 263–275.

Within a month of the serialized printing in The New Yorker, representatives of American Cyanamid, Stauffer Chemical, Monsanto, Velsicol, Dow, the Manufacturing Chemists' Association, and the National Agricultural Chemicals Association responded. In a preliminary investigative piece, New York Times reporter John Lee summed up the chemical industry's point-of-view writing, "The industry feels that she has presented a one-sided case and has chosen to ignore the enormous benefits in increased food production and decreased incidence of disease that have accrued from the development and use of modern pesticides."[197]

After the book's release for sale on September 27, the criticism became harsher, even personal. Foremost among Carson's critics, Dr. Robert White-Stevens, employed by Cyanamid, topped the list. Carson biographer William Souder describes White-Steven this way: "With his slicked-back hair, thin mustache, and black horn-rimmed glasses he was a dead ringer for the horror actor Vincent Price... speaking in echoey, Shakespearian cadences."[198]

Between White-Stevens and I. L. Baldwin, the pair formed a male phalanx of a formidable group of learned, scientists, industry spokesmen, and agribusiness interests critical of Carson's warning against pesticide abuse. Oft quoted, White-Stevens words typified the opposition. He, like many of his colleagues, believed Carson had cherry-picked data and information, and in his own words, "If man were to follow the teachings of Miss Carson, we would return to the Dark Ages, and the insects and diseases and vermin would once again inherit the earth."[199] Most governmental regulatory officials and industry spokesmen took a rational, measured approach when confronted with Carson's argument. They argued Silent Spring was a cautionary narrative concerned more with excessive use and abuse of the chemicals than a concerted effort by the author to abolish their products. This is closer to the truth. Carson herself realized there were instances which justified pesticide use as in the case of treating

[197] John M. Lee, "'Silent Spring' Is Now Noisy Summer," The New York Times, Sunday, 22 July 1962, sec. 3, p. F11.
[198] Souder, p. 360.
[199] Souder, p. 374.

regions affected by malarial mosquitoes in Africa, Asia, and Latin America. Even so, there were those representing the chemical industry who questioned her patriotism, calling her a communist sympathizer, a conspirator whose stand against pesticides played directly into the hands of sinister dictators in the Kremlin intent on world conquest after insects had devoured the Third World's food supply.[200] Such an accusation in 1962, given the volatile diplomatic relationship of the United States and the Soviet Union and Red China, was slanderous. Though Rachel Carson, environmentalists and the general public, for the most part, considered the source and took it in stride.

And how did *Silent Spring* play out in America's heartland? In St. Louis, Missouri, the Post-Dispatch serialized the book for twelve days, the first installment appearing in print on December 30, 1962. Amidst a featured headline "Who'll Be 'It' in Hollywood" speculation on the heir apparent to the deceased Marilyn Monroe with photos of likely candidates Ann Margaret, Natalie Wood, and Audrey Hepburn, editorialist William K. Wyart Jr. examined both sides of the controversy surrounding the book in the St. Louis newspaper. At stake were grain crops, fruits and vegetables of which insects destroyed eight billion dollars' worth annually. Also in fiscal year 1947, the United States chemical industry manufactured 124,259,000 pounds of insecticides; thirteen years later, the industrial production had increased to more than 637 million pounds, generating sales in excess of a quarter of a billion dollars. Regulating or banning such chemicals altogether would impact the American economy negatively. Wyart included those defending the government's position. With the words of a USDA spokesman who stated matter-of-factly: "At one time this country was supporting about 1,000,000 Indians and some wildlife, and things [nature's ecology] were in balance. Now we've got 180,000,000 people and we could go hungry if we don't use these chemicals."[201]

[200] Lear, p. 409 and Souder, pp. 346–347.

[201] William K. Wyant Jr. "Bug and Weedkillers: Blessings or Blights?" *St. Louis Post-Dispatch*, 29 July 1962, 1-C.

He sought out Byron T. Shaw, head of the USDA's Agricultural Research Service, who explained the procedure and expense chemical manufacturers had to comply with before a commercial pesticide went on sale to the public. Shaw agreed with Carson's conclusions then stated, "I have nothing against these articles by Miss Carson... She is discussing a subject of concern to us. After all, these things are poisonous. We think it is good to have public discussion, and we believe a lot is being done to protect the public." Shaw, like many who worked in the governmental bureaucracy and industry, made the case for more education, stressing users read instructions and warning labels carefully so they could apply the insecticide safely.[202] Eight months later, the newspaper would address the same subject.

This time, Bernard Gavzer of the Associated Press would ask the newspaper's subscribers, "Whom are we to believe? Is Miss Carson dead wrong? Or is she sounding a warning we must heed?" Those whose livelihood depended upon a steady supply of pest-free grown products for consumers broached the subject of Carson's book with measured caution, oftentimes taking a pragmatic approach to the issue of insecticide contamination in nature. At a convention of the National Canners Association in Chicago, food manufacturers expressed the opinion their reputations had sustained damage. Nonetheless, sales remained brisk despite *Silent Spring's* message. Gerber, the largest manufacturer of processed baby food in the country, was there in Chicago, and their spokesman insisted, "All chemicals used on any food it buys be water-soluble" (meaning the chemical can be washed away), and Beechnut actually claimed it made "field checks of every other plum tree before okaying fruit for its line of baby foods."[203]

Another canner, Robert C. Cosgrove, chief operating officer of Green Giant brand and head of the National Canners Association, admitted several insecticides were being used on his company's products. But when questioned about the impact of Carson's book on

[202] Ibid., p. 3-C.
[203] Bernard Gavzer, "Are Pesticides a Boon or a Food Poison," *St. Louis Post-Dispatch*, 25 March 1963, p. 3-D.

sales, Cosgrove answered it had had no effect. What did concern him "was the vision of a runaway situation that would repeat the cranberry scare, in which cranberry growers took a beating and had to be bailed out by the government."[204] Another canner, George Gooding, an executive with California Packing Company, insisted every phase of the growing of fruits and vegetables his company manufactured underwent intense scrutiny by inspectors from the field to the packing plant. Gooding went even further, saying, "I'm not interested in arguing with Miss Carson." Then he became personal by stating, "The question comes down to this: I'm a consumer of food—food that I pack—and I'm damned if I want to poison myself."[205]

As for Rachel Carson, she had no regrets. In the case she made against pesticide abuse, she said in her defense, "Nothing has happened to make me change my mind about the approach to the problem today... If I were writing *Silent Spring* today, I'd have a great deal more to add to the story. Evidence coming to me has been reinforcing what I've said." She claimed to be no muckraker, a reference to the progressive journalists of the early twentieth century. And she defended her book by saying, "'If there was sensationalism, it was in the facts. Good gracious. I didn't have to dress up the situation. I wanted to bring this to public attention. I think people have comforted themselves with the thought, 'The government is taking care of us.' But it isn't. That's what I wanted people to know.'" She got to the heart of the matter by declaring modern America stood at a moment in time in which it was "dominated by industry, in which the right to make a dollar at whatever cost is seldom challenged...."[206]

Rachel Carson would die of cancer in the spring of 1964, but her legacy in the message she brought into the mainstream of public discourse would remain. *Silent Spring* left a lasting impression on the minds of those who took her narrative to heart. A copy of the book made its way into the Oval Office, where after reading it, President John F. Kennedy created a special group of scientists and academics

[204] Ibid.
[205] Ibid.
[206] Ibid.

to investigate the validity of Carson's book. For eight months, the President's Science Advisory Committee analyzed her research. In the spring of 1963, a year before Carson's passing, the PSAC made its investigation public. The committee supported Carson, vindicating her book and the allegations she made in it: pesticides were not only a threat to wildlife but were also harmful to human health. Perhaps the most objective commentary on the validity of Carson's argument came from the Secretary of Agriculture in the Kennedy administration, Orville L. Freeman. He reasonably deduced, "Miss Carson does not advocate halting all use of chemical pesticides. She does advocate the use of the best judgement in selecting the right control method—whether biological, chemical, or other—for use in the right way at the right time. This is a policy with which we are heartily in agreement."[207]

Impressed by what he read, Supreme Court justice William O. Douglas called *Silent Spring* "the most important chronicle of this century for the human race." Aside from the eloquent prose which reads like poetry and the title gleaned from a poem by the Romantic poet John Keats, what gives *Silent Spring* its timeless quality as literature? The extensive sharing and networking Rachel Carson accomplished to accumulate her research is impressive enough, so much so that any self-respecting academic in this day of communication technology and social media should take inventory and blush in shame. What makes Rachel Carson's book a great work of literature is the way it appealed to Bob Dylan's generation by shocking them into examining their lives and taking stock of the world around them in a way no book had ever done before. *Silent Spring* signaled a tectonic shift in the consciousness of the American public, and once they had read what Carson wrote, they realized their lives would never be the same again. The book's timeless value lies in the fact its publication incited a generation of Americans to take action and summon the will within themselves to take to the streets and change the world. Most importantly, Rachel Carson challenged the industrial and gov-

[207] Bernard Gavzer, "Are Pesticides a Boon or a Food Poison?" *St. Louis Post-Dispatch*, 25 March 1963, 3-D and Souder, *On a Farther Shore*, p. 343.

ernmental establishment controlled exclusively by men to rethink what heretofore had been unthinkable: the fact that human beings and their anthropocentric behavior threatened not only the natural world but their health and well-being as well.

Silent Spring rates with the likes of Jacob August Riis's *How the Other Half Lives*, Upton Sinclair's *The Jungle*, contemporaries Ralph Nader's *Unsafe at Any Speed* and Betty Friedan's *The Feminine Mystique*, and Eric Schlosser's *Fast Food Nation: The Dark Side of the All-American Meal* as one of the finest activist books ever written. Nonetheless, the work activists started in Rachel Carson's name on Earth Day in April of 1970 is not finished. It was only a beginning. Though DDT was banned for commercial use in the United States in 1972, it still remains a threat to contaminate the natural world and potentially do harm. Carson biographer Linda Lear acknowledges, "The domestic production of DDT was banned, but not its export, ensuring that the pollution of the Earth's atmosphere, oceans, streams, and wildlife would continue unabated. DDT is found in the livers of birds and fish on every oceanic island on the planet and in the breast milk of every mother."[208] The problem humanity faces which Rachel Carson identified so very long ago, remains unsolved

[208] Rachel Carson, *Silent Spring*, (Boston: Mariner books, 2002), p. xviii.

Chapter 5

Sewers in the Sky

Samuel Langhorne Clemens mentioned it in his satirical commentary on late nineteenth century America *The Gilded Age*. First published in April of 1873, the title of Mark Twain's novel has come to symbolize that period in our nation's history. As the steamboat Boreas approached St. Louis, Missouri, on its voyage northward, Twain described it this way: "A long rank of steamboats was sighted, packed side by side at a wharf like sardines in a box, and above and beyond them rose the domes and steeples and general architectural confusion of a city—a city with an imposing umbrella of black smoke spread above it."[209]

But air pollution had been ongoing long before Mark Twain's day. Sixty-one years after the birth of Christ, Seneca, citizen of Rome, found the quality of air far removed from the city on the Tiber to be healthier, more invigorating. He wrote, "As soon as I had gotten out of the heavy air of Rome, and from the stink of the smoky chimneys thereof, which being stirred, poured forth whatever pestilent vapors and soot they held enclosed in them, I felt an alteration of my disposition." Convinced the burning of coal contaminated London's air, King Edward I issued a royal decree forbidding the city folk from

[209] Mark Twain, *The Gilded Age* (New York: Literary Classics of the United States, 2002), p. 39.

burning coal with Parliament in session. Doing so in no way diminished the problem. In Shakespeare's London, the Bard of Avon's contemporary John Evelyn commented on "'the hellish and dismal cloud'" which had a debilitating affect upon the residence of London in such a way that they suffered as he described it from "catarrahs, phthisicks, coughs and consumptions more in this one city than in this whole Earth besides."[210] But the burning of coal continued. In 1951, four thousand people died, victims of a killer smog which enveloped London; ten years later, similar air contamination killed four hundred more.[211]

As we have seen, radioactive fallout in the air from weapon's testing threatened the health of not just the United States but also the entire human race. There were other sources of air contamination though. Smoke from the controlled burns of brush and undesirable plants on farmland around the world constituted one hazardous source of air pollution. Geographer George H. T. Kimble estimated nearly 50 percent of the world's rural population engaged in some form of a controlled burn to rid their land of undesirable plants and brush. With no ground cover, this left valuable top soil exposed to wind erosion. And when the wind blew, dust particles and smoke from such burns got caught up in the oscillations of the Earth's jet stream which circled the planet then deposited it far removed from where the wind had become contaminated. Kimble, a World War II veteran stationed in New Zealand, claimed, "It was possible to write one's name in the dust that had been carried from the dried-out wetlands of Australia, more than 1,200 miles away."[212]

In the continental United States companies, a large part of the rust belt's smokestack industrial complex, contributed to a large part of the overall percentage of the total amount of air pollution after World War II. Facilities manufacturing everything from house paint to steel produced emissions in the form of toxic fumes such as hydrofluoric acid, sodium fluoride, calcium fluoride, sulfuric acid, and

[210] George H. T. Kimble, "That Hellish and Dismal Cloud," *The New York Times Magazine*, 21 April 1963, p. 20.

[211] Ibid.

[212] Ibid., p. 26.

arsenic. No less toxic, traces of hydrochloric acid, trace elements of zinc, and lead all could be found in the atmosphere hovering above most major cities in the United States by the time President John F. Kennedy gave the country hope in his inaugural address. Thus the perception most urban Americans and environmentalists had that the air supply of humanity was in need of cleaning up before the first Earth Day in April of 1970.

Increasingly, the American people came face-to-face with visible evidence of air pollution by looking at the horizons above the skyline of most American cities. By the 1960s, it appeared to be as hazardous to human health as the radioactive fallout from the above ground testing of nuclear weapons in the barren deserts of Nevada and New Mexico. Chronic air pollution even had a name: they called it smog. Though the term had been coined at the beginning of the twentieth century, the word smog had become a part of the vernacular in newspaper editorials and in the language environmentalists used to describe what they perceived to be a threat to life on the planet by Earth Day 1970. And another major cause: Americans had developed an infatuation for the automobile, which by the 1960s had become a necessity and an obsession. The car facilitated a culture of convenience—an outward manifestation of an American economy which produced a huge variety of merchandise for American consumers filling spacious shopping retail outlets and shiny showroom floor displays. Living in the suburbs of major cities in rural areas, American consumers used the automobile to shop and commute to work. And automobiles powered by the combustible engine burned poisonous leaded gasoline.

Such combustion produced fumes and, when combined with the right climatic conditions and geography, produced suffocating air pollution. Hence smog. Unknowingly, the federal government and states contributed to the problem and American's addiction to driving building highway systems, which crisscrossed the landscape in a checkerboard concrete and steel pattern. By the 1960s, a federally subsidized highway building plan the interstate highway system spanned the length and breadth of the nation in every direction. By 1970, the sense that air pollution posed a threat to public health was

palpable. And many journalists focused on the deterioration of air quality. Of those, none proved to be more effective than the cover story of Time magazine which hit newsstands two months before April 22, 1970.

Time reporters grabbed the nation's attention by announcing Apollo 10 astronauts orbiting the earth recognized Los Angeles's smog-filled atmosphere peering from their space capsule which they described as a "cancerous smudge" from their vantage point twenty-five thousand miles above the Earth's surface. Closer to Earth, airline pilots and their passengers complained of a brown haze hovering above the air space of every major airport in America.[213] Looking for a story, journalists capitalized on the issue of air quality. An air contamination feature appeared as Life's cover story in February 1969, following the printing of the magazine's 1968 yearbook that featured some of the most provocative images ever captured on film. The air contamination issue followed photos of the brutal execution of a Viet Cong insurgent by a South Vietnamese military officer, the moments just after an assassin's bullet struck down Martin Luther King Jr. on the balcony of the Loraine Motel in Memphis and photos moments after the murder of presidential candidate Robert F. Kennedy in a Los Angeles hotel, a bellicose Mayor Richard Daley in the gallery of the 1968 Democratic National Convention and a violent clash on Chicago's streets between police and anti-war activists during that fateful summer there.

The February Life, in similar fashion, featured the artistry of photojournalist Martin Schneider focusing on the poor air quality in America. It delivered the harmful, destructive effects of filthy air out of control in living color right into the living rooms and libraries around the country.[214] Schneider's pictorial essay took him to Polk County, Florida, where he photographed an illuminated phosphate plant belching fluoride compounds into the night air. To supplement what Schneider captured on film, Life reporter Richard Hall interviewed Florida citrus growers whose orange groves had died and farm-

[213] "Fighting to Save the Earth From Man," *Time*, 2 February 1979, p. 56.
[214] Richard Hall, "Air Pollution," *Life*, 7 February 1969, vol. 66, pp. 38–50.

ers whose livestock had developed respiratory problems due to the plants noxious fumes.[215] The pair then traveled to Montana's Big Sky country, where Schneider took shots of the lumber town of Missoula. With his lens, he captured smoke rising from burning debris which blackened the sky obscuring the Bitterroot Mountains. Similar to Pittsburg, Pennsylvania, where street lights remained illuminated in broad daylight, the air pollution was so severe in Missoula motorists had to turn their headlights on during the day for lack of sunshine. Further to the east, Hall experimented in Chicago by hanging laundry on an outdoor clothesline atop the Baltimore Hotel downtown. There it hung for weeks until Hall returned to the Baltimore's roof, only to find the same laundry virtually disintegrated from exposure to the acidic fumes from the nearby steel industry's smokestacks. What little remained of the cloth material blew in tatters in the blustery Windy City breeze.[216]

From coast to coast, the team traveled from Los Angeles and the Santa Monica Pier to New York City's Central Park. In Central Park, Schneider captured skaters on the ice in Wollman Memorial Rink gliding under the brown haze of the Big Apple's skyline. Hall's poignant caption below reminded Life's audience of the Thanksgiving holiday turned deadly. That year in 1966, smog caused the death rate to spike upward 10 percent.[217] But it was nothing compared to Schneider's shots of the nation's capitol. Utilizing time-lapse photographic techniques with a plain photo shutter lens, Schneider caught a glimpse of the auto exhaust filled atmosphere fogging Pennsylvania Avenue, the nation's capitol building barely visible in the smog shrouded background in what Hall described as "the dirtiest air in the nation." Perched atop the Washington Monument, the photojournalist captured the entire nation's capital engulfed in a witches' brew cauldron of automobile exhaust fumes and industrial pollution. Editorializing, Hall cut right to the heart of the problem by declaring pollution to be "a peculiar product of our civilization and

[215] Ibid., p. 46.
[216] Ibid., pp. 44–45.
[217] Ibid., p. 49.

of our carelessness, it is simply human litter and it is heaved into the atmosphere by all of us—from automobile tail pipes, from incinerator stacks, from power stations and home chimneys. Last year...over 143 million tons of it went up and fell right back down on Beautiful America and there will be more next year."[218] Hall acknowledged know-how and technology existed to eradicate air pollution. What he questioned was the conviction of the American public to act. His words came straight from the heart writing: "What is obviously lacking is will, the national will to admit we are all to blame, to spend the money and enforce the laws, and possibly, just possibly, save ourselves from choking to death."[219]

As Hall and Schneider and those residents living in such intolerable conditions could see, nowhere had more smog to sting the eyes and more dirty air to threaten human health than populous Los Angeles County.

California health officials put a Dutch-born scientist by the name of Arie Jan Haagen-Smit, a chemist teaching at the California Technology Institute (commonly referred to as Cal Tech), on the county payroll to monitor the effects of urban smog on the Los Angeles freeway. His findings would be his claim to fame and lead to a call for air pollution controls on automotive traffic. Like Joe Friday in the popular detective television show Dragnet, Haagen-Smit, with his portable carbon monoxide detector in tow aboard his Plymouth, traveled the freeway system searching for pockets of potentially lethal carbon monoxide (CO) filled air; he reported the data he recorded back to headquarters with "just the facts." Highways in and around Pasadena had tolerable amounts of carbon monoxide, but when Haagen-Smit hit the Santa Monica Freeway, the carbon monoxide meter began to register dangerous amounts of the gas. The detector's needle registered "30 parts per million" considered to be a human health hazard by California health officials.[220] The cause was obvious.

[218] Ibid., p. 43 and 39.
[219] Ibid.
[220] "Chemistry: Monoxide Rides the Freeways," Time, vol. 85, no. 8, 19 February 1965, p. 70.

Los Angeles County seemed to have no other transportation option other than the passenger car. During peak rush hour in the morning and evenings after work, Haagen-Smit registered a significant upward spike of 120 parts per million of pollution in the air motorists were forced to breathe. The Caltech academic explained it this way: "It is most exciting... You get behind another car, and the pointer [on his detector] goes way up, especially where you have a slowdown in traffic." Extreme upward measurements of carbon monoxide occurred frequently in areas on the Los Angeles Freeway "at nightmarish intersections where curling roadways tangle like spaghetti on a fork and hundreds of car engines pant in frustration." Haagen-Smit observed, "Tunnels and depressions concentrate the carbon monoxide...but in that interchange area it's really stinking."[221] A threat to commuters, carbon monoxide had the propensity to mingle in the blood, decreasing the blood's capacity to move oxygen throughout the human body. "If you breathe 30 ppm [parts per million] for eight hours...5 percent of the oxygen capacity of your blood is taken away," Haagen-Smit explained. (Richard Hall placed the number at 15 percent.) Oxygen depletion left those with respiratory ailments at risk.[222]

Haagen-Smit's experience in the labyrinth of the Los Angeles Freeway among thousands of combustible engines spewing noxious carbon monoxide from tailpipes was no different than the experience of the average commuter in America's cities every day. Polluted air was seen in their air and felt in their eyes with a stinging, burning sensation almost daily. The automobile was the culprit. The invention of German engineer Nikolaus August Ott, the combustible, piston-driven engine had undergone no environmentally friendly modifications since its invention shortly after the American Civil War. Science journalist Lawrence P. Lessing put it this way: "Probably no other single mechanism has contributed more to the economy, lore,

[221] Ibid.
[222] Ibid.

and present shape of western society. Indeed, its enormous success is the source of most of its current trouble."[223]

Auto exhaust from the tailpipe of every car emitted a mixture of chemicals into the atmosphere. Lawrence Lessing, whose wide range of expertise included subjects as diverse as earthquakes and deoxyribonucleic acid, the study of which in the midsixties was relatively new, provided the public with an analysis of auto exhaust produced by the burning of poisonous leaded gasoline. The first chemical compound Lessing singled out was carbon monoxide, which he estimated to be 190,000 tons produced by auto exhaust daily in the United States; he reinforced Haagen-Smit's findings of 120 to 150 parts per million in the air of most heavily traveled urban areas in the United States. Similar to Haagan-Smit, Lessing concluded such high amounts of carbon monoxide could alter the hemoglobin in human blood, which could contribute to respiratory problems.[224] Four pollutants, including "gaseous hydrocarbons" in auto exhaust, came from the internal combustion's inefficient burning of leaded gasoline. Those compounds contributed to stinging eyes as well as respiratory problems in humans. In addition to benzene, which in excessive amounts caused cancer in laboratory animals, a third pollutant, nitrogen oxide, when combined with hydrocarbons and sunlight produced the all-too-familiar smog. The fourth and final classification of pollutant produced from tailpipe exhaust were nongases, chief among those being poisonous lead. Similar to radioactive fallout, lead had been added to gasoline to improve octane ratings, which boosted performance and horsepower. Or simply stated, lead made a car run faster. In the air, it was ubiquitous and far more sinister, virtually invisible to the naked eye. Lessing warned of the dangers in leaded gasoline when he wrote, "And lead of course, once it gets inside the human body in any sizable quantity, is a highly toxic substance, tending to impair the functioning of blood, kidneys, liver, and central nervous system."[225]

[223] Lawrence P. Lessing, "The Revolt Against the Internal Combustion Engine," *Fortune*, vol. 76, no. 1, July 1967, p. 79.

[224] Ibid., pp. 80–81.

[225] Ibid., p. 81.

A thorough examination of the use of leaded gasoline is perti-
nent to any study of the plague of air pollution in America prior to
Earth Day. What Jan Haagen-Smit and Lawrence Lessing speculated
to be a threat to the public's health, the United States Public Health
Service (PHS) confirmed, calling lead contamination "the greatest
environmental health threat to children." A thorough PHS accumu-
lated substantive evidence that exposure to lead adversely affected
fetal development, infants, and early childhood in general. Valerie
Thomas whose specialty in environmental science involves determin-
ing the effects of energy delivery systems including leaded gasoline
on the natural world, put it this way: "Gasoline lead, emitted to the
air, falls back to the Earth and contaminates soil, urban dust and
crops. Thus, this lead is not only inhaled, but is also ingested as lead
deposited on soil and dust, food crops and pasture land."[226] Similar
to radioactive nuclear fallout from weapon's testing, lead contam-
ination entered the air and the human food chain, and penetrated
the human blood stream. And there were other sources of lead con-
tamination just as inconspicuous, albeit just as toxic: common lead-
based paint used on single family dwellings and apartment build-
ings, water pipes, sewer pipes, the cosmetic industry, tableware of all
descriptions, and metal cans used to preserve fruits and vegetables.
Such a variety of sources in the words of Thomas, "complicates mea-
surements of leaded gasoline's contribution to blood lead levels."[227]
Here was yet another part of the air pollution equation, and to better
understand it, a review of how the additive lead came to be in gaso-
line is necessary.

Discovered in the General Motor's Research Laboratory in 1921
by Thomas Midgley, tetraethyl lead, when added to regular gasoline,
prevented pinging and improved engine performance. It was the Jazz
Age when the once progressive McClure's Magazine reflected the
changing mood in America by advertising in The New York Times.
McClure's ad hyped Ida Tarbell's new biography of Elbert H. Gary,

[226] Valerie M. Thomas, "The Elimination of Lead in Gasoline," *Annual Review of
Energy and the Environment*, vol. 20 (Princeton, New Jersey: Center for Energy
and Environmental Studies, 1995), p. 305.

[227] Ibid., p. 306.

the man J. P. Morgan hired to run his US Steel Corporation. The magazine's ad read, "If I had a young son—I'd bribe him, if necessary, to start him reading The Life of Judge Gary: The Story of Steel." McClure's sellout to the irrational exuberance of the Roaring Twenties accompanied the not-so-subtle headline "Schools Are Started for Volstead Agents: Course of Study Is Outlined to Raise Standards and Insure Conviction in Court Cases." With the public's health in mind, adding lead to gasoline would be the agenda for a conference convened in Washington, DC, during the Coolidge administration. In hindsight, the decision made at this conference would be a disaster for air quality and the environment.

In the spring of 1925, US Surgeon General Hugh Smith Cumming convened a gathering of business and labor leaders, physicians and academics to determine whether or not tetraethyl gasoline posed a threat to public health. Cumming, a veteran of the Great War, approached the problem with objectivity claiming, "He sincerely hoped that if it should be found that tetraethyl gas was detritus to the public's health, some substitute possessing the same efficiency, but without any bad effects, would be developed."[228] Those in attendance included Dr. William Pusey, president of the American Medical Association; E. B. Vedder of the War Department's Chemical Warfare Service; Alan Jackson, vice president of Standard Oil Company of Indiana; Harry Horning, the secretary of the Society of Automotive Engineers; and W. H. Howell, professor of physiology of the John Hopkins University. Thomas Midgley, who had discovered the gas additive, also attended the conference.[229]

Not surprisingly, Standard Oil's Jackson and Ethyl Gasoline Corporation's A. S. Maxwell held sway over the conference, reassuring those in attendance, "The scientists would find no cause to fear any public health danger in its use." Borrowing a page out of Frederick W. Taylor's The Principles of Scientific Management, Maxwell claimed adding the chemical to regular gasoline would improve "efficiency."

[228] "Scientists to Pass on Tetra-Ethyl Gas," The New York Times, 20 May 1925, p. 4, and Lawrence Lessing, p. 81.

[229] "Scientists to Pass on Tetra-Ethyl Gas," Ibid.

Maxwell ignored the chemical's potential to do great harm to the environment, emphasizing instead production of tetraethyl had become more cost-effective. Rather than presenting evidence to support such a statement, Maxwell stressed the extensive research which had led to Midgley's discovery; he also estimated the cost it would add at the pump to be a mere three cents a gallon. Maxwell then summed up his case for adding lead to gasoline by heralding the creation of a new company: "The Standard Oil Company of New Jersey made great strides in this research, and the result was that that company and General Motors came to together and formed the Ethyl Gasoline Company," the company he represented at the conference. He concluded by adding, "While it is true that tragedies have occurred in producing it, we believe that the safeguards now in use make it possible to produce it without great risk."[230] The decision to add lead to gasoline came out of this conference. Within months, automobiles began spewing poisonous fumes onto concrete and dirt roads across the country. The decision made at the surgeon general's conference in the late spring of 1925 ranks as one of the most irresponsible to be made with the tacit approval of the federal government in American environmental history.

There is no way to quantify the health risks workers in the laboratory and industrial workplace who were exposed to a health hazard in a day and age when safeguards such as protective clothing and respiratory protective equipment did not exist on the floors of American industry. Nor did any governmental agency such as the Occupational Safety and Health Administration or an Environmental Protection Agency exist to insist testing the additive's toxicity during the Coolidge administration to determine whether or not tetraethyl gas use would be detrimental to public health. As the Surgeon General Cumming, apparently had no desire to take any business interest to task, given the mood of the country during a presidential administration of the pro-business Calvin Coolidge. All this occurred during a period in American history of unprecedented economic prosperity when business and industrial concerns

[230] Ibid.

were deified. Such was the naivete of America's government during the country's second Gilded Age.

By the 1960s, the mood of the country had changed. The scientific community, political pundits, politicians of both parties, and the press began to call for reform and regulation. Editor Gilbert Harrison of The New Republic, anticipating the presidential election the next day, made reference to the findings of the American Association for the Advancement of Science, which had named a special committee to report on air quality nationwide. The committee found "pollution of the air in urban areas and the relation between nutrition and cancer as two problems which the public too poorly understands." He acknowledged the five-year study sampled air across the United States, including farmland, small towns, and boroughs, as well as large metropolitan areas; the primary goal of the study was to measure air quality. Harrison reported the grim details in the terse, penetrating, persuasive prose of a journalist. He divulged the "latest findings show that one of the hydrocarbons—benzopyrene (the chemical results principally from the incomplete burning of fuels, waste materials, or other combustibles)—caused cancer in laboratory animals and is suspected of causing cancer in man." Empirical data showed concentrations of benzopyrene to be sixteen times greater in heavily populated urban areas than in the rural hinterland. Consequently, chemists and physicians working for the Public Health Service issued their own statement: "If annual inhalation of benzopyrene may be considered a measure of lung cancer exposure, this exposure is about 100 times greater for an urban resident than a non-urban one, and the exposure is greater for a nonsmoker in many large American cities than for a pack-a-day smoker in a non-urban...community." Dr. W. C. Hueper of the National Cancer Institute went even further, warning the exhaust fumes generated from the internal combustion engine produced a variety of "noxious gases" capable of being placed on the "atmospheric carcinogenic spectrum." A response would be forthcoming.[231]

[231] Gilbert Harrison, "Pollution in the Air," The New Republic, 7 November 1960, p. 9.

A precursor to the federally mandated catalytic converter, the state of California passed legislation mandating "that in the future a device to control 'blow-by' fumes from auto crankcases be standard equipment on all new cars, and auto manufacturers are including the equipment on cars to be sold in that state." Harrison speculated the District of Columbia would pass a similar law, which would be implemented on all new 1963 vehicles. Studebaker-Packard had already offered a similar device as an extra accessory to be installed for $4.52 something the head of the US Public Health Service's Air Pollution division referred to as "a real step forward." Even so, the governmental department head qualified the progress being made in the auto industry then insisted, "Standards are not yet perfected for these devices but when they are, it will take federal, not city-by-city, action to make them mandatory on auto production lines."[232] Harrison's editorial appeared the month John F. Kennedy was elected President of the United States. Ironically, it would take more than a decade for the federal government to act. And act it did. Air quality and leaded gasoline would eventually be front-page headline news.

Questions swirling around Congress on Capitol Hill led to a hearing convened by a Senate subcommittee during the presidency of Lyndon Baines Johnson. In a press conference after the hearing, the head of the Bureau of State Services of Health, Dr. Richard Prindle, stressed the importance of lessening public exposure to leaded gasoline exhaust, particularly in America's cities. Prindle emphasized "rising auto use and continuing use of lead as a gasoline additive would seem to make limitations inevitable." Dr. William H. Stewart of the Public Health Service testified, "There were indications that the patterns of human exposure to lead were changing. While most of it comes from food, an increasing amount may be entering the human body with air breathed into the lungs."[233] Both witnesses stressed more research on lead's impact on the environment and human beings needed to be done. Stewart testified, "The modern

[232] Ibid.

[233] Harold M. Schmeck Jr., "Leaded Gasoline is Termed a Peril," *The New York Times*, 9 June 1966, p. 49.

environment is contaminated by many substances whose potential threat to public health has not been widely recognized or adequately studied and evaluated.'" He elaborated further, "These include not only lead, but several other metals, asbestos and plastics. The number is continually increasing."[234]

Leaded gasoline's days were numbered. The very day sports writers reported Muhammad Ali's third-round TKO of Jerry Quarry in Atlanta, Georgia, the first of two such fights on the comeback trail that would eventually result in his dramatic defeat to Joe Frazier in Madison Square Garden, President Richard Nixon ordered all federal vehicles to begin using "low-lead" or "unleaded" gasoline. Nixon urged the governors of each state to implement the same restriction in the various states on a voluntary basis. Nixon adviser Russell Train, the chairman of the president's newly created Council on Environmental Quality, made a statement saying the executive order had two purposes: the first being "to reduce air pollution and to increase the market for low-lead and unleaded gasoline." Essentially, the Nixon administration would lead by example in hopes of promoting the consumption by motorists of unleaded gasoline.[235]

Six months after Earth Day, the thirty-seventh president mailed a letter to the governors of each state. Leading by example once again, the president hoped the various states would comply. By doing so, Nixon hoped to smooth the transition from leaded based fuel to unleaded gasoline. Nixon wrote, "If your state would undertake a similar program, our joint action would offer the gasoline and refining marketing industries a sizable incentive to produce and distribute low-lead and lead-free gasoline. As the production and distribution of such fuels become widespread the motorist will be able to buy them and thus make a major contribution to the cleaning-up of our air."[236] Richard Nixon, though pilloried, vilified, and demonized for his secret war in Southeast Asia and of course Watergate, deserves more praise for his decision to make environmental issues a part of

[234] Ibid.

[235] "Federal Cars Get Leaded Gas Curb" (the Associated Press), *The New York Times*, 27 October 1970, p. 1.

[236] Ibid., p. 23.

the national agenda. Given the threat to the environment of global warming and catastrophic climate change today, Nixon's maneuvering—though he had ulterior political motives for doing so—seems all the more impressive.

Nearly three decades before environmental scientist James Edward Hansen testified before a congressional committee warning America and the world of the threat of global warming, the scientific community had reasoned humanity was contributing to climate change caused by air pollution. A 1970 headline in the Seattle Times headline read, "Pollution to Overheat Earth, Says Expert." J. Murray Mitchell Jr. is quoted in an interview, "The release of increasing quantities of carbon dioxide (CO2) and thermal pollution into the atmosphere threatens to change global weather and melt the Antarctic ice cap, flooding wide areas." Murray believed there was substantive evidence that "carbon dioxide and thermal pollution produces a 'greenhouse' atmospheric effect, tending to push the earth's absorbed solar heat back into space."[237] Long before Al Gore's documentary An Inconvenient Truth, Lawrence Lessing raised the distinct possibility of climate change brought about by air pollution from auto exhaust. Lessing put it this way: "Meteorologists fear that by then [1980] the capacity of the air to cleanse itself may become so overburdened as to work irrevocable changes in the Earth's atmosphere."[238] The editors of US News and World Report also came to the conclusion humanity's carbon footprint was to a degree altering the Earth's weather patterns.

One week before the Democratic National Convention in Chicago in 1968, the popular news outlet published an article entitled "Is Man Spoiling the Weather? What the Experts Say." Its content bears a resemblance to twenty-first century environmental warnings about global warming. The magazine's staff relied upon the scientific expertise of Charles L. Hosler, dean of the College of Earth and Mineral Sciences at Penn State University and Vincent Joseph

[237] Frank Carey, "Pollution to Overheat Earth, Says Expert," *The Seattle Times*, 22 April 1970, p. A1.

[238] Lessing, p. 82.

Schaefer, the Rainmaker, who is credited with calculating weather patterns could be altered by the aerial seeding of clouds. Schaefer's thinking gave rise to the idea that creating the proper atmosphere artificially with chemicals to induce rain could relieve drought conditions. In such a way, not only rain could be generated but tornadoes and hurricanes could also be tamed. Even snowfall could theoretically be produced by seeding clouds with dry ice during optimum weather conditions. With the assistance of Nobel laureate Irving Langmuir, Schaefer dropped dry ice from an airplane flying over Mount Greylock in Massachusetts and actually made it snow. On another cloudy day, using a similar technique, he made it rain too. Schaefer would later also use silver iodide to create a chemical reaction to change weather patterns.[239]

The news magazine article indicted the federal government for failing to regulate and control air pollution; it also singled out the American people for their failure to heed the expansive nature of their collective carbon footprint. The result: miserable weather around the country. It made a strong case that "extremes of weather seem greater and more frequent. Droughts appear longer, thunderstorms more violent, cloudbursts heavier, snowfalls deeper. Fog is more common." Then it stated what had already been reported: commercial airline pilots reporting thick brown smog above commercial air terminals around the country.[240] Hosler used the example of a local paper mill which polluted the air in Happy Valley near Penn State. Basing his commentary on scientific data and personal observations, he made the point that the atmosphere in the valley where the industry operated was covered with fog affecting roughly twenty miles of the surrounding area of its location. After analyzing the chemical composition of the air near the plant, Hosler concluded the fog consisted of sodium sulphate emitted from the paper mill. To be objective, Hosler did a comparison: A similar valley in an adjoining area in the vicinity of the same mill had no fog whatsoever. He

[239] Bruce Lambert, "Vincent J. Schaefer, 87, Is Dead: Chemist Who First Seeded Clouds," *The New York Times*, 28 July 1993, p. A16L.

[240] "Is Man Spoiling the Weather? What the Experts Say," *US News and World Report*, 19 August 1968, vol. 65, no. 8, p. 60.

reasoned the fog was caused by the air released into the atmosphere by the suspect paper mill.[241]

The news outlet went even further. In LaPorte, Indiana, a city an hour's drive east of the rust-belt town of heavy industrialized Gary, Indiana, weather patterns had changed drastically over a thirty-year period. Schaefer called the LaPorte study "one of the most intriguing in some time." US Weather Bureau records measured over three decades a thirty-one percent increase in rainfall per year more than in other communities in the region. Eugene Bollay, the chief operating officer of the federally subsidized firm supporting Schaefer's cloud-seeding research, held the theory that regional industrial pollution had altered weather patterns in LaPorte. Bollay, also by measuring the annual precipitation, indicated an area in Oregon surrounding a paper mill received an abnormal amount of rainfall. The cause: "pollution from the industrial complex."[242] Other sources of emissions factored into the content of the article, including auto exhaust and the vapor trails from the engines of commercial aircraft.

The article tabulated the total of all sources of pollution. In the base year 1965, the National Center for Air Pollution Control, working under the authority of the US Department of Health, Education, and Welfare, estimated sulfur dioxide pollution at twenty-five million tons; carbon monoxide at sixty-six million tons; hydrocarbons, the burning of fossil fuels, at sixteen million tons; nitrogen oxides at ten million tons; and particulate matter from a variety of sources at twelve million tons. While a consensus of meteorologists, chemists, climatologists, and academics like Hosler acknowledged the Earth in the midsixties was in the middle of an aberrational two decade-long cooling period, that trend had gradually reversed itself. "From 1900 to midcentury, these scientists argued, the amount of carbon dioxide in the atmosphere rose by 10 percent. In the same period, worldwide, temperatures rose an average of 1 degree. Conclusion: Carbon dioxide was making the world warmer."[243]

[241] Ibid.
[242] Ibid.
[243] Ibid., p. 61.

Contrary to popular belief, Vincent Schaefer, not NASA's James Hansen, first warned the world of the threat of climate change. He reasoned "'false cirrus' clouds…may be contributing to another phenomenon—a worldwide cooling trend." Schaefer claimed some members of the scientific community had predicted and made it known "that by the year 2000 the world's climate would average 3.5 degrees Fahrenheit warmer." Similar to Hansen, Schaefer indicated the notion "was based on the increasing amounts of carbon dioxide added to the air by the burning of the work-horse fuels of the industrial age—coal, oil and gas."[244] Though he never named his sources, Schaefer proposed from the beginning of the twentieth century to midcentury, the carbon dioxide in the earth's air supply had increased by 10 percent; the earth's surface temperature during the same period had experienced a rise of 1 percent per year. Though he acknowledged a cooling of the climate had taken place, Schaefer deduced the two trends were occurring "simultaneously, one tending to offset the other." Nonetheless, both Hosler and Schaefer found evidence air pollution had changed the atmosphere affecting global temperatures. Charles Hosler put it this way: "We had better pursue this to the point where we can at least understand it and, if necessary, bring it under control."[245] In a memorandum to Congress in which he outlined his environmental agenda for the country, President Richard Nixon made reference to the impact industrial pollution was having on the atmosphere. The thirty-seventh president did not ignore the science, writing, "In highly industrialized areas, such pollution can quite literally make breathing hazardous to health, and can cause unforeseen atmospheric and meteorological problems as well."[246] Even more ominous, Dr. J. Murray Mitchell of the Federal Environmental Science Services Administration predicted within two hundred years, "air pollutants—mainly carbon dioxide—may

[244] Ibid., p. 61.

[245] Ibid.

[246] Richard Nixon: "Special Message to the Congress on Environmental Quality," 10 February 1970. Online by Gerhard Peters and John T. Woolley, *The American Presidency Project*, http://www.presidency.ucsb.edu/ws/?pid=2757 (under heading "Stationary-Source Pollution").

cause the Earth's temperature to rise to levels that will threaten life itself."[247] For people living in Donora, Pennsylvania, New York City, and London, England, Mitchell's theory had already become a nightmarish reality grounded in fact.

On a Tuesday morning in October 1948, air pollution turned deadly in Donora, a town in the Monongahela River Valley. A thermal inversion—in the vernacular of climatology, a phenomena when warm air above covers a region covering and holding in place polluted cooler air beneath it—killed twenty people. Nearly six thousand more residents were hospitalized for a variety of respiratory complications. Donora happened to be home to a steel manufacturer, a wire mill, and an industrial facility which processed zinc and sulfuric acid. That mixture of pollutants had mixed with the fog from the great river it was later determined caused the deadly incident. According to one reporter, "For five days this air was thickened with the waste of industrial gases, zinc fumes, coal smoke, and on it a footstep or a tire track appeared white, as in a photographic negative."[248] Then there was the London tragedy.

Of all the great cities in the western world the home to Parliament, Big Ben, and the royal family, London suffered most. During the early morning hours of December 5, 1952, "while most of London slept, a fog began to drift over the city. Londoners are accustomed to 'pea-soupers,' and only scarce attention was paid as the mist thickened." Similar to Donora, once again a thermal inversion of warm air in the upper atmosphere trapped colder air below, sealing in thick coal generated smog over the city. For five days Londoners were forced to breathe air "so black that in some parts of the city people could see but a yard in front of their faces."[249] London's hospitals began to fill with people complaining of various respiratory afflictions. By December 13, long after the smog had lifted, four thousand Londoners had died victims of the killer

[247] Richard Harwood, "Earth Day Sirs-Nation," *The Washington Post*, 23 April 1970, p. A1.

[248] Robert Alden, "1948 Donora Smog Killed 20; London Toll Was 4,000 in '52," *The New York Times*, 26 November 1966, p. 28.

[249] Ibid.

air pollution. Meticulous recordkeeping by the various city hospitals treating patients revealed the carnage. In 1948, nearly three hundred lives were lost; in January 1956, one thousand; in December 1962, suffocating air pollution took from three hundred to four hundred more lives. Not since Nazi bombers had rained death and destruction down upon the city during the Battle of Britain had the loss of life been so great. All were attributed to atmospheric conditions created by polluted air.[250]

In the United States, with the possible exceptions of Los Angeles or Chicago, no city had poorer air quality than New York City. For ten days, beginning on November 18, 1953, killer smog led to the deaths of 240 people, a statistical anomaly higher than the number of average deaths normally reported. In the five boroughs of New York City, the great loss of life had nothing to do with smoking cigarettes or gun violence in November of 1966. Another thermal inversion caused a citywide air pollution emergency alert on November 26 attributed to abnormally high rates of sulfur dioxide and carbon monoxide in the atmosphere. For five days, people had to breathe this suffocating elixir of toxic air. This despite assurances by City officials including the Hospital's Commissioner who claimed "the air pollution had no significant effect on the health of New Yorkers." A more objective assessment came from Dr. William H. Becker, representing the Continental Research Institute, a nonprofit specializing in the study of the effects of tainted air on respiratory conditions. Becker's twelve-point survey of more than two thousand New Yorkers revealed a substantive number of city residents suffered from burning eyes, wheezing coughs, and breathing difficulties. In Becker's opinion, "When you get anything above 2 percent, this is a considerable amount of people with problems.... When you get up to 10 percent, this is a public health problem." A newspaper photograph of a lab technician at the Air Pollution Control Center replacing a white fil-

[250] Ibid.

ter in a rooftop air sampler made Becker's case for him. The original filter he replaced after twelve hours of exposure, pitch black.[251]

Becker's survey carried with it the force of statistical analysis. An epidemic of pulmonary emphysema had increased the death rate of New Yorkers by five hundred percent from 1960 to 1970. That same decade revealed a mortality rate caused by chronic bronchitis increase of two hundred percent. Officials from the Public Health Service pointed out scant empirical evidence existed at the time proving air pollution as the cause. Dr. Ernest Wynder, who worked at the renowned Sloan-Kettering Institute for Cancer Research, had doubts. Wynder's research led him to the conclusion dirty air did not cause lung cancer. Men did, however, contract lung cancer at a rate six times greater than women when both were exposed to the same polluted air. Another expert, Dr. Stephen H. Ayres, head of the Cardio-Pulmonary Laboratory at New York City's St. Vincent Hospital pointed out no one "tidy set of symptoms acts as a sign-post for the diagnosing physician, for in fact there was no 'air pollution disease' as such. Among the experts, however, there is a general agreement that pollution's primary effect on health is to exacerbate a variety of existing diseases, such as arteriosclerosis."[252] Five weeks before Earth Day, one New York City medical examiner who worked in the morgue put it this way: "On the autopsy table it's unmistakable... The person who spent his life in the Adirondacks has nice pink lungs. The city dwellers are black as coal."[253] Such words in such graphic detail guaranteed the turnout by activist for the first Earth Day. Dirty air in the Big Apple even motivated a group of residents to form an organization calling itself GASP, an acronym for "Group Against Smog and Pollution," and picket the downtown office of

[251] Homer Bigart, "Smog Emergency Called For City; Relief Expected," *The New York Times*, 26 November 1966, p. 1 and p. 28. Paul Hofmann, "Easing Is Urged on Pollution Law," *The New York Times*, 10 December 1966, p. 31. Paul Hofmann, "10% Here Suffered Effects of Smog, Private Study Finds," 10 December 1966, p. 31.

[252] "500% Rise in Emphysema Mortality Rate in Last Decade Reported for City," *The New York Times*, 12 March 1970, p. L27.

[253] Ibid.

Consolidated Edison Company the utility which provided energy for the electrical grid in the city.[254] The reporting of the deterioration of air quality in New York City also had an assist from Times's photographer Neal Boenzi, the Fred Astaire of American photographers. Boenzi's photojournalism captioned, "New York City, in a Shroud of Gray, Gasps for Air," shot from Hoboken, New Jersey, and his photo "Polluted Manhattan" shot from the vantage point atop the Empire State Building are tour de forces of environmental photographic journalism.

Another suspected source of air pollution was the condensation trail of commercial and military jet aircraft. By the 1960s, jetliner transportation had had such an impact upon American cultural habits the term "jet set" became attached to a generation. The lifestyle was in vogue, finding expression in flights on Pan American Airlines, Trans World Airlines, and United Airlines, global enterprises making it possible for a passenger to fly around the world living the life of the "jet setter." Charles Hosler put it this way: "In 'airline alley' between New York and Chicago, below which I happen to live in Pennsylvania, we get cirrus clouds 90 percent of the time now. Most of them would not have been there naturally before. They are formed strictly by the thousands of jet aircraft flying overhead.'" Hosler referred to these clouds as "false cirrus clouds" similar to the natural cirrus variety in appearance, only these cloud formations were synthetic produced by jet vapor trail condensation. The academic explained how these "false" clouds were formed. They were created from "water vapor" emissions from jet aircraft exhaust, the moisture entering the atmosphere at a high altitude freezing and forming ice crystals. Once frozen, "one ice crystal begets another, which begets another and so on." Hence, a cloud formed, albeit a "false" cloud created by human activity.[255] Such an environmental argument, the volume of noise pollution created by their jet engines, and budgetary concerns were primary considerations for the Senate voting to cancel

[254] Ibid.
[255] "Is Man Spoiling the Weather? What the Experts Say," pp. 60–61.

funding for the supersonic transport (SST) despite President Nixon's support for the aircraft.[256]

Pollution from aircraft engines was minuscule compared to auto exhaust as a percentage of air contamination. It would be the automobile which received the most publicity of the environmental protestors on Earth Day. Environmentalists had visions of solutions. Those included what once was the stuff of science fiction fantasy and grist for comic book material. The idea of an electric car was just that in the minds of most Americans. It came to be perceived as the product of the fertile science fiction imagination, not a practical reality. Nonetheless, by the middle of the decade millions of environmentalists and public opinion in general were aroused by sensory, physical evidence. The visible, tangible, the stinging, burning sensation in the eyes caused by the air hung above almost every large city in the United States. This motivated Detroit auto manufacturers to consider alternatives to the combustible engine.

It was Thomas Edison, the Wizard of Menlo Park, who once said, "If you continue to produce your present quality of electric automobiles, and I my present battery the gas buggy won't stand a chance."[257] In 1910 one magazine advertisement featured a couple of Washington, DC, aristocrats driving down Pennsylvania Avenue in their new electric car manufactured by the Baker Motor Vehicle Company. Entrepreneur-inventor Walter Baker took Edison at his word, headed into his workshop and machine tooled an all-electric horseless carriage which the man named the Baker Electric, the second known motorized vehicle ever created. There were several electric-powered vehicles invented during the Gilded Age. First came the French who led the way, then Americans Philip Pratt, Andrew Riker, and William Morrison followed with electric-powered contraptions of their own. Not to be outdone, British inventor Walter Charles Bersey's Landau built in 1896 preceded even Walter Baker's invention. The British government even sponsored the designing and

[256] J. Brooks Flippen, *Nixon and the Environment*, (Albuquerque: University of New Mexico Press, 2000), p. 136.

[257] George P. Hunt, ed., "Ford Builds a Better Battery: New Spark for Old Electrics," *Life* magazine, 21 October 1966, vol. 61, no. 17, p. 74A.

building of the Peel Trident, a light commuter vehicle—similar to the micro-cars of the twenty-first century—to combat London's smog problem. Slightly heavier than a child's toy car, the vehicle weighed only five hundred pounds; the energy cell which powered the vehicle was more than half its total weight. But it would be Baker who exceeded all expectations and shocked the world with his electric torpedo built in 1902, that he boasted could reached a top speed of 104 miles per hour. Baker's braggadocio never materialized.[258]

What condemned the idea of an electric car to the dust bin of obscurity? Inadequate technology, Frank Sprague's electric trolley, logistics, and American culture, particularly the flight to the suburbs, which increased commuting distances relegated the electric car to obsolescence. Nonetheless, because of pernicious air pollution, Life magazine heralded the Ford Motor Company's new technological projections, which it claimed would solve America's air pollution problem. Life went a step further, prophesying the internal combustion engine would be replaced in every car with an "atomic reactor which would be guaranteed not just for the life of the car but for the life of the driver," given the longevity of nuclear power well known at the time. Envisioned as the wave of the commuting future, New York City Mayor John Lindsay drove an electric car to observe the Earth Day festivities on April 22, 1970. As much a political photo-op as it was intended to bolster moral support for the idea of electric transportation, Lindsay's commute on an electric bus received wide publicity across the country and on network television.[259]

Lindsay's demonstration notwithstanding, the electric car in April 1970 was about as practical as a flying car, a figment of the fertile imagination of science fiction writers and enthusiasts. Nonetheless, sensing the changing mood in the country, Ford and General Motors developed two electric-powered prototypes in 1966. They never went into production.[260] For starters, combustible

[258] Ibid., p. 74B.

[259] Richard Harwood, "Millions Observe Earth Day in US," *The Washington Post*, 23 April 1970, p. A20.

[260] Jack Doyle, *Taken for a Ride: Detroit's Big Three and the Politics of Pollution*, (New York: Four Walls Eight Windows, 2000), p. 509.

engine-driven vehicles were cheaper to manufacture; the technology for electric engines lagged far behind, making such an automobile impractical. And factor in the interstate transportation system which stretched across the country for thousands of miles, linking suburbia with every major city and coast to coast in every direction and the limitations of electric mileage capacity, and you get a sense of why the idea of an electric car was just not feasible. These factors were ignored by a fringe element of the environmental movement and the American public giving rise to conspiracy theories.

By April 22, 1970, there were as more conspiracy theories surrounding the demise of the electric car as there were conspiracy theories explaining the assassination of John Fitzgerald Kennedy. And not surprisingly, the main conspirators which did the electric in were Big Oil and its minions, primary lobbyists and cigar-smoking executives spending big money and doing business in secret in the nation's capitol.

The Beltway got the message. A variation of the Air Pollution Control Act of 1955, Congress passed and President Lyndon Baines Johnson signed an improved piece of legislation, the Clean Air Act of 1963. The first law of its kind, the mandate's effectiveness lay in the principal of federalism. This first installment to clean-up the nation's air only recommended clear air standards, allowing states to enforce them on a "voluntary basis." A renewed and amended federal law in 1967 required states to enforce federal air quality standards. Meanwhile, the Department of Justice filed a lawsuit against the Detroit auto manufacturers under the Sherman Antitrust Act alleging the Big Three had engaged in a sixteen-year conspiracy to avoid installing pollution control devices on their products.[261] A new and vastly improved version of the same legislation arrived in the Oval Office of President Nixon in December 1970. He signed it. The bill instructed states to test auto emissions; it set "specific emission standards" for stationary (industrial) sources and mobile sources (automobiles). Most importantly, it began the phasing out of leaded

[261] Jack Doyle, *Taken for a Ride*, pp. 509–510.

gasoline which would be completed in 1976.[262] Environmentalists with leadership from like-minded legislators in both the House and Senate made this possible. Student Earth Day coordinator Denis Hayes, a part of the effort to make the legislation the law of the land, believed, "It drew strength from its authenticity...these were real people not professional green lobbyists. I'd argue that the 1970 Clean Air Act campaign was the first successful lobbying effort of the modern environmental movement."[263]

Almost as if Earth Day activists had planned it that way, something quite amazing happened a world away, less than four weeks removed from April 22, 1970. On the island of Japan, the Tokyo city government ordered 122 of its busiest streets closed for a day to automobile traffic. The car moratorium challenged the residents of the city to envision "what life could be like without the noise and the stench of the internal combustion engine." Led by Tokyo's governor, Ryokichi Minobe, the carless day demonstrated an urban area of 11.5 million people could live without the automobile. Meters measuring air pollution in the city recorded a substantial reduction in carbon-based gases. In the world-famous Ginza shopping and entertainment district in downtown Tokyo, the pollution level dropped to half its normal reading. Ginza district merchants who had had reservations about such a policy were astounded when sales increased more than 30 percent. Department stores recorded record sales and steady foot traffic. "The Misukoshi department store said it had 200,000 shoppers, compared with a usual Sunday figure of 130,000. Sales ran 50 percent ahead of the usual figure, store officials said." One manager at another large retailer said, "Sales are just about like Christmas."[264]

[262] J. Brooks Flippen, *Nixon and the Environment*, p. 115.

[263] Denis Hayes, letter to Jack Doyle, 9 August 1998, 2 pp., as quoted in Jack Doyle, *Taken for a Ride*, p. 62.

[264] Reuters, "Tokyo Curb the Car, Beats the Smog," *The Washington Post, Times Herald*, 3 August 1970, p. A1 and A12, col. 1. Reuters, "122 Shopping Streets in Tokyo Get a Breather From Traffic Pollution," *The New York Times*, 3 August 1970, p. 34; Jack Doyle, *Taken for A Ride*, p. 63.

Wisconsin Senator Gaylord Nelson realized the vastness of the country, the culture of convenience created by the mobility of the automobile, and the Tokyo solution to be impractical in the United States. Combating dirty air would take that kind of change in human behavior, but it would also take legislation to bring the full force of the federal government to bear on establishing air quality standards to address the problem. The urban-industrial complex of Los Angeles, New York City, Chicago, and Gary, Indiana, notwithstanding, state and local governments had little resolve to deal with the problem nor did they have the financial resources to combat air pollution. And as Nelson pointed out, more than 60 percent of air pollution came from auto exhaust with no regard for state or regional boundaries. Nelson reasoned, "Private industry should not be faced with widely differing standards from city to city. This creates the old problem of competitive disadvantage and encourages some industries to threaten to move away if tough standards are set."[265] Though his amendment to ban the sale of the combustible engine by 1975 never became law, the Clean Air Act of 1970, which established stringent air quality standards nationwide and which Nelson supported, would be a beginning in the long arduous struggle to rid America's air of impurities. Earth Day, which was Nelson's idea, made that legislation a legal reality.

At present, the focus of the world community on improving air quality is reducing greenhouse gases and humanity's carbon footprint, in particular carbon dioxide. In theory, the idea being by reducing the amount of carbon dioxide in the Earth's atmosphere, the greenhouse effect will be greatly diminished and global climate change reversed. Auto manufacturers worldwide have addressed this concern, producing at least sixty electric hybrid models, the Toyota Prius being the first rolling off the assembly line and also the most popular of that number. Naturalized American citizen Elon Musk's Tesla model, though pricy, has continued the trend, joining the large number of hybrid electric vehicles on the world's highways.

[265] Gaylord Nelson, *America's Last Chance* (Waukesha, Wisconsin: Country Beautiful Corporation, 1969), p. 59.

Alternative energy sources such as wind and sun have captured the imaginations of the scientific community and businesses alike, generating a technological revolution here in the United States but also in mainland China, a country which not only leads the world in the production of carbon dioxide from the burning of coal and other fossil fuels but paradoxically also takes a leading role in manufacturing the technology to prevent it from being churned out into the atmosphere. And though the debate continues between the scientific community and those political pundits call deniers, evidence continues to mount in favor of those who insist the burning of fossil fuels has changed the Earth's atmosphere in not-so-subtle ways. Even the Pentagon has studied the problem, labeling global climate change a "threat multiplier" which threatens human habitation living along coastal regions and contributes to political instability on a global scale. Those societies most affected by climate change even have their own place in the American vernacular: they are called climate refugees.

Chapter 6

Dirty Water

Verified by an investigation authorized by President Theodore Roosevelt, Upton Sinclair's *The Jungle* is a graphic depiction of the deplorable conditions in Chicago's meat packing district in the early twentieth century. Sinclair's historical fiction includes references to the environment in that city during the Gilded Age. We learn of a tributary of the Chicago River the meat packers called Bubbly Creek. In its waters flowed the animal hair, tallow, and blood from slaughtered livestock, the water so vile Sinclair referred to it as a "great open sewer." Bubbly Creek acquired its name because of the chemical reaction from the contamination in which "bubbles of carbonic acid gas [rose] to the surface and burst," causing ripples in the waterway measuring several feet long quite visible to anyone walking along its banks. Now and then, Sinclair claimed, "the surface would catch fire and burn furiously, and the fire department would have to come and put it out."[266] In graphic detail, Sinclair captured the essence of an urban environment as filthy and corrupt as the city government's big city bosses who ruled Chicago. The two worked in tandem creating something akin to a place so repulsive, so abusive to its workers it seemed to emanate out of Dante's Inferno. [267]

[266] Upton Sinclair, *The Jungle* (New York: Penguin Books, 2006), p. 106.
[267] Ibid.

Like polluted air, dirty water could be seen and like air smelled, oftentimes so much so the stench permeated urban and the rural atmospheres. On his cross-country trip to visit soul mate Neal Cassidy in Denver, Colorado, during the summer of 1947, Jack Kerouac took in the sights and sounds and the people he encountered along the way. Those experiences found expression in Kerouac's novel *On the Road*, the spontaneous narrative which would earn the twenty-five-year-old the nickname "King of the Beats." Kerouac's unorthodox style of prose did for literature what Miles Davis, Thelonious Monk, and Wes Montgomery's bebop style of jazz did for music. Girlfriend Joyce Johnson acknowledges in her biography of Kerouac, *The Voice Is All*, he returned from Denver to New York City confiding in her how the Mississippi River had an unpleasant smell and was visibly polluted.[268] Kerouac's kindred spirit Allen Ginsberg made reference to the "filthy Passaic" the river running through his childhood hometown of Paterson, New Jersey in his poem Howl, the anthem of the Beat Generation. The words grounded in fact, the river's water so toxic in 1956 when the poem was published there is no need for any sort of symbolic interpretation.

By the sixties, Kerouac's experience crossing the Mississippi had company. Millions of Americans saw the country's contaminated lakes and rivers, a visible, visceral experience. The pungent smell along the shores of the country's waterways garnered publicity, generating headlines in newspapers, in the many mainstream news outlets, and on the television nightly news, and in so doing captured the public's imagination and elicited a reaction. In some instances, the polluted water they could see and smell served as a constant reminder of the quality of their own drinking water and what they used in their kitchen to cook with or bath in at home. Politicians scanning the political landscape for an issue which would win voters over on election day in water pollution found themselves a wedge issue which garnered support across the political spectrum. Water

[268] Joyce Johnson, *The Voice Is All: The Lonely Victory of Jack Kerouac* (New York: Viking Press, 2012), p. 241.

pollution, which threatened the health and well-being of the public at large proved to be ideological neutral by April 1970.

Attached more to the issue of escalating America's war in Southeast Asia, President Lyndon Baines Johnson made water pollution a top priority. Six days after congratulating poet Carl Sandburg on his eighty-eighth birthday, LBJ delivered his State of the Union Address to the Congress and the American people. Johnson called for promoting trade with the Soviet Union and countries behind the Iron Curtain in eastern Europe. He also provided the Congress with an update on the military situation in Vietnam; he called upon the Congress to pass legislation outlawing housing discrimination to people of race. Then in his slow, deliberate Texas drawl, Johnson challenged the Congress "to end pollution in several river basins, making additional funds available to help draw the plans and construct the plants that are necessary to make the waters of our entire river systems clean, and make them a source of pleasure and beauty for all our people."[269] Johnson's speech is dated January 12, 1966. With midterm elections imminent and Johnson the incumbent and expected to run again for the presidency in 1968, he and the first lady made a campaign swing to Buffalo, New York, in August that same year.

The president gave a speech to a partisan gathering in Buffalo. In attendance were Governor Nelson Rockefeller, representatives Richard D. McCarthy, Thaddeus J. Dulski, and Buffalo Mayor Frank A. Sedita, as well as Chairman Joseph F. Crangle of the Erie County Democratic organization. After paying his respects to those in attendance, Johnson described the problem of water pollution in the nation's streams, rivers, and lakes. Johnson defined the federal government's mission by saying, "We are attacking head-on the massive problems of water pollution in the United States and I am glad to come here this afternoon and enlist under that banner."[270]

[269] Lyndon B. Johnson, *Public Papers of the Presidents of the United States, 1966* (in two books), (Washington: Office of the Federal Register, National Archives and Records Service, General Services Administration, 1967), p. 6.

[270] Ibid., p. 838.

It was Lake Erie, its shoreline joining the city of Buffalo, which would be the focal point of Johnson's remarks. The president challenged the gathering, stating, "The steady decline of Lake Erie is one pollution problem which I know has a special meaning to every person here."[271] The president described the magnitude of the problem, claiming the polluted Great Lake touched the lives of nearly twenty-five million people, including not only the residents of the city but those to the north in Canada as well. Johnson outlined a plan to save the lake. Spearheaded by the Department of the Interior, the Rand Development Corporation would build a new, innovative waste water treatment facility. Its purpose: to extract contaminants from water tainted with industrial waste and purify it to be recycled for human use. To educate his audience, Johnson explained what had caused the problem: The American spirit, ambition, and dream of moving westward for a better life dating from the days of Thomas Jefferson. Johnson declared, "And this is what we see in America today: a powerful drive to clean up the very problems that our progress has created. So much of American ugliness and impurity, so much of the contradictions of American life, are caused by just this: the eager and aggressive spirit by which we tamed this continent of ours. So, Lake Erie just must be saved."[272] The president addressed many of the themes of the environmental movement in that speech. The words he spoke that day was a clarion call, a moral imperative, a challenge to the American people and the nation's political parties to unite in a common cause for clean water for recreational purposes but, more importantly, to drink.

By the late summer of 1966, when LBJ gave his speech in Buffalo in his typical Southern Texas Hill Country accent, the Rust Belt of the urban-industrial complex in the upper Midwest and the entire country for that matter had been using the Great Lakes and the nation's vast water tributaries to dispose of industrial waste and raw sewage. The circumstances had not changed since the time of Upton Sinclair. For more than a century, Lake Erie had provided Detroit,

[271] Ibid., pp. 838–839.
[272] Ibid., p. 839.

Michigan, Cleveland, Ohio, Erie, Pennsylvania, and the greater Buffalo metro area with a convenient depository for liquid industrial waste and raw sewage. Erie, Pennsylvania, Buffalo, and more than 110 communities filled the rivers draining into the great lake with more than a million gallons of untreated industrial wastes and sewage daily. Excess fertilizer run-off from agricultural operations leached into the rivers as well. Time magazine's investigation into Lake Erie's demise succinctly in vivid detail summed up the chemistry. "These chemicals act as fertilizer for growths of algae that suck oxygen from the lower depths and rise to the surface as odoriferous green scum."[273] Noxious plants in this water fed upon chemical fertilizers which had run off or had been dumped into the water thrived, "turning water frontage into swamp."[274]

In effect, Lake Erie had become a convenient holding pond for the urban-industrial complex of the Great Lakes region. Cities joining the lake dumped 1.5 million gallons daily, a toxic mixture of waste water, which included nitrates, phosphorus, and human waste. Of the sixty-two beaches along Erie's lakeshore, fifty-nine were so polluted they remained closed, their once-enticing sandy beaches near refreshing cool water marked with signs reading "Unsafe for Swimming" or "No Swimming Allowed" by the authority of local health departments.[275] And the vibrant fishing industry which had provided commercial fishermen with a living and sportsmen the thrill of the catch had all but vanished. The disappearance of blue pike, cisco, walleye, whitefish, sturgeon, and the famous northern pike, which thrived in pure, fresh, cold water had given way to invasive species and less desirable species which flourished on less oxygen.[276] The harsh reality was, as we have noted, Lake Erie's waters were depleted of oxygen, a necessity for desirable game and market fish.

Standing along its shoreline near any urban area, you could see raw, untreated sewage, human waste, and even commercial fertilizers

[273] "The Cities: The Price of Optimism," *Time*, 1 August 1969, p. 41.
[274] Ibid.
[275] Ibid.
[276] Ibid.

spread by farms adjoining the lake and massive amounts of organic matter running into the water. Whether wastewater pumped in from an industrial site or, in the case of agriculture, fertilizer runoff after a hard rain, Erie suffered as a result. Oxygen necessary to breakdown such waste had been depleted to dangerously low levels, the result a chemical imbalance more often than not toxic to desirable, normal aquatic life. This chemical reaction caused oxygen depletion and a chemical process biologists call eutrophication, which caused the spread of algae blooms during hot summer months. The algae blooms eventually died floating to the lake's bottom, contributing to an organic overload. Levels of untreated sewage and industrial waste flowing from upstream into the lake from locations on the Detroit River, the River Rouge, the Cuyahoga River, and the Niagara River also contributed to Lake Erie's woes, were unprecedented. Aerial photography taken from two thousand feet above the lake's surface showed clear and convincing evidence of pollution; a lake once clear blue with a green tint had been replaced by a brown-orange swirl of contaminated liquid. One of America's natural treasures had become an open sewer.

President Lyndon Johnson and Lady Bird Johnson saw it. While Lyndon Johnson gets very little credit for his contribution to cleaning up the environment, his wife too goes virtually unnoticed as an environmental advocate. If Richard Nixon can lay claim to being America's environmental president, Lady Bird Johnson certainly was the country's environmental first lady. She supported with her husband's consent the Highway Beautification Act signed into law by LBJ in October 1965. She committed herself with his blessings to the crusade of regulating billboards along the nation's highways, which obstructed scenic vistas. She also promoted the seeding and planting of trees and wildflowers, which she had become so accustomed to near her birthplace in Texas, along highway right-aways. And by doing so, she helped reduce the cost to state highway departments which assisted in the beautification of federal and state thoroughfares. Like her husband, she witnessed the sorry condition Lake Erie was in. After the president's speech, the couple inspected the lake from the deck of a barge floating on the lake. With White House

staffers and the news media in tow, they inspected the Great Lake, which took no more than a couple of hours. The first lady, like many environmentalists at the time, realized water quality had to be placed among the nation's highest priorities. She reflected on the topic of conversation that day by saying, "The subject was the pollution of our lakes and rivers." The barge crew showed the Johnson's what Erie's water was like by dropping a bucket over the side of the boat and "swung it around onto this flat barge surface." She recalled that day. "We looked at it (the bucket of water) real close. It looked like sort of a mixture of ink and glue; all of that was waste that was being put into those waters. You could imagine that no fish could live in it, and no plant life either." She declared, "We just had to do something about cleaning up our world, or else we couldn't inhabit it…"[277]

The great body of water received high profile news coverage, so much so that by 1968 environmentalists had written the lake's obituary. Press coverage of the Cuyahoga River crises received equal billing by the national news media galvanizing public opinion like never before. Here is what happened. In July 1969, the river flowing through the city of Cleveland, Ohio into Lake Erie became so saturated with oil and flammable chemicals produced by the petroleum industry, it literally "burst into flames and burned with such intensity two railroad bridges crossing the river were nearly destroyed."[278] Cleveland's Cuyahoga had gained a reputation as the most polluted river in America. In 1912, another river fire killed five people; in 1952 a similar fire had damaged property resulting in losses totaling $1.3 million. Concerned as much about the publicity the incident generated as the pollution which caused it, Cleveland mayor Carl Stokes said, "What a terrible reflection on our city." Following the president's example, Stokes appointed Ben Stefanski the head of Cleveland's public utility and had him devise a program to clean up the Cuyahoga. First Stefanski issued one hundred million dollars in bonds investors would purchase to finance a state-of-the-art waste

[277] Michael L. Gillette, *Lady Bird Johnson: an Oral History*, (New York: Oxford University Press, 2012), p. 358.
[278] Ibid., "The Cities: The Price of Optimism," p. 41.

water treatment facility similar to the new one in Buffalo, New York; the bonds also financed an upgrade to existing facilities as well.[279]

Stefanski estimated the project would take five years. In the meantime unfortunately for the people of Cleveland, the city had no control over municipalities upstream. This dilemma Cleveland faced would be a microcosm of what city governments faced all over America. For as Time pointed out, similar circumstances existed in the Potomac River, the Missouri River, the Chattahoochee, the Merrimack, the Monongahela, the Milwaukee, the Niagara, the Delaware, the Rouge, the Escambia and Havasupi, and the mighty Hudson River, which ran through New York City.[280]

Some took it upon themselves to take action. Folk singer and political activist Pete Seeger took up the cause of cleaning up and preserving New York's Hudson River. The iconic waterway carved through wooded wilderness eleven thousand years before the late Pleistocene Epoch, had once linked the upper Midwest and Great Lakes with New York City by way of the man-made engineering marvel the Erie Canal. During the Antebellum period, the Hudson served steamboat packets plying the river's free water to New York City and Hoboken, New Jersey, gateway to the salt water of the transatlantic trade route circling the globe. The river's majestic beauty had inspired the imaginations of the Hudson River School of art and writers Washington Irving and James Fenimore Cooper who found inspiration in its natural beauty. Flowing south to scenic Tappan Zee near New York City, the river widens considerably to a distance of three miles. Generations were awed by the picturesque Palisades, a cliff which projects its shadow over the entire width of the river at dusk. In the nineteenth century, "the water was still clear. Ice cut near Kingston on the river tinkled in the glasses of New York restaurants. Sturgeon were common; the packing of this market fish was an important industry. They called the fish 'Albany beef.'" Its water was so pure Hudson River companies even exported caviar.[281]

[279] Ibid.

[280] Ibid.

[281] Pete Seeger, "To Save the Dying Hudson: Pete Seeger's Voyage," George Goodman ed., "The Tragic Misuse of a Majestic River," *Look* magazine, 8

By the time Seeger launched his sloop Clearwater into the river and began to flex his celebrity clout to draw the public's attention to cleaning up the Hudson, more than eight million New Yorkers were dumping more than 111 billion gallons of raw sewage into the river every year. Look magazine's George Goodman put into graphic language what he and Seeger had seen along the banks of the great river:

> From a communal drain for slaughterhouses near Troy, New York, a man-made tributary of chicken blood goes in. Oil from refineries and barges is so thick in places that mud is considered a fire hazard and cats walk away from the oil-soaked fish. When Consolidated Edison built a nuclear reactor at Indian Point (The facility is still in operation today.) in 1963, two million bass were reportedly killed. Shellfish are gone. The most visible victims of pollution, fish are only a link in a chain from microscopic life to man. When man is most productive materially, he is most destructive too.[282]

Scanning the American landscape, what Goodman and Seeger witnessed could have been any major river in the country at the time. Goodman went even further, condemning the wanton destruction of New York's natural treasure. His op-ed called for the people of the state to put pressure on Governor Nelson Rockefeller in Albany to take action and for federal intervention by the Nixon administration to clean-up the river. Goodman questioned the priorities of a nation which ignored the quality of its precious water resources at the expense of the price tag of massive defense expenditures on an intercontinental ballistic missile system and a war in Southeast Asia which seemed to have no end in sight.[283] Meanwhile, Seeger had set

August 1969, vol. 33, no. 17, p. 65.

[282] Ibid., p. 66.

[283] Ibid.

sail in the Clearwater to navigate the length of the river stopping at every village and town along its banks to draw attention to the plight of the Hudson and drum up support for his cause.

For Seeger, the decrepit condition of the great river was personal. Near its banks, he had made his home. On the Seeger property, a spring-fed stream ran so pure Seeger's family could draw from it to drink. But by 1969, waste water from an adjoining property where a paper mill existed flowed directly into the Hudson not far from the Seeger homestead in the vicinity of Glens Falls, New York. The pollution threat to Pete Seeger's property led the folk singer to take up the environmental cause. With his neighbors there in the Hudson Valley, Seeger had organized a political action committee he named Hudson River Sloop Restoration Inc. Hundreds of valley residents had joined Seeger by Earth Day, contributing time, money, and moral support to clean up the mighty Hudson River. By the spring of 1969, Seeger had undertaken a float trip. His plan—to sail the length of the Hudson on his ship Clearwater. His purpose: to generate publicity to the plight of the Hudson putting in to shore at every village and town doing benefit concerts to improve the quality of life in the Hudson River Valley. A man with a knack for putting together words in song, Seeger came up with a catchy jingle to promote his cause: "No beer maker backs this boat. You and I got to keep it afloat."[284]

Determined souls such as Seeger contributed significantly to the cause of environmentalism which resulted in the sentiment of a common cause within the American people who participated in the first Earth Day. Another was Michigan native Bil Gilbert, who as a writer penned articles for The New York Times, the Washington Post, Esquire magazine, the Smithsonian, and Audubon Magazine. A prolific journalist, Gilbert, whose first name had an unusual spelling, made most of his living writing for Sports Illustrated, a media outlet which rapidly gained popularity after its first issue hit newsstands in 1964. In 1968, Gilbert submitted an article he titled "Old Swimmin' Hole" to draw attention to a polluted stream in Greenfield, Indiana,

[284] Ibid., p. 65.

a place which the author had enjoyed as a child. Greenfield happened to be the birthplace of the poet James Whitcomb Riley; a plaque commemorated the place on the creek where Riley swam as a boy growing up in Hancock County. But by the time Gilbert's article appeared in Sports Illustrated near the idyllic place where Greenfield's people spent weekends and holidays leisurely picnicking under cool shade trees while children swam and splashed water from the creek, there were signs warning the public to "Stay Out—No Swimming, Wading, Danger, Disease," which lined the banks of Brandywine Creek.[285]

Brandywine Creek flows into the Blue River, a tributary of the Wabash and greater Ohio River south of Greenfield. Calling himself an ecologist, Gilbert's inspiration flowed from the typewriter of investigative journalist Dick Spencer, who managed and edited the local Greenfield Daily Reporter. Spencer's reporting was embellished by the photography of Dick Baumbach. The story is significant not only for its merits as environmental history of the period but also for its human interest. This occurring at a time when Sports Illustrated was gaining readership as a mainstream publication.[286] Running in an east-west direction across the Brandywine, Interstate 70 received rain, the highway's concrete diverting contaminated run-off, which emanated into ditches then into streams and rivers including Greenfield's "Old Swimming Hole." It takes little imagination to perceive this problem with highways created by the Interstate Highway System Act of 1956 creating the necessity of bridges across the length and breadth of the United States. Water run-off pollution was inevitable.

Even more destructive, a city landfill, a depository for garbage near the creek, had attracted a large infestation of rats which fed on the offal and solid waste refuse. Hancock County health inspector Dick Wilson purchased four hundred dollars' worth of rat poison spreading it strategically around the dump; the rats consumed the poison, died, and some of the dead rodents wound up floating in the

[285] Bil Gilbert, "The Old Swimmin' Hole," *Sports Illustrated*, vol. 29, no. 17, 21 October 1968, p. 72.

[286] Ibid., pp. 72–73.

creek along with the poison, which mixed with rainfall and inevitably found its way into the water children once enjoyed cooling off in on hot summer days. Dead rats could be seen floating in the same water the community had enjoyed as a picnicking venue. Gilbert reported a specialist from Purdue University had scheduled a visit to Greenfield to make certain the rat poison had been used properly.[287] In reality, by the decade of the 1960s, Brandywine Creek was a microcosm of America's deteriorating water quality problem in general.

Though not a scientist, Bil Gilbert saw the problem and wrote about it with clarity and objectivity. American society, bingeing on the prosperity of the postwar economy, really found it difficult to comprehend the immensity of the problem. To many Americans, Brandywine Creek was out of sight and out of mind. The people of Greenfield, Indiana, were no exception. Gilbert summed up what could be said about any small town in the Midwestern United States in 1968. Gilbert put it this way: "There is, in the end, no method, no instruments of analysis sufficiently sensitive to determine precisely the composition of the compound that flows down the Brandywine into the Old Swimmin' Hole. Generally, incompletely, however, it is a mix of water, silt, human, animal and industrial wastes highway drippings, fertilizers herbicides pesticides, soluble garbage, insoluble trash, dead rats, and live bacteria…this is the sort of broth that is the stock solution of most the rivers, lakes and estuaries of America."[288]

Hearing the public outcry of environmentalists such as Bil Gilbert and sensing a swing in the pendulum of public opinion, federal, state, and local governments would make the attempt to clean up America's dirty water by recycling it. Lyndon Johnson's Water Quality Act of 1965 would be a down payment, the first installment of what would be a multibillion dollar investment to clean up America's polluted water. As early as the winter of 1960, United States Senator Robert S. Kerr, an oil company executive before his political career, estimated it would take six hundred million dollars spread out over eight years to bring America's cities waste water treatment facilities

[287] Ibid.
[288] Ibid., pp. 73–74.

up to standard; the financial burden did not include outlying areas in America's rural heartland, nor did it include the country's rivers and streams or industrial polluters outside urban jurisdictions. Senator Kerr chairman of a senate select committee acknowledged America's polluted water problem, calling it a "fountain of death...a serious threat to our way of life...a major hazard to the national health as well as a major cause of the destruction of our fish and wild life."[289] Kerr, a red state Democrat from Oklahoma, feared the intrusion of federal authority into state jurisdiction and into the private business sector calling such an eventuality "totalitarian control." But Kerr faced reality and the challenge. "He noted that Soviet Premier Nikita Khrushchev has said that such major reforms cannot be done under a capitalist, democratic system." In the final analysis, Kerr realized pure drinking water to be desirable to address a national health problem: "He endorsed the view of federal responsibility in this area suggested by US Surgeon General Leroy E. Burney."[290]

Senator Kerr and the surgeon general knew water pollution threatened all living things everywhere in America. Like contaminated air, polluted water was a constant threat, stalking the public's piece of mind and sense of well-being. Industrial waste, raw sewage, and chemicals combined to create toxicity in the waters of America's streams and rivers. The lurid result: massive fish kills their total, numbering in the millions by April of 1970. Between 1961 and 1975, more than 465 million fish died in America's rivers, lakes, and streams from pollution the Environmental Protection Agency calls "low dissolved oxygen" syndrome. Typical was the case journalist Rusty Cowan reported in Sports Illustrated in the fall of 1961. Local fishermen were the first to report the kill. An investigation by state biologists and the Pennsylvania Fish Commission determined a pumping station along the Susquehanna River in Pennsylvania operated by the Glen Alden Mining Company had discharged tens of thousands of gallons of waste water laden with iron, sulfur, and

[289] "Fountain of Death," *Science News Letter*, vol. 78, no. 26, 24 December 1960, p. 418.
[290] Ibid.

other toxic minerals from its deep shaft mining operation into the river. Over a two-week period at least 116,280 walleye and other game fish had died, warranting an investigation by the Pennsylvania Fish Commission. The Commission determined the north branch of the "Susquehanna had been ruined for perhaps three years as a fishing stream."[291] There would be more incidents like the one on the Susquehanna. Many more.

Investigative journalist James Ridgeway, who along with young attorney Ralph Nader would question the road worthiness of the Chevrolet Corvair, authored the book *The Closed Corporation: American Universities in Crises*. Two months before the disappearance of civil rights activists James Chaney, Michael Schwerner, and Andrew Goodman in Neoshoba County, Mississippi, he submitted an article to The New Republic titled "Death on the Atchafalaya," an investigation into the effects of the chemical endrin on the aquatic life in the lower Mississippi River basin. Sightings of massive fish kills near Franklin, Mississippi, had been reported in the town newspaper the Banner-Tribune; barge crews and other water traffic plying the great river from New Orleans north to St. Louis, Missouri, reported seeing the ecological devastation on the lower Mississippi Delta.[292]

Comprised of wetlands, bayous, and freshwater streams, local Cajun inhabitants in the Atchafalaya River Basin made a living for generations fishing those waters for catfish, crab, crayfish, and Louisiana shrimp, which they marketed to suppliers servicing the restaurant trade in New Orleans. Word spread of the massive fish kill and the financial hardship inflicted upon Cajun fishermen along the Atchafalaya. Ridgeway explained, "Seven thousand fishermen once made their livelihood along the Atchafalaya's basin. Many of them can neither read or write. They live with their families on camp boats back in the swamps."[293] By the time Ridgeway's article went to

[291] Rusty Cowan, "The Mystery of the Walleyes and the Water," *Sports Illustrated*, vol. 15, no. 19, 6 November 1961, p. 26.

[292] James Ridgeway, "Death on the Atchafalaya," *The New Republic*, 25 April 1964, p. 13. William Souder, *On a Farther Shore: The Life and Legacy of Rachel Carson* (New York: Crown Publishers, 2012), p. 348.

[293] Ridgeway, Ibid.

press the estimated value of a single catch that year, which had been averaging $250 had plummeted to only $4. Some Cajun men had resorted to salvaging "dying fish" to sell to vendors who provided seafood and fish to restaurants.[294] Perplexed by the enormity of the fish kill and to determine its cause, Louisiana officials called upon the expertise of Public Health Service officials, a federal entity.

Ridgeway identified the cause: the chlorinated hydrocarbon endrin used by farmers to eradicate boll weevil infestations in the cotton fields and insects threatening the sugarcane crop. The insecticide had made it into the river by either crop dusting plane's spray or by way of rain runoff that leached into the Atchafalaya. As with the Atchafalaya the cause of many fish kills around the United States was readily identifiable: excessive use of chlorinated hydrocarbons. Efforts to bring about regulations from the federal government and more directly the state of Louisiana had been in vain. Lobbying by agribusiness interests and the chemical industry had stone-walled federal regulators. Subsequently, the Atchafalaya River watershed was at risk of pesticide contamination. Its wildlife population, including catfish, crayfish, shrimp, and birds such as cranes, songbirds, ducks, the alligator and otter populations also decimated by poisoning. The year 1964 was not an aberration. In 1960 alone, more than three million fish died in more than thirty different locations in Louisiana alone; publicity from the devastating effect on wildlife had generated twenty-seven different reports from the US Public Health Service.[295]

On May 16, 1963, Senator Abraham Ribicoff of Connecticut convened a Senate subcommittee to investigate and vent the findings of the president's Science Advisory Committee established by Kennedy to investigate Carson's findings. Rachel Carson would testify along with numerous scientific experts and government regulatory officials. Ribicoff, one-time Secretary of Health, Education, and Welfare in the Kennedy administration, would become famous for his face-off with Chicago Mayor Richard Daley during the Democratic National Convention in 1968 and his reference to the "Gestapo tac-

[294] Ibid.
[295] Ibid.

tics" of law enforcement in Chicago's streets in his convention speech that summer. James Ridgeway included a brief excerpt from the testimony of Food and Drug Administration head George P. Larrick in his article. Ribicoff requested to know if the agency had a zero tolerance for pesticide contamination in fish supplied to markets and restaurants. Larrick, in a measured response, replied the federal agency set the standard at zero tolerance, testifying, "We haven't found any yet in interstate commerce. We are sampling interstate commerce."[296] Dr. Clarence Cottam, once head of the US Fish and Wildlife Service, prophesied, "We're going to find human beings dying of this thing unless we act with intelligence now." Interior Secretary Stewart Udall believed the case to be strong enough against endrin that a ban on the manufacturing, sale, and domestic use of the chemical was in order.

Ridgeway included the pushback from the chemical industry as well. Kennedy's Secretary of Agriculture, Charles S. Murphy, in a letter to The New York Times, said the department "does not conduct its regulatory functions on the basis of probabilities, iffy conjectures, likelihoods or presumptions—all of which he said were present in the Mississippi fish kill matter."[297] Parke C. Brinkley of the National Agricultural Chemical Association testified during the congressional hearing, "The great fight in the world today is between Godless Communism on the one hand and Christian Democracy on the other. Two of the biggest battles in this war are the battle against starvation and the battle against disease. No two things make people more ripe for Communism." Bringing the Cold War analogy to its logical conclusion, Brinkley declared, "The most effective tool in the hands of the farmer and in the hands of the public health official as they fight these battles is pesticides."[298] Despite Rachel Carson's case and the evidence in the waters of the Atchafalaya to the contrary, spokesperson Sumner Hatch McAllister of Shell Chemical

[296] Ibid., p. 14. And US Federal Government Responds/Environmental & Society Portal__www.environmentandsociety.org/exhibitions/silent.../us-federal-governmemnt-responds__Virtual Exhibitions, no. 1__Rachel Carson Center for Environment and Society, 2012 Mark Stoll.

[297] Ibid.

[298] Ibid., p. 14.

Company, a major supplier of endrin, remained steadfast. McAllister stated emphatically, "No reputable scientist has expressed the view that parts per billion of aldrin, dieldrin or endrin in our environment constitute a public health hazard." He went even further by warning, "To continually belabor this point, there is evidence to support the assertion, could induce a form of hypochondria in the American people."[299]

Ribicoff's committee investigation drew upon testimony from Assistant Secretary of Health Education and Welfare James M. Quigley, who emphasized he would be hesitant to eat a gulf-fished shrimp cocktail at a New Orleans restaurant. This view, qualified by Assistant Surgeon General Dr. James M. Hundley, who testified he believed the threat to "drinking water and seafood was probably very small." Hundley did say, "he would not hesitate to eat the shrimp cocktail, though a diet of nothing but catfish would be [in his words] 'most inadvisable.'" When informed catfish made up a considerable percentage of the people's diet living in the Louisiana bayou, Dr. Hundley equivocated. When asked "What [amount of endrin] would be lethal to human beings?" Hundley responded, "'I do not know the answer... I don't know that an answer is available."[300]

Shortly after the Ridgeway article, things changed. In 1965, the job of collecting data on fish kills shifted from HEW to the Department of the Interior. In fiscal year 1964 alone, a total of more than eighteen million fish were reported killed in forty-five states, a record total at that time. To determine sources of pollution and manage collecting fish and game deaths from the various states, the Department of the Interior created the Federal Water Pollution Control Administration.[301] The staggering death toll of fish and aquatic life in general, which died in America's waterways during the 1960s in the minds of environmentalists was the collateral dam-

[299] Ibid.

[300] Ibid.

[301] US Department of the Interior, *Pollution Caused Fish Kills in 1965*, Sixth Annual Report (Washington, DC, Government Printing Office [GPO], 1965), Chart: Historical summary of pollution-caused fish kills, June 1960–December 1965, p. 7.

age of what the chemical manufacturers advertised as "Better Living through Chemistry."[302] As we have seen, most of these kills circulated through the headlines of major newspapers around the country. News of massive fish kills also appeared in outlets such as Time, Newsweek, US News and World Report, and even Sports Illustrated. All were immensely popular at the time and gaining readership market share by the month. Copies of the annual kill reports could be purchased by the public from the Superintendent of Documents by way of the US Government Printing Office for twenty-five cents.

And the carnage continued unabated. The year 1968 was typical of that turbulent decade. The Federal Water Pollution Administration recorded more than fifteen million dead fish in 1968 an increase of more than 30 percent than the reported kill in 1967. Of the more than four hundred incidents that year, the single costliest kill occurred in the Allegheny River near Bruin, Pennsylvania, The pollution source: an oil refinery holding pond which flooded into another holding lagoon. The lagoon's earthen banks collapsed, spilling toxic waste water into a nearby stream, forming foam drifts in the water measuring six feet in depth. [303] The Allegheny incident was typical. The year 1969 would be the single most deadliest year of the sixties with more than forty-one million fish reported dead of some source of pollution or another. From 1961 to 1970, 201 million fish died in American waters, the photographic evidence sometimes making headlines on a national level.[304] Highlights of these reports from 1960 to 1970 demonstrate the deadly impact of chemical pollution upon nature and the glaring need for reform and governmental accountability at the state and federal level demanded by environmentalists who participated in Earth Day.

FWPCA officials recorded more environmental atrocities. Many were committed unknowingly by naive polluters going about

[302] Ibid.

[303] US Department of the Interior, *Pollution Caused Fish Kills, 1968*, Federal Water Pollution Control Administration (Washington, DC: GPO, 1968), p. 1.

[304] Environmental Protection Agency, Office of Water Planning and Standards, Fish Kills Caused by Pollution: Fifteen-Year Summary (Washington, DC: National Service Center for Environmental Publications, 1978), pp. 7–8.

their daily routine, as usual without forethought or unlawful intent. Others, motivated by simple greed, were blatant acts of careless, calloused indifference toward nature and wildlife, their irresponsible actions having a devastating effect upon the natural world. Precise locations of incidents and the names of the individuals and companies involved were obfuscated in the official record. Some incidents admitted to the record are revealing. Examples include more than "five thousand rainbow and brook trout" perished when a herbicide washed into a farm pond from a nearby field. "The eyes of the fish were white prior to death. The fish gasped and struggled at the surface before succumbing," according to an eyewitness at the site. A ruptured gasoline pipeline contaminated one waterway then flowed into an adjoining stream, "killing all marine life in its path." FWPCA inventoried the kill, which "included frogs, crayfish, salamanders, and muddlers" and more than sixty-two thousand fish of various species. The report concluded, "Efforts are being made to recover damages for the fish killed."[305] As previously noted, the precise locations of the kills were never recorded, nor were the suspected sources of the pollution.

Similar to 1968, reports recorded in 1962 seem to have been an exceedingly deadly year in American waters. Massive fish kills were not confined to rivers, lakes, and streams. Some occurred on both the Atlantic and Pacific coasts as well. In August that year, a kill near the entrance to San Diego harbor around North Island jetty warranted media coverage. The California game warden determined fish oil mixed with mineral spirits used in the manufacturing of paint caused a massive catastrophe. The Public Health Service report stated, "Measurements of the dead fish [anchovies] deposit were 1,000 feet by 10 feet wide with an average depth of 3 feet. At 63 pounds per cubic foot and 20 fish per pound, this amounts to 945 tons or about 37,000,000 fish."[306] Sharks attracted by the kill lurked offshore not far from the historic Hotel de Coronado; the decaying, smelly ancho-

[305] Ibid., pp. 4–5.

[306] US Department of Health, Education, and Welfare, *Pollution-Caused Fish Kills in 1962* (Washington, DC: GPO, 1962), pp. 3–4. And "70 Tons of Fish Washed Ashore," *The San Diego Union*, 25 August 1962, p. 1.

vies dozed into trenches which stretched for a half mile covered up in the ninety-five-degree heat by city sanitation workers and naval personnel.[307]

On the east coast, in the midst of the national coverage of Governor Ross Barnett's attempt to bar James Meredith from admission to the University of Mississippi, the east coast PHS received information of a kill in Anacostia River near the nation's capitol. In September 1962, an estimated 3,180,000 fish died within walking distance of the downtown Washington, DC, metro area. The culprit pollutant: raw sewage amounting to more than forty million gallons "were dumped into the river briefly in mid-September during an interruption in the sewage system by construction on the Anacostia freeway."[308] Kills were reported on a standard form, which included information on the general location of the incident, parish, county or state, and the nearest populated area; the type of water, whether it be fresh or salt water; the pollution source classification, whether it be industrial, agricultural pesticides, or commercial fertilizers, or sewage leak. The type of fish killed were also recorded as were suggestions for "corrective action" and general comments in addition to a section of the form with the heading "Significant Changes in Aquatic Food Organisms."[309]

Coverage of such news oftentimes appeared on network television, which, at that time, included just three channels broadcast by CBS, NBC, and ABC. Such broadcast journalism brought the American public face-to-face with water contamination around the United States. Municipal sewerage system failures, which included municipal sanitary and storm sewer water mostly untreated, was the most frequently reported cause followed by food product pollution, insecticides, power source pollution, or combinations thereof. This massive fish carnage antagonized not only environmentalists but drew the ire of conservationists, sportsmen, and the general pub-

[307] 42 US Department of Health, Education, and Welfare, *Pollution-Caused Kills in 1962*, ibid.

[308] *Pollution-Caused Fish Kills in 1962*, p. 4. and "Smelly River, Fish Kills Due to Drought," *The Washington Post Times Herald*, 20 September 1962, p. B-8.

[309] Ibid.

lic who enjoyed outdoor recreation in the bodies of water affected. Established by George A. Griffith, Trout Unlimited's membership consisted of professionals in the legal and medical professions with deep pockets; the organization not only lobbied for a tougher Clean Water Act on the part of the federal government but also advocated the removal of dams, which obstructed the spawning of game fish in the country's spring-fed, cold-water watersheds across the country, particularly in the higher altitudes.

Such flagrant disregard for the natural world and deteriorating water quality disturbed Gaylord Anton Nelson. As a child, Nelson had spent countless afternoons and summer vacations walking the shores of Lake Superior. He too could see what was happening to America's lakes, rivers, and streams. Among environmentalists, Lake Erie's condition had become common knowledge, as we have seen. In what can best be described as prose with a sense of urgency, Nelson warned of the impending threat to all of the country's water resources. Whether it be wetlands along the Gulf Coast, the nation's rivers and streams, or the Great Lakes, Nelson, like many environmental activists, stressed improving water quality. He singled out the causes of water pollution: a rapidly expanding population, unregulated industrialization, and conspicuous consumption by American consumers. All had contributed to the problem. Nelson, like many environmentalists, also blamed excessive pesticide use, which made its way into rainwater runoff.[310]

Nelson elaborated further: "Every major river system in America is seriously polluted, from the Androscroggin in Maine to the Columbia in the Pacific Northwest. The rivers once celebrated in poetry and song—the Monongahela, the Cumberland, the Ohio, the Hudson, the Delaware, the Rio Grande—have been blackened with sewage, chemicals, oil and trash."[311] He singled out the Monongahela claiming the watershed which draws from remote areas of West Virginia and western Pennsylvania deposited every year on average

[310] Gaylord Nelson, *America's Last Chance* (Waukesha, Wisconsin: Country Beautiful Corporation, 1969), p. 28.
[311] Ibid.

approximately two hundred thousand tons of toxic sulfuric acid into the Ohio River, a riverine which provided drinking water for millions of people living along its shores. Though Nelson's calculations in numbers of fish killed and pollution tonnage were often suspect, the sentiment of public opinion and what he said were not in doubt.

A possible run for reelection in 1964 and the issue of water quality, protecting, and conserving the nation's natural resources brought John F. Kennedy to Wisconsin, a key swing state, once a Republican stronghold. In November 1962 with the Cuban Missile Crises resolved, newly elected United States Senator Gaylord Nelson approached the president's brother Attorney General Robert Kennedy, suggesting his brother embark on a "national tour" focusing on conservation. Nelson used the Outdoor Recreation Act Program he had signed into law as Wisconsin's governor to persuade the president's brother conservation and the issue of improving water quality to be "good politics." In doing so, Nelson believed the issue of environmental quality could be placed on the docket and made a priority on the president's agenda to gain political traction with the issue.[312] With the approval of the president's brother and White House staffers Lee White, Mike Manatos, and Larry O'Brien, Kennedy embarked on a weeklong "conservation tour" touting the recent Senate ratification of the Limited Nuclear Test Ban Treaty he had brokered with Soviet Premier Nikita Khrushchev a month before.

Beginning with a campaign-style swing in Washington on September 24, the president covered eleven states including Wisconsin. Accompanying the president were four Democratic senators, including Pennsylvania's Joseph Clark; Minnesota's Hubert Humphrey, the future vice president; and Democratic Senator Eugene McCarthy, as well as Nelson. Air Force One had an entourage of no less than fifty members of the press including correspondents from television networks NBC, CBS, and ABC.[313]

[312] Bill Christofferson, *The Man From Clear Lake: Earth Day Founder Senator Gaylord Nelson* (University of Wisconsin Press: Madison, Wisconsin, 2004), p. 175–177.

[313] Ibid,. p. 180.

An essential life-giving element on Earth, it seemed water made it onto everyone's priority list by Earth Day. Nelson biographer Bill Christofferson dedicated a brief chapter in his book to water and the Wisconsin senator's efforts to restore water quality. Nelson focused his political energy on reducing detergent pollution. Eventually, biodegradable would replace traditional laundry and industrial grade detergents in the American marketplace. In post–World War II America, "the foam, primarily from dish and laundry detergents used in homes, businesses, and commercial laundries, was sometimes five to ten feet high, floating down the rivers and over the dams."[314] Unsightly to say the least, alkyl benzene sulfonate "passed right through septic systems or municipal treatment plants and into lakes, streams, groundwater, and wells, producing the foam." Traces of the chemical turned up in drinking water samples. Nelson introduced legislation, which would ban detergents composed of ABS by June of 1965. Manufactured in bulk by large industrial conglomerates Proctor and Gamble, Colgate-Palmolive, and Lever Brothers, the Soap and Detergent Association represented a formidable lobbying force plying its trade in the nation's capitol.[315] Though it never became law, Nelson's legislation coincided with publicity generated by newspaper and periodical reports of massive fish kills and Lake Erie's condition, which deteriorated by the day. This galvanized public opinion.

More personal than the headline news of Lake Erie and the fiery Cuyahoga, residential water quality had become an issue by Earth Day. It is one of the main components of Adam Rome's *The Bulldozer in the Countryside: Suburban Sprawl and the Rise of American Environmentalism*. By Earth Day 1970, residential development had occurred because of American culture's headlong rush toward modernity after World War II. Of all the leading economic indicators, new housing starts had generated wealth and provided a growing population with shelter. Sensing a business opportunity in the postwar period, William Levitt designed a plan to build houses

[314] Ibid., p. 213.
[315] Ibid., pp. 214–215.

in assembly-line fashion. Single family units built with generic wood would be constructed and sold at a reasonable price to accommodate the growing demand for housing near Hicksville, Long Island after the Second World War. There, more than ten thousand single-family homes sprang up within a matter of months. The landscape around Hicksville would be replicated hundreds of times across the United States during the post war years. Much of the financing for the purchase of a new home came from the federal government, particularly in the GI Bill of Rights which accommodated veterans who had been drafted into military service during World War II or the Cold War.[316]

Home builders across the country cashed in. Based on the Levitt paradigm, multiple housing developments sprang up on cheap land in rural areas within reach by car of urban areas where the jobs were. Demographers and sociologists call this urban sprawl, a phrase used by environmentalists to sensationalize and draw attention to this cultural phenomenon. And this, in logical progression, gave rise to another demographic phenomenon, the baby boom generation, a dramatic increase in the number of children born between 1945 and 1965. Giving a financial boost to home builders, the federal government and states provided funds for massive highway projects connecting rural areas to urban areas where homeowners worked. And always preceding such housing builders was the ubiquitous bulldozer and chainsaw, laying waste to pristine rural scenery and everything in their path.

Even before the exterior paint dried on the first Levittown subdivision, federal officials began to monitor and measure the environmental impact of housing development. The US Geological Survey, fish and game officials and soil conservation agents began measuring water quality. Environmental problems occurred in the form of below-ground septic systems. With no city sewage systems extending out into suburbia, home builders including William Levitt sought

[316] Adam Rome, *The Bulldozer in the Countryside: Suburban Sprawl and the Rise of American Environmentalism* (New York: Cambridge University Press, 2001), pp. 15–18.

an expeditious, cheap method to manage sewage disposal for single-family dwellings.[317]

Septic tank waste water oftentimes contaminated ground water in wells, from which families drew drinking water with less than pleasant consequences. Raw sewage and nonbiodegradable detergents leached into well water used for drinking water, in the kitchen and for bathing. Such sewage systems required constant, labor-intensive maintenance; septic systems even caused landslides where leaching permeated shale-based soil covering hilly terrain. Not surprisingly, this aroused neighborhoods in predominantly rural areas in suburban developments by April 1970. By then, political action groups began to insist upon building codes to restrict, regulate, or ban septic tank use altogether.[318]

But the most destructive force was the bulldozer, the mantra of Rome's book. Always moving, snorting diesel fumes, clanking, and destroying everything in its path, this was the machine in the garden the main tool in the tool chest of builders and real estate developers. The bulldozer always preceded the mass movement of the postwar population to their homes in suburbia. And this cultural transition which resulted in urban sprawl led to the disappearance of something Adam Rome calls open space—pristine farmland, country scenery, and natural wilderness, the habitat for wildlife. Housing developments in the United States today occur with little or no regard for the aesthetic beauty or spatial quality of the natural world. As if to replace that which they had laid waste to, home builders landscaped residential family dwellings with new tree plantings the flora and fauna the bulldozer had destroyed. In so doing, they try to recreate that which they had undone.[319]

Consequently, the federal government because of public pressure began to subsidize sewage treatment systems matching state and local funds for such projects. The sudden conversion of Congress and the administration of Lyndon Johnson to clean up America's water

[317] Ibid., pp. 87–118.
[318] Ibid.
[319] Ibid., pp. 119–152 and 153–154.

would culminate in Henry "Scoop" Jackson's introduction onto the floor of the Senate the National Land Use Policy Act. This legislation placed the burden of reasonable land use in environmentally fragile areas upon the states. Jackson's law faced a formidable headwind from landowners and developers who grounded their opposition on the time honored tradition of private property rights. The NLUPA never became law. Nonetheless, Jackson's legislation was indicative of the mood in the country at large regarding unregulated real estate development.[320] The times they were a-changing in the public's mind on environmental issues.

Sensing this seismic shift in the national consciousness on environmentally sensitive issues, President Richard Nixon placed cleaning up the country's rivers, lakes, and streams at the top of his political agenda. The thirty-seventh president identified the major sources of water pollution in a letter to Congress dated February 10, 1970. In it, Nixon addressed soil erosion, commercial fertilizers, municipal sewage, pesticides, and industrial waste water as sources of the problem. Claiming agricultural pollution to be the most problematic to control, Nixon stressed his administration had confronted the problem of water pollution head-on, having taken steps to phase out DDT and other toxic chemicals; his administration had taken steps to implement regulations controlling leaching from commercial feed-lot operations into America's waterways. The president boldly proposed spending ten billion dollars over a five-year period to accomplish his objective by building waste water treatment facilities in urban areas near vulnerable waterways. Nixon's letter "Special Message to the Congress on Environmental Quality" represented a significant shift in the chief executive's vision for the nation. Cleaning up the nation's water supply topped a list of environmental issues, which included solid waste disposal, industrial pollution, improving air quality and improving public parks and recreational facilities.[321]

Nixon's proposal to Congress received a review from journalist Gladwin Hill. Writing for The New York Times Hill expressed con-

[320] Ibid., pp. 236–253.
[321] http://www.presidency.ucsb.edu/ws/?pid=2725.

cern for the deteriorating condition of the environment long before it became fashionable to do so. Though he lived in Los Angeles, Hill spent much of his time commuting cross-country to New York City where he reported for the Times. Always fastidiously dressed in a Brooks Brothers' style suit and bow tie, Hill had covered the Normandy invasion for the Associated Press; he had the distinction of being one of the first Western journalists to enter Berlin, Germany, in the spring of 1945. He developed a friendly rivalry with fellow war correspondent Walter Cronkite, who reported for United Press International.

Four weeks before Earth Day, Hill identified three obstacles that could complicate the formidable environmental task Nixon proposed. First, the country's water quality had deteriorated significantly over a ten-year period by early 1970; second, new sources of water contamination which complicated matters, in particular, pesticides used by fruit and vegetable growers; and lastly, Nixon's proposal depended greatly upon Congress, which in early 1970 was controlled by the Democratic Party.[322] At the heart of the plan to clean up America's water, Hill implicitly identified federalism: the system of authority to do the job shared by the states and the federal government. It would take a team effort with the large urban areas sharing a portion of the burden. Through arbitration state and federal authorities, Hill claimed, "Fifty formal abatement actions have been instituted, involving most of the states, two thousand communities and two thousand industrial sources." Though there had been no water-related threats to human health, Hill objectively identified a disturbing trend. "In the last two decades, waterways became so overburdened with fluid refuse as to point toward only one conclusion: a day not far off when rivers and lakes would be nothing but open sewers."[323] Such thinking was paramount in the minds of those who gathered to celebrate renewal of the commitment to a cleaner water, and a healthier America on April 22, 1970.

[322] Gladwin Hill, "Purification of Nation's Waters Expected to Be Long and Costly," 17 March 1970, p. 1.

[323] Ibid., p. 29.

Environmental Radicalism

I n the late winter of 1970, Rolling Stone magazine ran advertise-
ments for the environment-friendly publications Earth Times
and Ramparts. Rolling Stone magazine focused primarily on the
youth counterculture and rock-and-roll music intermingled with the
occasional editorial commentary from the likes of Timothy Leary
and Allen Ginsberg. Ramparts, one of the most radical publica-
tions of the day, had a distinctive cutting edge to its presentation.
Antiauthoritarian, anti-capitalism, and antiestablishment, the May
edition of Ramparts just after Earth Day featured a cover page with
a red-and-yellow negative photograph of a burning building and a
caption below it which read, "The Students Who Burned the Bank
of America in Santa Barbara May Have Done More Towards Saving
the Environment Than All the Teach-Ins Put Together."

The editorial staff billed the May 1970 issue as the "Ecology
Special." Its theme heralded a militant, antiestablishment point of
view. In retrospect, Earth Day marked the beginning of a more mil-
itant, violent phase of student protests during a social revolution,
which began with the Civil Rights movement, then moved to the
streets of Chicago during the Democratic Convention of 1968 and
ended with the campus protests after the United States military inva-
sion of Cambodia in the spring of 1970. Earth Day is oftentimes
characterized as a "kumbaya" moment by environmental historians

in an otherwise tumultuous period of social and political upheaval in American history. A closer look reveals there was much more to the original Earth Day than parades, street theatre, and speeches. That more militant edge of this event and how it took shape is the subject of this chapter.

The decade of the sixties played out like a Greek tragedy. An apocalyptic war with no end in sight. An American president murdered in Dallas, Texas, and many of America's inner cities burned with more than one hundred race riots, leaving entire neighborhoods in charred ruins. The assassination of Civil Rights leader Dr. Martin Luther King Jr. in Memphis, Tennessee. The murder of presidential candidate Robert F. Kennedy in a Los Angeles hotel. Demonstrations in the streets of Chicago during the 1968 Democratic National Convention. All left an indelible scare upon the collective memory of those who lived during those tumultuous times. If Rachel Carson's book *Silent Spring* happened to be the manifesto of the environmental movement, the Santa Barbara oil spill had to be its Lexington and Concord, its Triangle Shirt Waist Factory fire, its Pearl Harbor. Peering out the window of a commercial airline flight from Los Angeles to San Francisco, during the summer of 1969, Wisconsin Senator Gaylord Nelson came face-to-face with the Santa Barbara catastrophe. Watching the television news Nelson witnessed firsthand the once pristine sandy beaches of the California community on the Pacific coast covered in black crude oil. Nelson saw the cleanup effort, the utter devastation it brought to the natural world, its sea birds and sea mammals on the beaches of Santa Barbara and coastal waters.

Sickened by what he saw, Nelson had an epiphany. He envisioned using the anti-war teach-in concept being used to promote environmental activism. In such a way, Nelson believed the public's awareness and, subsequently, the American consciousness could be lifted to a higher level of environmental awareness. From this vision, the idea of Earth Day was conceived.[324]

[324] Bill Christofferson, *The Man from Clear Lake: Earth Day Founder Senator Gaylord Nelson* (Madison, Wisconsin: the University of Wisconsin Press,

With California Republican congressman Paul McCloskey by his side, on the evening of September 20, 1969, Nelson launched his Earth Day idea at a meeting of the Washington Environmental Council in Seattle, in the auditorium of the Pacific Science Center, "Nelson said he would be leading a movement to set aside a day for scientists, public leaders, students and faculty to discuss the problem." The Wisconsin senator called for no more and no less than an awakening of the American people to solve America's environmental problems; he "called for a national teach-in next spring on every university campus in the nation."[325]

Calling students to action, he warned if they did nothing there would be nothing left for future generations. Nelson then took solace in the younger generation, praising them for taking on the causes of the day: "I am convinced that the same concern for the youth of this nation took in changing this nation's priorities on the war in Vietnam and on Civil Rights can be shown for the problems of the environment." He then called for the same sense of urgency and financial commitment by the country on cleaning up the environment as the country had committed to defense spending, an explicit reference to the Pentagon's budget earmarked for the war in Southeast Asia.[326] Building upon the warnings in *Silent Spring*, Nelson had introduced a law which would ban the use of "pesticides and herbicides." Nelson also prophesied what would come to pass with the creation of a cabinet-level environmental regulatory agency. "'You must have a body of scientists to delineate the problem,'" Nelson said. 'Then you give political organizations the tools to fight with the views of a distinguished body."[327] The Wisconsin native had reservations about the effectiveness of Nixon's newly created Environmental Council. Nelson called it "nonsense," the notion the Secretary of Agriculture "could be a leader in the fight against pesticides." Taking a more mili-

2004), p. 302. Robert Easton, *Black Tide: The Santa Barbara Oil Spill and Its Consequences* (New York: Delacorte Press, 1972), p. 224.

[325] "World's Ecology In Peril, Says Solon," *The Seattle Times*, 21 September 1969, p. 92.

[326] Ibid.

[327] Ibid.

tant posture, Nelson echoed the Malthusian thinking of Paul Ehrlich when he labeled overpopulation a "fundamental problem. We've been unable to sustain two hundred million people in this country without desecrating it." He singled out humanity by calling man "an arrogant creature who sets himself above nature's scheme of things. He feels he has the right to spoil the environment for all other creatures but forgets than in doing so he is spelling his own doom."[328]

What Gaylord Nelson realized is there are moments in history after which everything changes. Nothing remains the same. Sensing a shift in public opinion toward the Vietnam War and environmental issues, Nelson knew the moment in time had come to leave a lasting impression on the American consciousness. What had changed? Here is a retelling of what happened that made Earth Day a historical inevitability.

Tuesday morning, January 28, 1969. In the coastal waters off the California coast near Santa Barbara at approximately 10:45 a.m., the roustabouts and roughnecks on the offshore oil platform of Union Oil Company's A-21 well were in the process of removing seven ninety-foot sections of drill pipe from the ocean floor more than 3,400 feet down, disconnecting each length of pipe as it extended to the platform deck high above the ocean's churning surface. Drill crew member Bill Robinson noticed the sound of gas escaping from the eighth section of pipe and immediately "dark gray mud mixed with gas" shot more than one hundred feet into the air covering the oil crew below. Santa Barbara local Robert Easton described what happened next: "The crew hastily finished disconnecting the eighth stand and set it in the racks. As they did so, mud and gas shot with a deafening roar from the open pipe at their feet and rose twenty feet or more into the derrick. Well A-21 had blown out, and the largest disaster of its kind to that point in United States history had begun."[329] Only the Deepwater Horizon blowout of April 2010

[328] Ibid.

[329] Robert Easton, *Black Tide: The Santa Barbara Oil Spill and Its Consequences* (New York: Delacorte Press, 1972), p. 8. Ross MacDonald and Robert Easton, "Santa Barbarans Cite an 11th Commandment: 'Thou Shalt Not Abuse the Earth,'" *New York Times Magazine*, 12 October 1969, sec. 6, p. 142.

has eclipsed the Santa Barbara spill in volume of oil lost and loss of human life. Though no human lives were lost in Santa Barbara, the spill of three million gallons of crude oil and resulting loss of animal life and visible scars on nearby beaches was significant. Once he saw the utter devastation of the pristine ocean shoreline and the spill's impact upon wildlife, Gaylord Nelson realized the same fate might be in store for his beloved Lake Superior. Hence another reason for planning a day to commemorate and protect the Earth.

For Santa Barbara more than any other event forced not only California but the entire nation to take an objective look at environmental quality making Earth Day possible. It is one of the defining moments in the history of the American environmental movement. And Nelson fully realized this and sensed a massive shift in public opinion and the American public's resolve to express themselves on environmental problems which they believed the government should address. This also was one catalyst which drew Life magazine's editorial staff to cover the oil spill and its immediate aftermath. Far from being a radical publication, the magazine's coverage added more weight to the argument the natural world should be protected from environmental degradation. Life reporter David Snell arrived in Santa Barbara less than five months after the blowout with renowned photojournalist Harry Benson. Their collaborative effort appeared in print in Life on June 13, 1969. Benson's photographs accentuated Snell's narrative, the duo collaborating to create a stunning achievement in the environmental iconography of the period. Benson, the Scottish-born artist, deserves special recognition for his photographs of the period. His artistry includes the Beatles' pillow fight in the George V Hotel in Paris in 1964, the James Meredith Civil Rights march in Mississippi in 1966 and Robert F. Kennedy's campaign for the presidency in 1968. Benson's camera seemed to be ubiquitous during that eventful decade.

Off the coast of California near Santa Barbara, aboard a fishing boat covered in oil from bow to stern, the Snell and Benson team made their way through the muck to San Miguel Island one of four islands in the Santa Barbara Channel. The rancid smell of oil mixed with salt water filled the sea air around them. Reaching the island

shoreline for the fishing vessel in a dinghy, the Life team investigated the impact the spill had had upon the island's rookery, the place pinniped females bore their pups then mated with bulls, completing the cycle for life to begin anew. The seal population during the summer of 1969 was estimated to be in excess of fifteen thousand, according to California wildlife officials.

Those who observed seal migration patterns and Life's photographic evidence at the site indicated oil sludge had had a catastrophic impact upon their number. Female seals, the cows, identified their young by smell; pups identified their mothers in kind. The chemical smell of oil left many of the female seals unable to identify their young, causing many pups to die of starvation. Seal pups numbering in the hundreds died that summer. David Snell explained it this way:

> All things being in balance, the little sea lion might have been expected one day to stake his own territory and mating claims. But things are not in balance on San Miguel. In a harsh and ugly disruption as ever was inflicted upon a harmonious environment, the oil tide had altered many of nature's subtle mechanisms among them the scent which identified the pup to his mother. As a result he and many like him would die. While we stood around and pondered his plight, another odor met our nostrils, borne upon the wind and more sickening than that of the oil. It was the stench of death.[330]

Snell's narrative focused on more than the wildlife of San Miguel. He anguished over Big Oil's cavalier attitude toward the fragile geographic condition of the plate tectonics in the Santa Barbara Channel. During the summer of 1968, seismologists recorded no less than sixty-six oceanic tremors; that fact alone was cause for Snell to

[330] David Snell, "Iridescent Gift of Death," Life, vol. 66, no. 23, 13 June 1969, p. 24. (Photographs by Harry Benson.)

question the judgement of a presidential panel appointed by Richard Nixon which he believed would decide in favor of Big Oil and approve further drilling for oil in the Channel. Snell documented the financial loss of market fishermen, many of whom faced bankruptcy and financial ruin without the fish they depended upon for their livelihoods. He objectively assessed the authorities, who approved signing legally binding leases with the oil companies: Secretary of the Interior, Stewart Udall, and his successor, Nixon appointee Walter Hickel. Drilling for oil in the geographically sensitive channel was risky business, and Udall knew it. Later, Udall would regret signing such leases, calling it one of the greatest mistakes of his life. Both Udall and Hickel were legally bound to honor oil leases, and in the case of Udall's boss Lyndon Johnson, the financial proceeds earned from Big Oil helped finance the Vietnam War.[331] This fact alone gave cause for protest and the radicalization of the environmental movement.

Death surrounded the landing party on San Miguel. Accompanying Snell and Benson that day were the environmental writer for the Santa Barbara News-Press, Dick Smith; his college-aged daughter, Judy; zoologist Jodi Bennett; and US Fish and Wildlife's on-site observer, Bob DeLong. Snell's reporting touched the hearts and minds of the millions who picked up a copy of Life from their local newspaper kiosk and read it. The landing party surveyed the desolation around them, and Snell reported, "At water's edge on the channel beaches the blight of oil extended in both directions as far as the eye could see, a slippery, stifling belt of tarry blackness the width of a tidal ebb." Harry Benson's photography is a wordless story in pictorial form leaving an impression on anyone who read Snell's narrative. Comparable to Robert Capa's photos of the Normandy invasion and David Douglas Duncan's Korean War photography, Benson's pictures are a tour de force in the history of photojournalism. But it would be the words of Dick Smith's daughter Judy which captured the emotions generated by those who witnessed the

[331] Robert Easton, *Black Tide*, p. 101. Ross MacDonald and Robert Easton, "Thou Shalt Not Abuse the Earth," p. 144.

catastrophe. With tears streaming down her cheeks, she said, "I feel as though I had just gone into somebody's house where everyone was murdered, for no reason at all." Such were the raw emotions among the American public which made Gaylord Nelson's vision for a day to commemorate the Earth a reality.[332] For others, their anger after they saw the environmental degradation at Santa Barbara would metastasize into rage.

One such radical incensed by Santa Barbara would have been avowed anarchist and founder of the environmentally friendly communalism movement, Murray Bookchin, whose ties to the Congress of Racial Equality made him a formidable political voice of the period. Bookchin, an eco-anarchist, admired Leon Trotsky and the Russian Social Revolutionary party; he spent the better part of the 1960s promoting the idea of an eco-friendly society in the youth counterculture. His article "Ecology and Revolutionary Thought" is a touchstone of the environmental movement and signaled a more militant, radical brand of environmental thinking. Bookchin's "Toward an Ecological Solution" appeared in Ramparts' May 1970 issue and called for no less than "far-reaching revolutionary changes in society and in man's relation to man."[333] He argued pollution by 1970 was a far-greater threat to humanity than ever before in the long struggle to rid human cultures of air, water, and food contamination. By the spring of 1970, fallout from nuclear weapon's testing and pesticides were also a part of the mix

Such pollutants were capable of entering the food chain and by osmosis penetrating into the bodies of living beings. Bookchin claimed environmental pollution had existed in human cultures since ancient times. But in the modern age, things had changed. Building upon Rachel Carson's research, he argued pollutants were capable of infecting the "bone structure, tissues, and fat deposits" of their host. Such contamination, Bookchin claimed, produced long-term "mutational effects"; invisible to the naked eye, such foreign substances

[332] Snell, "Iridescent Gift of Death," pp. 24 and 26.

[333] Murray Bookchin, "Toward an Ecological Solution," *Ramparts*, vol. 8, no. 11, May 1970, p. 7.

could incubate in the living host only to surface in future generations damaging "not only specific individuals but the human species as a whole and virtually all other forms of life."[334]

Bookchin's narrative described an environmental catastrophe of massive proportions: rising nonbiodegradable detergents, lead contamination in the atmosphere from auto exhaust, chlorinated hydrocarbons, food preservatives and the urban problem of overpopulation. Reinforcing what most of those active in the environmental movement already realized, he condemned the wanton exploitation of nature and the land itself, a net-Malthusian reference to carrying capacity, as potentially a threat to all living things on planet Earth. Bookchin insisted, "The result of all this is that the Earth within a few decades has been despoiled on a scale that is unprecedented in the entire history of human habitation on the planet."[335] Bookchin gave no indication as to when his prophecies would come to pass. Even so, his sentiments had traction with many who participated in the first Earth Day the previous month. What Murray Bookchin called for was no less than a radical restructuring of the social order in America and human societies in general. His anarchistic ideology led him to embrace "spiritual spontaneity" and a net ecology, which he insisted "must now be directed toward revolutionary change and utopian reconstruction in the social world."[336]

Alongside Michael Myerson's insightful and provocative "Angela Davis: A Prison Interview" was Roger Rapoport's documentation of the environmental hazards of weapons-grade plutonium at the Rocky Flats facility complex just sixteen miles from Denver, Colorado. Rapoport's reporting coincided with protests in Washington state against rail shipments of nerve gas during the observance of Earth Day. Appropriately titled "Catch 24,400 (or Plutonium Is My Favorite Element)" revealed substantive evidence of the harmful effects of exposure to plutonium. Most vulnerable: Rocky Flats' workers. Rapoport wrote, "Radioactive contamination

[334] Ibid., p. 8.
[335] Ibid.
[336] Ibid.

has been found in the cafeteria, drinking fountains, sinks, laundered caps, shoes, drums, flasks, carts, lifts and saws—all these in the supposedly 'cold' (nonradioactive) areas of the plant."[337]

Its title borrowed from the lyrics of "The Star-Spangled Banner," the first copy of Ramparts hit newsstands during the summer of 1962. Its articles addressed the iconoclastic, antiestablishment milieu of the radical social revolutionaries of the 1960s. The war, Civil Rights, gender equality, even theories swirling around JFK's assassination in Dallas and environmental issues were fair game for the magazine's publishers. The publication itself was the creation of Edward Keating and his wife, Helen English Keating, whose inheritance bankrolled the publication. With Ramparts they hoped to appeal to Catholic intellectuals with an editorial staff, which included Warren Hinckle and David Horowitz, authors Kurt Vonnegut, Ken Kesey, Eric Jong, Gary Snyder, Noam Chomsky and Susan Sontag. Though Keating's intention was to fashion the magazine into a mainstream glossy, its content was consistently underground with a radical edge. Its demise came as underground publications such as New Times and Rolling Stone rose in popularity, the latter focusing primarily on rock and roll music and the counterculture, staples of America's youth at the time. That and the brutal murder by Black Panthers of Betty Van Patter, who worked for Ramparts as a bookkeeper, doomed the publication to the dust bin of sixties' radical obscurity.[338]

Of course, neither Senator Gaylord Nelson and Denis Hayes, the national student coordinator of Environmental Action, nor the vast majority of the Earth Day protestors would have condoned violence. Their brand of environmentalism was a clarion call for American to awaken to the controversial issues of the day. The same can be said of Garrett De Bell, the activist who compiled *The Environmental Handbook*. De Bell's collection of essays and editorials in its tone and content, is radical in that they called Americans who read it for nothing less than a change in thinking and human behavior. A tall

[337] Roger Rapoport, "Catch 24,400 (or Plutonium Is my Favorite Element)," *Ramparts*, vol. 8, no. 11, May 1970, p. 7.

[338] Peter Richardson, *A Bomb in Every Issue: How the Short, Unruly Life of Ramparts Magazine Changed America* (New York: The New Press, 2009), pp. 195–196.

order, given the binge of conspicuous consumption which had been ongoing for more than a hundred years before the first Earth Day. Economist Thorstein Veblen saw it and critiqued it in his book *The Theory of the Leisure Class*. Veblen's narrative included "conspicuous consumption" and its consequence "conspicuous waste." In fact, it was a scathing, erudite criticism of the habits of upper-middle-class values and American wealth. So impressive are Veblen's observations and analysis distinguished economist John Kenneth Galbraith has identified Veblen's book as one of only two which were produced "by nineteenth century economists that is still read" during his lifetime.[339]

Though many of the contributors to *The Environmental Handbook* are by far more obscure than Veblen, their contribution to the cause of raising the environmental consciousness of the public are no less relevant. Take Robert Rienow and Leona Train Rienow. Their essay "38 Cigarettes a Day" focused on air pollution, a part of Robert Rienow's book *Moment in the Sun: A Report on the Deteriorating Quality in the American Environment*. Dr. Rienow, a Columbia University–educated political scientist and founder of the New York state chapter of the Audubon Society, insisted American's driving habits produced deadly carbon monoxide and at least seven chemical components which caused smog and greatly diminished air quality. Rienow demanded Detroit automakers convert its products to "non-toxic fuel cells…" scrapping the internal combustion engine. He used provocative language to shock his audience. Rienow compared life-threatening air pollution in London, Los Angeles, Chicago, and New York City to the Triangle Shirtwaist fire in 1911, which took 146 lives, almost all of them women seamstresses.

Rienow inferred smog in urban areas correlated to higher mortality rates caused primarily by chronic respiratory maladies. With available technology and knowhow making the production of fuel cells a pipe dream, Rienow insisted electric golf carts as a viable alternative for short jaunts around town. He wrote, "While cars get faster and longer, lives get slower and shorter. While Chrysler competes with Buick for the getaway, cancer competes with emphysema for the

[339] www.lib.uchicago.edu/projects/centcat/centcats/fac/facch09__01.html.

layaway. This generation is indeed going to have to choose between humans and the automobile."[340] The Rienow's polemic attacked the Detroit establishment and their combustion engine, calling for a cleaner, more environmentally friendly alternative, and the American people to forsake their cultural love affair with the automobile for cleaner, environmentally alternatives as well as governmental regulations. In no uncertain terms, the Rienows challenged the American people to choose between engine performance and living a life free from the health risks associated with auto exhaust pollution. That in itself constituted a radical proposition at the time, given the driving habits of Americans. In general, the *Handbook's* theme proposed a drastic reduction in the Earth's population, air and water pollution, and consumer consumption suggesting ways to make it happen. That in itself made the *Handbook* too something radical, raising those who read it to a higher level of environmental consciousness.

During the sixties, there were three sources of radical thought, which also happened to be college campuses: the University of California, Berkeley, Columbia University, and the University of Wisconsin in Madison. The publication "Radicalization in 1960s Madison, Wisconsin: One Participant's Reflection" is a recollection of such student activism. Operation Rolling Thunder, a bombing campaign which targeted North Vietnam during February 1965, galvanized student activism around the country particularly on the campus at the University of Wisconsin. Student activists calling themselves the Committee to End the War in Vietnam took matters into their own hands voting to stage a sit-in in the School of Commerce to disrupt Dow Chemical's interview session to recruit students to work for the company. Dow manufactured napalm, a fiery, petroleum-based bomb widely used in bombing raids in addition to Agent Orange, the defoliant sprayed on jungle in Vietnam.[341]

[340] Robert and Leona Train Rienow, "38 Cigarettes a Day," *The Environmental Handbook* ed. Garrett De Bell (New York: Ballantine Books, 1970), pp. 125–127.

[341] Facebook, http://www.solidarity-us.org/site/node/3545. Patrick M. Quinn, "Radicalization in 1960s Madison, Wisconsin: One Participant's Reflection," *Solidarity*, 27 February 2012.

On the morning of October 18, 1967, a sit-in began when students occupied the building. At noon that same day, helmeted police and sheriff's deputies arrived at the scene, entered the Commerce building, and began using brute force to remove the protestors, hitting students with police nightsticks and arresting them. Within the hour, they removed students from the premises. What became known as the Dow Protests represented the antiestablishment political activism that spread to other college campuses across the country. By confronting an industrial giant like Dow, student activists were taking on not only a company which produced napalm but Agent Orange, the defoliant used to defoliate dense Vietnamese jungle which rivaled only DDT as a target of environmentalists at the time. Historian David Maraniss divides his book *They Marched into Sunlight: War and Peace, Vietnam and America October 1967*, covering the Dow Protests with an account of the Battle of Ong Thanh as well. Though the hazards of Agent Orange were not generally known at the time and ending the war topped their list of priorities, the protests added to the momentum of history which concluded with Earth Day.[342]

Events in the fall of 1967 on the campus of the University of Wisconsin did not match the highly publicized occupation of the abandoned maximum security prison on Alcatraz Island by the American Indian Movement. On the morning of November 20, 1969, more than eighty Native Americans set out on boats from San Francisco to occupy the most notorious prison facility in the federal system. Their goal: to make a political statement drawing attention to broken treaties and reclaiming the island as a protest against the loss of Native American land to the white man. The occupation lasted for more than a year and ended peacefully compared to the occupation of Wounded Knee four years later. The occupation of Alcatraz attracted worldwide attention, captured front-page newspaper headlines, and garnered coverage by television journalists at CBS, NBC, and ABC news.

Inspired by the American Indian Movement's Alcatraz occupation and the civil rights movement, members of the Puyallup

[342] http://www.pbs.org/wgbh/amex/twodays/peopleevents/e_napalm.html, p. 8.

tribe, organized by headman Bob Satiacum, stormed the army base of Fort Lawton on Puget Sound in Washington state, not far from downtown Seattle. Lesser known than the Alcatraz incident, what became known as the "Fort Lawton Re-Occupation" on March 8, 1970, according to Frank Herbert of the Seattle Post-Intelligencer occurred not so much for political reasons as for environmental reasons. In the words of environmental historian David Stradling, the group calling themselves the United Indians of All Tribes "tended to link nineteenth-century imperialism over Native Americans with twentieth-century American imperialism over nature."[343] Their purpose was fourfold: (1) establish an adoption agency, "where orphaned Indian children would be given to Indian families"; (2) to preserve the 1,100 acres of the fort returning it to something the protestors called "Indian natural"; (3) to construct on the fort grounds an "Indian Half-Way House" where Native Americans leaving the sanctuary of the reservation would prepare for assimilation; and (4) to establish an environmentally friendly community which would show whites "how to stop destroying the Earth."[344]

Named for Captain Henry Ware Lawton commander of a cavalry unit which crossed the United States–Mexico border and captured the Chiricahua Apache war chief Geronimo, the abandoned fort on Puget Sound thirty-five miles south of Seattle had been decommissioned by the Pentagon. After unsuccessfully petitioning the city of Seattle to use a portion of the post to build a Native American cultural center, United Indians of All Tribes decided to act. Among the protestors who stormed the fort grounds to occupy it three times unsuccessfully were Bernie Whitebear, a veteran of Alcatraz; Grace Thorpe, daughter of Jim Thorpe; and Native American historian Vine Deloria. Military police arrested many, confining protestors to the post's military stockade. Native American protestors constructed

[343] Frank Herbert, "How Indians Would Use Fort," *The Environmental Movement, 1968–1972*, ed. David Stradling (Seattle: University of Washington Press, 2012), p. 60.

[344] Ibid., p. 77.

Resurrection City outside the fort to draw media attention to their cause.[345]

At least 150 protestors, including actress Jane Fonda, were arrested, some of them claiming they had been victims of military police brutality. After being detained briefly in the Fort Lawton stockade, the protestors were released.[346] Fonda, the thirty-two-year-old actress, added the clout of a celebrity drawing media coverage to the cause. Fonda claimed she hoped "to gain the sensitivity to problems faced by Indians in this country."[347] Her involvement with UIAT is a fascinating subplot to this lesser known incident in environmental history.

At a dinner party, movie director Mike Nichols threw for fellow director Michelangelo Antonioni who had just wrapped up his film Zabriskie Point, Jane Fonda met Harvard-educated playwright Fred Gardner. An avowed Marxist, Gardner had gained the reputation as Lillian Hellman's best student. Hired by Antonioni to touch up the script for the film, Gardner had established a chain of GI coffeehouses across the country for veterans who opposed the Vietnam War. Between 1967 and March of 1970, "an increasing number of soldiers were very supportive of the antiwar campaign. They were a vital part of the GI movement against the Vietnam War."[348] Through Gardner, Fonda met members of the radical United Indian People's Council or UIAT movement.

[345] Losson Allen, "United Indians of All Tribes Retakes Fort Lawton," Seattle Civil Rights and Labor History Project, University of Washington, Seattle, http://depts.washington.edu/civilr/; http://depts.washington.edu/civilr/Ft.Lawton takeover.htm (spring 2006).
Note: This website is replete with newspaper clippings from the period. It remains a valuable resource imparting understanding of a little known event in contemporary Native American history.

[346] "Army Repels Indians At Fort Lawton, Lewis," *Bremerton Sun*, 9 March 1970, http://depts.washington.edu/civilr/display.cgi?image=FtLawton/news.

[347] Steven H. Dunphy, "Jane Fonda Uses 'Leverage' to Aid Cause of Indian Rights," *The Seattle Times*, 8 March 1970, p. A20. Patricia Bosworth, *Jane Fonda: The Private Life of a Public Woman* (New York: Houghton Mifflin Harcourt, 2011). pp. 295–299.

[348] Bosworth, ibid.

United Indians of All Tribes never successfully occupied Fort Lawton. Occurring five weeks before Earth Day. The protest drew attention to the plight of the Puyallup tribe and environmental issues in general. With the support of Washington Senator Henry "Scoop" Jackson and Seattle mayor Wes Uhlman, the tribe negotiated funds for the creation of a 390-acre park and a Native American cultural center.[349] As for Jane Fonda, she would continue to engage in political activism against the Vietnam War. Her fact-finding mission to North Vietnam in July of 1972 enhanced her anti-war notoriety and contributed greatly to her infamy among conservatives who viewed her actions as unpatriotic, un-American. Putting the Fort Lawton incident into its proper prospective, Puyallup Chief Bob Satiacum put it this way, "We don't think we have to destroy the Earth to prove or 'improve' its value. It would take a pretty insensitive human being to ignore today's evidence that our environment is being made deadly to all of us."[350]

Such radical thought resonated in most mainstream news outlets. Hardly a radical publication on the gauge of the political spectrum, Henry Luce's Time magazine published a cover story in April 1967 on oral contraception. The medical section of the magazine that week provided its readership with a detailed explanation of a woman's reproductive system and female sexuality. "Contraception: Freedom from Fear" were words borrowed from the Norman Rockwell painting "The Four Freedoms." Time's investigation would be one of the most provocative, graphic treatments of the female reproductive system in modern history. Not since Alfred Kinsey and Wardell Pomeroy's book on the same subject in 1953 had the public been exposed to such a graphic treatment of such a sensitive subject. In addition to a brief history on how the pill came to be and the chemical engineering involved, Time investigated the trend of usage among the female population of the United States and abroad.[351]

[349] Hilda Bryant, "City Indians In Accord on Lawton Center," *Seattle-Post-Intelligencer*, 15 November 1971, p. 1 and p. A20.

[350] Frank Herbert, ibid., p. 78.

[351] "Contraception: Freedom from Fear," *Time* magazine, vol. 89, 7 April 1967, pp. 78–84.

Religion's role particularly among Catholic women and the part the Pope's encyclical had had on determining the pill being prescribed received fair and balanced coverage in Time's feature story. A brave new world of female contraceptive devices in the pipeline were also examined: a minipill for women who might forget to take their daily contraceptive dosage; injectables like Depo-Provera; an implant contraceptive; and a morning-after pill, which today is called RU-486. Each heralded a new method to prevent pregnancy. With Time's expose, now what Margaret Sanger had once been arrested for making public had now made it into mainstream media available to any high school student in their local library. Coming as it did after the United States Supreme Court upheld the use of oral contraception in Griswold v. Connecticut, the outlet's feature story was a radical departure from the media norm. Once strictly the domain of parental responsibility in the home, sex education had been a private matter. No more. Now it was public information. With Time's article, how babies were made became public knowledge disseminated in the mainstream of American society.[352]

There would be nothing "mainstream" in the content of Ramparts. Five months before the Altamont Rock Festival tragedy on December 6, 1969, the magazine ran a story on the Santa Barbara oil spill. Author Harvey Molotch would go on to distinguish himself by pioneering a field of study at the college level called environmental sociology. His contribution to Ramparts "Santa Barbara: Oil in the Velvet Playground" documented the shift in the political winds in the conservative community of Santa Barbara. The California community, a bastion of conservatism, Molotch referred to it as consisting of "hard-rock Republicans," had undergone a transformation to a group of people infected with the fever of political activism since the environmental disaster unfolded in Santa Barbara Channel in January that same year. Molotch, teaching sociology on the campus of the University of Santa Barbara, California, noted the great lengths community leaders had taken to protect the city from environmental

[352] Ibid.

degradation only to have its image degraded by an ecological disaster on an astronomical scale.

Molotch made the case that the disaster of January 1969 had had unintended consequences, pushing the otherwise conservative, upper-class Santa Barbarans, mostly Reagan Republicans, toward radicalism and civil disobedience. Lesser known and far removed from the mainstream reporting of David Snell in Life, Molotch's Ramparts article was no less profound. His acumen for political analysis is penetrating and revealing. Snell did his report directly from San Miguel Island in the Santa Barbara Channel; Molotch served up his heavy dose of political analysis with his thumb on the pulse of the beleaguered community where he worked.

Basing what he authored on editorials published in the Santa Barbara News-Press, Molotch concluded governmental intransigence and indifference to be factors in the radical wave sweeping the politically conservative community. Disillusioned were Santa Barbarans once willing to work within the system by circulating petitions and contacting elected officials through proper channels. What happened is a classical case of concerned, law-abiding citizens becoming disillusioned with "the establishment," the same mantra as student protestors would adhere to by Earth Day.

Regulatory agencies, the Interior Department in particular, charged with the responsibility of placing restrictions and regulations upon violators, in this case Union Oil, were instead perceived as lobbyists for the violators, not the public interest. In such a way, in the words of Molotch, "Santa Barbarans became increasingly ideological, increasingly sociological and, in the words of some observers increasingly 'radical.'" Santa Barbarans elation when Nixon's Interior Secretary Walter Hickel's declared a moratorium on drilling in the Santa Barbara Channel turned to outrage because of disputed numbers released from Union and Interior on the volume of oil spilled and denials as to the ecological damage done to area beaches and wildlife. All seemed to place federal and state governmental officials

on the side of Big Oil and the industry's assessment of what had taken place.[353]

Protests would follow. An attempt to sail to Platform A, the site of the disaster, and to occupy it by one community activist group calling itself Get Oil Out (GOO) failed due to bad weather. One GOO activist reasoned the only hope to save Santa Barbara was to awaken the nation to their dilemma; that would be to deny the oil industry access to the docks and Santa Barbara harbor, thereby creating an incident that would bring federal troops in to quell the civil disobedience and attract media attention. GOO perceived themselves no different than the Mississippi Freedom Summer volunteers, the Montgomery bus boycott protestors, or the marchers who were attacked by Alabama sheriffs, deputies, and highway patrol on the Edmond Petus Bridge during their march to Selma. One reporter for the Santa Barbara News-Press admitted there was no way to predict the outcome of the protest movement. The journalist did predict if state and federal authorities continued to fail in their efforts to end "the pollution and its causes, 'there will at best, be civil disobedience in Santa Barbara and at worst violence.'"[354]

Molotch's narrative dealt with average Santa Barbarans. Most had voted for Nixon and newly elected California governor Ronald Reagan. These citizens, even the members of GOO, had no sympathy for the radical causes at the University of California, Berkeley, Columbia University, or the Chicago Seven. Conversely, Richard Flacks and Milton Mankoff, two academics in the heady political mix at the University of California, Santa Barbara, were neither Republican nor conservative. One month before Earth Day in 1970, Flacks and Mankoff analyzed the political atmosphere on campus and the community for The Nation. In their article "Revolt in Santa Barbara: Why They Burned the Bank," Flacks and Mankoff placed the burning of the Bank of America within the broader context of greater student radicalism of the period.

[353] Harvey Molotch, "Santa Barbara: Oil in the Velvet Playground," *Ramparts* vol. 8, no. 5, November 1969, p. 45.
[354] Ibid., p. 51.

They made the case that UCSB student's protest movement was multifaceted. Grievances included inadequate housing on campus and in Isla Vista, the location of the bank which resembled the blighted ghetto of any inner city in America; student resentment following the firing of popular UCSB professor William Allen, an act by university officials students believed was politically motivated; harassment of African American students by local law enforcement; the war in Southeast Asia; and Nixon's indifference to the War Moratorium the previous October all contributed to a crises atmosphere. Speeches on campus by Chicago Seven defendant Tom Hayden and outspoken Chicago Seven attorney William Kunstler in February did nothing to ease the political tension on campus. The burning of the Bank of America branch occurred after these impassioned addresses to students and the arrest of student Rich Underwood for possessing a wine bottle law enforcement believed to be a Molotov cocktail. It was a Wednesday evening. That evening, students went on a rampage.[355]

The burning itself occurred on the second day after a week of protests and unrest. Flacks and Mankoff stressed the Santa Barbara oil spill disaster contributed to "politicizing" UCSB students. They reasoned, "The oil-drilling catastrophe struck Santa Barbara Channel, and nothing could more concretely threaten the student's daily freedom than the spoiling of the ocean shore." That and broken promises by political leaders at the time to end the drilling in the Channel and stop the oil leak, promises unfulfilled.[356] Those same issues had radicalized members of an otherwise conservative community to become radicalized. Compounding the frustration and anxiety was another controversy. UCSB officials had drawn up plans for a highway connected to campus, which threatened a fragile ecosystem: a fragile and "rare salt water marsh and bird refuge" near the path of the highway

[355] Richard Flacks and Milton Mankoff, "Revolt in Santa Barbara: Why They Burned the Bank," *The Nation*, 23 March 1970, pp. 337–339. Taylor Haggerty, "Forty Years Ago, A Mob of Students Stormed the Bank of America Building," 25 February 2010,<http://dailynews.com/2010-02-25/forty-years-ago-a-mob-of-students-stormed-the-bank-of-america-building/> (Tuesday, August 23, 2016).

[356] Ibid., p. 339.

which would also threaten air quality. To protest the oil disaster and highway building project on the first "anniversary of the blowout, some 500 students staged a sixteen hour sit-in to block the use of the city wharf by oil company vehicles."[357]

The burning of the bank occurred on Wednesday night. Assessments vary, but "property damage was estimated at several hundred thousand dollars," not exceeding $350,000. Law enforcement officials arrested 136 students, and California Governor Ronald Reagan used a photo-op in Santa Barbara to "proclaim a 'state of extreme emergency'"; ordered to Santa Barbara by Reagan, the California National Guard arrived on Friday night, ending the weeklong protest by students. Newspaper editor Taylor Haggerty found the burning of the bank a symbolic gesture of nihilism, the bank "a symbol of big business, capitalism and the Vietnam War, citing its ties to the defense industry."[358] "It was the biggest capitalist thing around," fourth-year UCSB student Becca Wilson, the editor of the student newspaper El Gaucho, said. "It was a symbol of the corporations that benefited from war and were oppressing people all over the world, in whose interest government was acting."[359] Bob Easton went even further. Based on a community-authorized investigation after the Bank of America incident, Easton placed the burning of the bank and three subsequent riots in Isla Vista where UCSB was located squarely on the Union Oil platform blowout and subsequent environmental disaster. In Easton's own words, "The Santa Barbara Citizens Commission on Civil Disorders found the oil spill to be the root cause of these disturbances."[360]

Easton, Richard Flacks, and Milton Mankoff were not alone in identifying the radical trend. By gaining control of their reproductive lives, women confronted an unspoken, unwritten moral imperative in place since biblical times. Women, for the first time in human

[357] Ibid.

[358] Taylor Haggerty, "Forty Years Ago, A Mob of Students Stormed the Bank of America Building," ibid.

[359] Ibid.

[360] Robert Easton, *Black Tide: The Santa Barbara Oil Spill and Its Consequences* (New York: Delacorte Press, 1972), p. 223.

history, took issue with the words in the book of Genesis 1:28: "And God said to them, 'Be fruitful and multiply and fill the earth.'" These words placed second wave feminists in direct defiance of Jehovah and the Judeo-Christian ethic. Oral contraception, the pill, was a game changer. Young, single women taking the pill now opened themselves up to the charge of being morally promiscuous, the pill giving them a license to indulge and expressed themselves sexually at their discretion. Margaret Sanger's vision of "a scientific method of birth control, something with a magical quality that would permit a woman to have sex as often as she liked without becoming pregnant" had become a reality. More importantly, Sanger believed that without the pill, "women would never gain equality, she had argued, until they were freed from sexual servitude." Physiologist Gregory Goodwin Pincus's marvelous contrivance of chemical engineering, with financial assistance from Katherine McCormick, had fulfilled Sanger's vision.[361]

In any case, by the summer of 1961, oral contraception was readily available after being approved by the Food and Drug Administration. Using the pill in and of itself constituted a radical decision. For the first time in human history, women could enjoy sex in or out of the institution of marriage in a way in which they were relatively safe from pregnancy. By Earth Day, groups such as the National Organization of Women (NOW), the Society for Cutting up Men (SCUM), the Redstockings, and Women Inspired to Commit Herstory (WITCH) blamed men for the war in Southeast Asia and threatened violence against men. Such gender activists demanded control of their reproductive lives and the repeal of state laws prohibiting abortions, and demanded access to contraceptive devices and sex education. They even blamed males for being the destroyers of nature. Even though in 1968, Pope Paul VI proclaimed the encyclical Humane Vitae, prohibiting the use of oral contraception, women defied the Church and continued to use the pill.[362] That in itself was

[361] Jonathan Eig, *The Birth of the Pill: How Four Crusaders Reinvented Sex and Launched a Revolution* (New York: W. W. Norton & Company, 2012), pp. 1–3.

[362] Lucinda Cisler, "Unfinished Business: Birth Control and Women's Liberation," ed. Robin Morgan in *Sisterhood is Powerful: An Anthology of Writings From the*

radical. But there were problems with what many perceived to be the silver bullet to prevent unwanted pregnancies.

By March of 1969, at least nine million women had been prescribed oral contraception by a personal physicians or Planned Parenthood clinicians. Of those, 1,034 had reported serious health problems; there had been 118 deaths. All had been prescribed a regimen of oral contraceptives. Food and Drug officials added a disclaimer by issuing a statement to the effect the women in question did "not mean necessarily that the pill was in any way responsible for the ailments affected. They simply mean, the spokesman said, that the women were taking the pill when the ailment was diagnosed."[363] In a survey conducted by Princeton University and the University of Wisconsin funded by the United Public Health Service, 80 percent of the women surveyed had stopped taking oral contraception. They had done so because of reports of serious health problems associated with the pill. Complications such as blood clots, blackouts, breast cancer, strokes, diabetes-like symptoms, and even cervical cancer had been reported by users.[364] There would be a congressional hearing by a Senate subcommittee on the topic before Earth Day.

Chairing the all-male Subcommittee on Small Business Monopoly was Senator Gaylord Nelson. Witnesses, all male, were called to testify sharing information which targeted drugs, especially the pill. Nelson questioned whether patients and their physicians had sufficient facts to make informed decisions on the pill. Other distinguished witnesses included Marvin Legator of the Food and Drug Administration; physicians such as Dr. David Carr of McMaster University in Hamilton, Ontario; the Johns Hopkins University's Dr. Hugh Davis; and Dr. M. James Whitelam of San Jose, California.

Women's Liberation Movement (New York: Random House, 1970), pp. 286–287. Thomas Robertson, *The Malthusian Moment: Global Population Growth and the Birth of American Environmentalism* (New Brunswick, New Jersey: Rutgers University Press, 2012), pp. 155–156. Robin Morgan, ed., *Sisterhood is Powerful*, p. 514, 517, and 539.

[363] Jane E. Brody, *"Birth Control Pills: A Balance Sheet on Their National Impact,"* *The New York Times*, 23 March 1969, p. 60.

[364] Ibid. p. 1 and p. 60.

Davis and Legator's testimony virtually duplicated each other. Davis was critical of the manner in which pill distribution had been managed claiming prescriptions had been "handed out without proper medical examinations." Davis testified, "In many clinics…the pill has been served up as if it was chewing gum." Davis claimed thirty women out of one million users died every year since the pill had become available; he also volunteered the lesser known fact federal regulators had felt pressure by the "threat of an 'enormous' world population problem."[365]

Unknown to Dr. Davis and Senate subcommittee chair Gaylord Nelson, the audience admitted to the hearing included six women, one of which was pregnant. Since none of their gender had been called upon to testify, these women insisted that their voices be heard by disrupting the proceedings. Calling themselves the Women's Liberation Front, they refused to acknowledge the authority of Senator Nelson shouting out, "Nothing makes the oppression of women more obvious than the hearing today." In loud acclamation, "they said the subcommittee staff had refused to speak to them or grant them time as witnesses."[366] As a conciliatory gesture, Chair Nelson agreed to listen to their grievances. Even so, disrupting the hearing proceedings would be similar to the most radical actions by any American protest group of the period prior to Earth Day.

One of the most radical environmentalists of the period had made a name for himself with the Federal Bureau of Investigation. Edward Abbey's name appeared in a dossier among J. Edgar Hoover's Counterintelligence (COINTELPRO) list by 1950 after Abbey posted a protest letter on a bulletin board on the campus of State Teacher's College in Pennsylvania encouraging draft-age male stu-

[365] Stuart Auerbach, "Breast Cancer Peril Feared in Birth Pill," *Washington Post*, 15 January 1970, p. 1 and p. A12, and Harold M. Schmeck Jr. "Biologist Urges a Drive to Study Possible Genetic Peril in Drugs," *The New York Times*, 15 January 1970, p. 1.

[366] Ibid., A12 and p. 23 sec. L, and video documentary, *The Pill*, dir. Matthew Collins III and dir. Rocky Collins, 55 min., WGBH Boston, 2003 (VHS & CD) and Stuart Auerbach, "Breast Cancer Peril Feared in Birth Pill," *Washington Post*, p. A-12.

dents to mail their draft cards to President Harry Truman.[367] Making it into COINTELPRO, a collection of dossiers on American citizens deemed subversive by Hoover, provided the Bureau with information; Abbey's name appeared on Hoover's hit list along with the names of Mario Savio, Abbie Hoffman, and Black Panther Huey P. Newton long before he graduated with a master's degree from the University of New Mexico. The title of Abbey's thesis: "Anarchism and the Morality of Violence." As to Abbey's whereabouts on April 22, academics Thomas Lyon and Utah State University student Ingrid Eisenstadter persuaded him to speak in Logan, Utah, to commemorate the event.[368]

In his speech Abbey, an eco-anarchist, railed against big business, proposing environmental action to preserve America's wild places and the natural world in general. Afterward, he resumed his duties working for the National Parks' Service in Organ Pipe Cactus National Monument, west of Tucson, Arizona, in the Sonoran Desert.[369] Abbey would go on to receive notoriety as a member of the radical environmental group "Earth First," founded by Dave Foreman, which would demand the destruction of the Glen Canyon Dam, an eyesore and obstruction to the free-flowing Colorado River. Their frustration would be vented ten years after Earth Day when Foreman and Abbey led activists onto the dam, unfurling a huge role of black visqueen from atop of it to give the appearance of a huge crack in the dam's concrete structure. The event captured in the documentary "The Cracking of Glen Canyon Damn" distributed by Earth Image Films, still stands as an iconic moment in the history of radical environmentalism.[370] Earth First took its inspiration from Abbey's fictional *The Monkey Wrench Gang*, a novel which inspired radical environmentalists to protect nature from what they perceived as the onslaught of civilization by any means necessary.

[367] David Gessner, "Edward Abbey's FBI File," *Orion Magazine*, January–February 2015, pp. 9–10. https://vault.fbi.gov/cointel-pro.

[368] James M. Catalan, *Edward Abbey: A Life* (Tucson: The University of Arizona Press, 2001), pp. 123–124.

[369] Ibid.

[370] Ibid., p. 193.

Edward Abbey, an eco-anarchist, had been radicalized by what he perceived as crimes against the natural world. By the spring of 1970, he was not alone. In Santa Barbara, California, where with the exception of students attending the university, the vast majority of the community supported Governor Ronald Reagan, the disastrous oil spill and the federal government's response had radicalized otherwise law abiding citizens. Professor Harvey Molotch placed the extremism of the environmental movement in its proper perspective when he wrote, "As a consequence, some Santa Barbarans, especially those with the most interest in and information about the oil spill, while still surrounded by comfort and certainty, have nevertheless come to view power in America more intellectually, more analytically, more sociologically—more radically—than they did before."[371] The momentum of history had set the stage for the first Earth Day.

[371] Harvey Molotch, "Santa Barbara: Oil in the Velvet Playground," *Ramparts*, November 1969, vol. 8, no. 5, p. 51.

America Celebrates the Earth

I t occurred because of several issues that lifted the collective American consciousness and the spirit of those times. Lake Erie's obituary, the burning Cuyahoga River, the Santa Barbara oil spill, massive fish kills around the country all received high-profile news coverage—if not on television then in the local newspaper where it happened. And as we have seen of all the environmental problems facing the country, the most tangible, the most visible and threatening were the contamination of the nation's air and water supply. These issues caused a massive shift in American public opinion and a growing spirit of reform, which made Earth Day possible. Political protests, both spontaneous and organized by the New Left and youth counterculture against the war in Indochina and the cause of civil rights, only added to the momentum of environmental activism. Filling the FM radio airwaves, Joni Mitchell's "Big Yellow Taxi" sent the folk singer's environmental message to all who listened.[372]

Environmental historian Philp Shabecoff places Senator Gaylord Nelson in California meeting with Paul Ehrlich. Nelson read an article in Ramparts on the effectiveness of the teach-in concept in

[372] www.pophistorydig.com/topics/tag/joni-mitchell-big-yellow-taxi

September 1969, which also inspired his idea for Earth Day.[373] In any case, taking advantage of the anti-war sentiment and the growing public awareness of environmental problems facing the country he then announced his idea for Earth Day. Nelson capitalized on the political momentum of four historical events: The Santa Barbara oil spill off the California coast, which created an eight-hundred-mile-long mass of oily scum south to Catalina.[374] Protests at Harvard University opposing the presence of the Reserve Officers Training Corp, organized by the Students for a Democratic Society that same month, which led to a riot and general strike by the student body.[375] On August 16, 1969, one of the most destructive hurricanes of the century Camille, smashed into the Gulf Coast in Mississippi, claiming 283 lives. The tropical storm seemed to confirm meteorologists' and climatologists' prophesies that air pollution had destabilized global weather patterns.[376] And finally, hundreds of thousands of students turned out for the Vietnam War Moratorium on October 15, 1969, on college campuses, taking their opposition to the streets, showing their solidarity against the war almost three weeks to the day after Nelson announced his Earth Day idea.[377] Students against the war participating in the Moratorium directed their protests on Earth Day at the US military industrial complex comprised of companies, contracted with the defense department, profiting from a war they believed to be immoral. Those companies, particularly Dow Chemical, were targets on Earth Day as polluters of the environment.

As student coordinator of Environmental Action, the organization Nelson created to plan and promote Earth Day activities around

[373] Philip Shabecoff, *A Fierce Green Fire: The American Environmental Movement* (New York: Hill and Wang, 1993), p. 115.

[374] Gaylord Nelson, *Beyond Earth Day: Fulfilling the Promise* (Madison: University of Wisconsin Press, 2002), p. 6.

[375] Lawrence E. Eichel, Kenneth W. Jost, Robert D. Luskin, and Richard M. Neustadt, *The Harvard Strike* (Boston: Houghton Mifflin Company, 1970), pp. 51–54.

[376] "Is Man Spoiling the Weather? What the Experts Say," *US News & World Report*, 19 August 1968, p. 60.

[377] Todd Gitlin, *The Sixties: Years of Hope, Days of Rage* (New York: Bantam Books, 1993), pp. 356–357.

the country, Denis Hayes attended Harvard's John F. Kennedy School of Government at the same time as Sam Brown the national coordinator of the war moratorium. In addition to the Brown connection, Environmental Action had ties to a number of informal student organizations: Zero Population Growth, the Student Environmental Confederation, the Planning and Conservation Club, and the National Student Association. All encouraged students to turn out for the Earth Day protest. They planned "write-ins, trash-ins, teach-ins, speeches and panel discussions," promoting environmental awareness to educate the public.[378]

A careful examination of the Life magazine photograph taken by John Olson of Denis Hayes, Andrew Garling, Arturo Sandoval, Steven Cotton, Barbara Reid, and Bryce Hamilton reveals the confident look of determined optimism. From their cramped office headquarters located over a Chinese cuisine takeout in Washington, DC, they began canvassing and calling and answering letters from at least fourteen thousand public schools, colleges, and civic groups interested in making plans for Earth Day. Hayes and his fellow staffers deployed similar tactics used by anti-war protestors urging activists to take "collective action against local polluters."[379] In such a way, John Roberts, Joel Rosenman, Artie Kornfeld, and Mike "The Kid" Lang had set up shop to manage and sell tickets for the Woodstock Music and Art Fair in an office building on West Fifty-Seventh Street in New York City eleven months earlier.[380]

Without the commitment of student activists like Denis Hayes, much of the political change which occurred from the landmark Supreme Court decision Brown v. Board of Education to Earth Day in 1970 would not have taken place. Hayes is exemplary of a generation that made momentous events happen. Growing up in forested Camas, Washington, in the Pacific Northwest, Hayes saw the

[378] Ed Meagher, "Survival Walkers for Ecology Reach Castaic," *Los Angeles Times*, 22 April 1970, part 2, p. 1.

[379] "A Day Devoted to a Better Earth," *Life* magazine, 24 April 1970, vol. 68, no. 15, p. 41.

[380] Bob Spitz, *Barefoot in Babylon: The Creation of the Woodstock Music Festival, 1969* (New York: Plume-Penguin Random House, 2014), pp. 81–85.

environmental degradation inflicted upon the surrounding forests where he had hiked as a boy near the paper mill where his father worked. Entering Stanford University, Hayes got caught up in the protest movement against the Vietnam War; he participated in the student occupation of the Applied Electronics Laboratory engaged in weapons development on campus. Admitted to Harvard law school, he accepted an internship in the government bureaucracy where he learned of Senator Gaylord Nelson's idea to apply the teach-in concept student activist Tom Hayden articulated in *The Port Huron Statement*. Hayes called Nelson to volunteer his services, dropped out of law school, and committed himself to make Nelson's vision a reality. For more than six months, Hayes dedicated his life "to organizing rallies, street demonstrations, and trash cleanups."[381]

It all started with a class assignment requiring students to gain employment as an intern in some governmental agency, which for Hayes proved to be the defining moment in his life. The assignment brought the graduate student into contact with Nelson. Aside from his previous experience as an anti-war activist, the Harvard graduate student reflected upon what inspired him to take up the cause of environmentalism: "Washington state is deteriorating—becoming a colder California, with the wrong kind of development... I feel a genuine sense of anger that those who are responsible are buffered from the results of their decisions." A young man on a mission seeking enlightenment, Hayes had traveled around the globe and witnessed firsthand environmental degradation wrought by humanity. That too factored into his decision to serve as Nelson's national coordinator of Earth Day.[382]

One day after the UCLA Board of Regents voted to fire philosophy instructor Angela Davis for her Communist party affiliation

[381] David S. Jackson, "Denis Hayes: Mr. Earth Day Gets Ready to Rumble," *Time* magazine, 26 April 1999, p. 63; Bill Christofferson, *The Man From Clear Lake: Earth Day Founder Senator Gaylord Nelson*, pp. 304–305. Stephanie Strom, "Earth Day Extravaganza Sheds Its Humble Roots," *The New York Times*, 22 April 1970, p. 26.

[382] "Angry Coordinator of Earth Day, Denis Allen Hayes," *The New York Times*, 23 April 1970, p. 30.

and Los Angeles County Prosecuting Attorney Vincent T. Bugliosi prepared the legal briefs in his case against Charles Manson for the murder of actress Sharon Tate, America celebrated Earth Day. Environmental activists around the country that day joined together to focus through the news media attention on the sanctity of the Earth from coast to coast in a well-coordinated demonstration. Rock radio stations spun the Crosby, Stills, Nash, and Young hit "Woodstock," the lyrics "And we've got to get ourselves back to the garden" heralding the dawn of a new age in which environmental activists felt empowered to transform America into a new Eden if only they willed it so. On the east coast with the support of New York City Mayor John Lindsay, auto traffic was banned from Fifth Avenue between Fifty-Ninth and Fourteenth streets closed to traffic so crowds could enjoy an "ecological carnival." At Union Square, the sound of amplified voices were heard from teach-ins throughout the day. Nearby organizers inflated a massive "polyethylene bubble" that stretched over a block in length along Seventeenth Street where visitors could enter, walk through, and breath "pure, filtered air." Within the hour, the pure air bubble had been "contaminated" with marijuana fumes smoked by protestors who entered.[383]

Under the flashing lights, neon signs, and the glare of the signs advertising porn shops and exotic female dancers in Times Square, Father Philip Hurley of the Sixteenth Street St. Xavier's Roman Catholic Church led a group of parishioners carrying a banner which read, "Xavier's Parish Condemns Soul Pollution." More students following Father Hurley carried posters that read, "Save Our Souls-Stamp Out Smut," and "Why a Clean Earth with Polluted People?" Looking like a cartoon drawing from a Rube Goldberg cartoon "Boob McNutt," a junk sculpture sat on a flatbed truck in Union Square as part of a surreal atmosphere.[384] The truck had begun its journey in upstate New York near Lockport and was followed by a chartered bus filled with teenagers who added a new discarded artifact to the

[383] Joseph Lelyveld, "Mood Is Joyful as City Gives Its Support," *The New York Times*, 23 April 1970, p. 30.

[384] McCandish Philips, "The Day the City Caught Its Breath," *The New York Times*, 23 April 1970, p. 31.

contraption at every stop along the journey to New York City. At journey's end, their eclectic artwork, "A Study in Obsolescence," had been commissioned by the Kenan Center for the Arts then welded together by New York City artist Al Cooke. Cooke had put his avant-garde welding torch to everything from chrome car bumpers to junk car doors, beer cans, and bicycles. The final artistic creation accentuated with a trashed nude female store mannequin wearing a gas mask.[385]

In the city, the church bells of St. Thomas Cathedral peeled heralding Earth Day. Merrily, housewife Barbara Youngberg pushed her toddler Neil in his stroller down Fifth Avenue to join in the festivities. "They should have this every Wednesday," she said.[386] Sitting near police barriers on Thirty-Eighth Street New York cabby Victor Yusa, his yellow vehicle at a standstill, sounded frustrated. Business was slow. "Look it! They've got everything all messed up!" he said. In Central Park, balloons and kites filled the sky; standing on East Fifty-Third Street, eleven-year-old Norma Richardson, flowers adorning her hair, passed out daisies from her basket to passers-by. Within sight of Richardson, New York Times reporter McCandish Philips noted, "Half a block from where the daisies were being given out, five policemen stood in riot helmets, ready for anything.[387]

A political moderate, Republican New York Governor Nelson Rockefeller used the publicity generated by the event to sign a bill creating a New York Department of Environmental Conservation.[388] Rockefeller, like many politicians, used Earth Day to promote the idea of a clean environment as well as a media opportunity to further their political careers. Such was the importance of this first-of-a-kind event.

Congressional representatives in Washington, DC, sensing the political magnitude and repercussions of the environment movements call for action, adjourned for the day. (A mere coincidence, April 22

[385] Ibid.
[386] Ibid.
[387] Ibid.
[388] "Americans Rally to Make it Again Beautiful Land," *Chicago Tribune*, 23 April 1970, p. 3.

marked the birthday of Vladimir Ilyich Ulyanov, Lenin.) Politicians
of both parties presented speeches at teach-ins around the county, not
only in the nation's capitol but also in their home states, promoting
the idea of a clean environment to gain political capital. As crowds
gathered under the shadow of the Washington Monument, dignitar-
ies including presidential hopeful Senator Edmund Muskie, journal-
ist I. F. Stone, and the Reverend Channing Phillips gave speeches on
topics ranging from environmental responsibility to the evils of the
war in Vietnam.[389] By the time the folk singer Pete Seeger stepped
onto the stage to begin his first set at the Sylvan Theatre to perform
near the Washington Monument grounds, the rally had taken on the
air of spontaneity of "our own little Woodstock in Washington" as
one rock 'n' roll musician put it. Marijuana smoke filled the air as
joints were passed freely through the gathering in plain view of Park
Police.[390]

One speech stands out. In Bryant Park, near the Parthenon-like
New York City Public Library, author-essayist Mary Mannes spoke
to the crowd gathered there. In her "Hymn of Thanksgiving," like a
high priestess of some forgotten Grecian oracle on an island in the
Aegean, she stepped to the rostrum and pronounced judgment upon
American society for its ruthless exploitation of nature and proph-
esied an environmental apocalypse. In a forceful voice, she prayed,
"In boundless gratitude for all wealth, O gods of plenty, profit, and
convenience, we lay at your feet a hundred cans of beer and bottles
of Coke, sixty billion plastic containers and paper wrappings, ninety
billion tons of raw sewage, and enough lethal chemicals in air and
water to kill legions of animals and to invade our lungs with deadly
gases and our blood with deadly poisons." She then renounced mate-
rialism and the gods of waste and despoilment of nature and pro-
nounced benediction by proclaiming, "These we have made in your
name from the boundless beauties you stole from the Creator of all
things. May we not expiate these massive crimes by repudiating you

[389] "Area Holds Cleanup With Rally," *The Washington Post*, 23 April 1970, p. A20.
[390] Ibid.

and by restoring the beauty of life on Earth before its death claims us all. Amen."[391]

The list of celebrities who had enlisted in the environmental crusade were many. Among their names, actor Eddie Albert and Arthur Godfrey stand out. Godfrey exemplified the new environmental ethic of the times. A radio pitchman whose baritone voice set the tone for starting your day like a morning cup of hot coffee, Godfrey became known for improvising radio commercials. Unknown to many today was Godfrey's conversion to environmentalism. The ukulele-playing reality talent show host read Wesley Marx's *The Frail Ocean*, Paul Ehrlich's *The Population Bomb*, Barry Commoner's *Science and Survival*, and of course, *Silent Spring*. Of those, Ehrlich's book had had the most profound influence upon the radio talk show host given the tone of Godfrey's editorial in Stewart Brand's January 1969 issue of the Whole Earth Catalog. In his op-ed, the radio talk show host placed the country on notice, writing, "Hardly a day passes that every newspaper and magazine doesn't carry one or several conservation stories, pollution reports, anti-pollution legislation proposed and enacted." Once an avid sportsman, Godfrey had the same mind-set as many professional men who fished for trout in America's streams and rivers. He went on to say, "The National Wildlife Federation has published the results of a poll which shows an overwhelming majority of Americans are very concerned—even willing to pay extra taxes to do something about it."[392]

Calling the human race an endangered species and saving the environment a matter of human survival, Godfrey urged his male audience to get vasectomies. Given the sanctity of private property rights, he proposed the federal government create a Board of Ecological Survey with sweeping powers to protect the environment. Within its jurisdiction, "no one would be permitted to build a highway, dig a ditch, build a dam, 'develop' a swamp or an estuary, build a jetport or anything else without first submitting the plan to the

[391] Mary Maunes, "Hymn of Thanksgiving," National Staff of Environmental Action, Garret Bell, ed., *Earth Day—The Beginning* (New York: Avon Press, 1970), p. 226.

[392] Arthur Godfrey, "The Outlaw Area," *Whole Earth Catalog*, January 1969, p. 20.

Board." He emphasized the need for a cabinet level agency to address the issues of cleaning up the country's air and water but had reservations about President Nixon's commitment to the environmental cause.[393] One month before April 22, the affable radio celebrity gave a speech at the University of Michigan, Ann Arbor along with Gaylord Nelson, Barry Commoner, Senator Edmund Muskie, Eddie Albert, Ralph Nader, ecologist LaMont Cole, and environmental legal expert Victor Yannacone. The teach-in at Michigan, organized by Environmental Action for Survival, lasted five days.[394] From Michigan, Godfrey hoped aboard a flight to New York City, where on April 22, he had another speaking engagement. In Manhattan, at Union Square, Godfrey shared the stage with "Leonard Bernstein, Paul Newman, Dustin Hoffman, Pete Seeger, and the cast of the musical Hair who performed for the crowd."[395]

A word on the colorful Stewart Brand and his publication, Godfrey's platform. Brand's Whole Earth Catalog represented a tectonic shift in American culture and the public's environmental consciousness which took place after the Second World War. Before its publication, there had been relatively little concern about the human footprint on nature and its environmental consequences. But Brand's magazine represented something new, something which reflected a change in how Americans perceived their role in protecting and preserving the Earth. Whole Earth featured articles on how to construct Native American teepees, promoting alternative living accommodations. On its pages was self-help information, some of which today would appear in Organic Gardening magazine. Instructional articles included "How to Make Booze" and "How to Make Hard Cheese"; methods on how to make medicinal herbs and storing vegetables and fruit were common. Just before April 1970, the March issue featured a counterculture volleyball match. The volleyball: the planet Earth precariously being batted from one side to the other in the air over a net. Where it landed depended exclusively on human's actions. The

[393] Ibid.
[394] Doug Fulton, "Earth Week: Time to Reflect," *Old News*, 19 April 1971, p. 17.
[395] Mary Graham, *The Morning After Earth Day: Practical Environmental Politics* (Washington, DC: Brookings Institution Press, 1999), p. 1.

spring issue cover which followed Earth Day had a real-time pho-
tograph of the Andromeda galaxy. A thought balloon typical of any
cartoon filled with a question mark originated in Earth's approximate
location in the galaxy.

But of all the celebrities, none compared with folk musi-
cian-singer Pete Seeger. Known for his outspoken opinion on civil
rights and labor activism, and as an advocate for constructive social
change, Seeger wrote the tunes "Where Have All the Flowers Gone?"
and "If I Had a Hammer," songs which were protest anthems of the
1960s. As we have seen, to promote ecology and environmentalism in
general, Seeger founded the Hudson River Sloop Restoration group
to raise funds to restore and preserve the mighty Hudson River in
1969. Seeger's home had been built on the river's banks near Beacon,
New York.[396] To draw attention to the polluted Hudson, Seeger, with
the help of the organization, launched a seventy-six foot sloop he
christened the Clearwater. A crew comprised of Restoration donors
sailed down the Hudson into the Atlantic along the coastline days
before Earth Day. Seeger moored the Clearwater at Municipal Fish
Wharf on the Potomac River to celebrate the event in the nation's
capital on April 21.[397]

Of the literally hundreds of teach-ins held on Earth Day around
the country none was more thought provoking than the symposium
at Harvard University, the flagship of American higher education.
Harvard's business school sponsored Russell E. Train, Dan W. Lufkin,
and Charles F. Luce to debate the responsibility of business in solv-
ing environmental problems. Train, Nixon's newly appointed head
of the Council on Environmental Quality, absolved capitalism from
causing pollution pointing to socialist Countries behind the Iron
Curtain with pollution problems as severe as in the United States.
In front of 800 business students, Train took to task the notion that
"pollution can be 'blamed on the self-seeking activities of greedy cap-
italists.'" Luce the chief operating officer of Consolidated Edison the

[396] Pete Seeger, "To Save the Dying Hudson: Pete Seeger's Voyage," *Look*, 26 August
1969, vol. 33, p. 65.

[397] William C. Woods, "No Clear Water," *The Washington Post*, 22 April 1970, p.
B1.

New York based utility and target of environmental protests, delineated the complexity of the problem modern society faced with an example. Luce revealed "the new World Trade Center alone would require more electricity than a city of 100,000." Hence the demand for more fossil fuel generated electricity. But it was Lufkin the Wall Street executive whose words echoed the thoughts and sentiments of environmental protestors that day. Lufkin insisted environmental problems must be dealt with not by the public relations department of a company. By then the damage had been done and it was too late. Rather the chief executive of a company in question must uphold environmental standards and be enforced by the chief executive first. In other words, better management of the environment was necessary in order to improve environmental quality. At the same time outside the business school building students circulated a newspaper: The front page featured a factory smoke stack belching pollutants into the air under a headline which read, "Capitalism Fouls Things Up!" [398]

Though the celebration reduced through traffic in New York City, the Air Resources Administration there reported air in the greater metropolitan area to be more polluted than usual. In the deep South, in Alabama, Governor George Wallace, during his campaign for the presidency on the American Independent Party ticket in 1968 had referred to environmental activists as "ecology freaks." Even so, Wallace, a shrewd political operative, locked in the political fight of his life with incumbent Alabama Governor Albert Brewer, convened an emergency meeting of environmentalists at Montgomery to draft "his first big environmental policy statement." [399] Where smelters always belched polluted air, in the steel capitol of the South, environmentalists calling themselves the Greater Birmingham Alliance to Stop Pollution (GASP) held a "right to life rally at the municipal auditorium." [400]

[398] Ibid.

[399] George C. Wilson, "Demonstrations to Mark US 'Earth Day' Today," *The Washington Post*, 22 April 1970, A15.

[400] Richard Harwood, "Earth Day—Stirs Nation," *The Washington Post*, 23 April 1970, p. A20.

In Dade County, Florida, activists organized a "Dirty Orange Parade," a parody of the New Year's Day traditional procession, complete with floats lampooning industrial polluters and emphasizing family planning. Miami environmentalists used the same street theatre made popular by the youth counterculture at the time. Not far from South Beach, librarians working at Miami public library received a coffin covered with black bunting. A sign inside atop an Earth symbol coffin said, "Littered to Death."[401] When Earth Day passed without notice, unobserved and uncelebrated in tiny Earth, Texas, embarrassed city officials, who neglected to capitalize on their town's notoriety, issued a statement claiming it "just slipped up on us."[402] Echoing the theme of the Merle Haggard hit tune "Okie From Muskogee," Louisiana oil executive John Smith ridiculed protestors when he said, "'The kids campaigning for clean air are polluting their minds with marijuana...'"[403]

In the upper Midwest, protestors celebrated the dawn of a new day of environmental awareness. At the University of Wisconsin, a hotbed of student anti-war activism, protestors braved the cold to hear a religious service then joined together in a choral reading, praying for God to forgive man for polluting the Earth. Then the service concluded with Sanskrit incantations.[404] In a show of solidarity, United Auto Workers marched in mass through St. Louis, Missouri, streets behind a propane-driven vehicle, the union members promising to include guarantees of "a pollution-free car in contract negotiations with management in the future." There were no gas masks left on store shelves in Omaha, Nebraska; teenagers, mostly high school students, taking a stand on the issue of air pollution, had purchased the entire inventory and wore them to class.[405] Emboldened by the ethos of second-wave feminism and the fledg-

[401] Ibid.

[402] Gladwin Hill, "Activity Ranges from Oratory to Legislation," *The New York Times*, 23 April 1970, p. 30.

[403] Associated Press, "All Ages Join Pollution War in Celebration of Earth Day," *Los Angeles Times*, 23 April 1970, p. 18.

[404] Ibid.

[405] "Earth Has Its Day, *San Francisco Chronicle*, 23 April 1970, p. 2.

ling Women's Liberation Movement, twenty coeds dressed as witches with pointy hats frolicked through the Earth Day demonstrators at the University of Indiana, throwing birth control pills at the crowd, shouting, "Free our bodies, free our minds."[406] In Detroit, at Wayne State University in the University Center on campus, more than one hundred students pressed together in a room designed to hold only fifty, a protest against overpopulation. Then the gathering streamed out into the grounds of the Alumni Center and listened to a teach-in, where sociology instructor Dr. Richard Lobenthal spoke to the gathering. Lobenthal looked into the young faces of his audience and informed them, "Every eight seconds, another American is born, and in his seventy years of lifetime, he is going to require 56 million gallons of water, 21,000 gallons of gasoline, 10,500 pounds of beef, 28,000 pounds of milk and cream, 9,000 pounds of wheat, $5,000 to $8,000 worth of school building materials, $6,300 worth of clothing, $7,000 worth of furniture and somehow 210 pounds of peanuts."[407] The Wayne State University experience exemplified the teach-in experience around the country that day.

In California, where the sun dawned last that day, here the hot, white flame of political activism and student protest burned brightest. Covering the festivities for the Los Angeles Times, reporter Ed Meagher noted the visible absence of smog that Wednesday. Demonstrations in the Golden State ranged from the practical to the macabre. At affluent Santa Monica High School, not far from the celebrity of Beverly Hills, students wore surgical masks while they held a mock funeral service for a combustible engine they then buried on school property. In the valley, at Miralesta High School near Palos Verdes, more than sixty students rode horses to class. On the campus of San Jose State University, a headstone marked the spot where students buried a brand-new car valued at $2,500. Indicative of the shift from acts of civil disobedience to a more radical mind-set, a group calling themselves the Environmental Vigilantes vandalized

[406] "Coeds Throw Pills at Rally," *The New York Times*, 23 April 1970, p. 30.
[407] Jean Pearson, "Squeeze: Population Explosion Felt at WSU Earth Day," *The Detroit News*, 23 April 1970, p. 11–B.

the fountain outside the corporate headquarters of Standard Oil of California by pouring several gallons of motor oil in the water.[408] Within a few blocks of Wilshire Boulevard, more than three hundred students attending UCLA biked from MacArthur Park near campus to a meeting of Los Angeles County officials, where they presented petitions urging the "construction of bikeways" to reduce smog.[409] Off Vermont Avenue, on the campus of the University of Southern California, students ceremoniously buried an automobile, commuted to class on bicycles, and added a gas mask to Tommy Trojan to compliment the statue's metal helmet and breastplate.[410]

Gaylord Nelson's Earth Day hectic itinerary included nine teach-in appearances, which began at his alma matter on the campus of the University of Wisconsin to Denver, Colorado, then ending his day on the west coast at the University of California, Berkeley. At each stop along the way, as he jetted across America, he questioned the average American's commitment to help save the environment and then outlined a plan the equivalent of the Apollo moon project or the Manhattan project. Nelson challenged American's resolve on a personal level and proposed tough new guidelines to regulate industry, unrestricted urban development, and auto manufacturing. His plan included a National Policy on Resource Management to curtail mining interests and oil producers. With the Santa Barbara oil disaster fresh on everyone's mind, Nelson proposed creating a National Oceans Policy to regulate offshore oil drilling and to prevent beach front communities from using coastal waters as private sewers.[411]

Nelson demanded accountability in the testing of chemicals used for agricultural purposes and a national policy on population

[408] "An Oil Spill on Market Street," *San Francisco Chronicle*, 23 April 1970, p. 2 and "All Ages Join Pollution War in Celebration of Earth Day," *Los Angeles Times*, 23 April 1970, p. 1.

[409] Meagher, *Los Angeles Times*, Ibid. p. 1.

[410] "Earth Day Events to be Conducted on LA Campuses," *Los Angeles Times*, 22 April 1970, part 2, p. 2.

[411] Gaylord Nelson, "Five Who Care," *Look*, 21 April 1970, p. 42 and Bill Christofferson, *The Man From Clear Lake: Earth Day Founder Senator Gaylord Nelson* (Madison: the University of Wisconsin Press, 2004), p. 309.

to promote family planning. Most importantly, he stressed reject-
ing anthropocentrism, the idea that relegated nature to the status of
involuntary servitude and that all life revolved around humanity's
interests. He urged humanity to find their place within the fragile
balance of life and, in so doing, "evolve a philosophy emphasizing
our interdependence with nature."[412] With his congressional col-
league and Earth Day co-sponsor Republican representative Paul
McCloskey of California by his side, Nelson argued that decisions
affecting the ecology of America should be moved from Wall Street
to Main Street. In impassioned words, Nelson proposed ratifica-
tion of a constitutional amendment to guarantee every American "a
decent environment." For Nelson and McCloskey and many others,
Earth Day was only an environmental beginning. With more than
twenty million Americans involved in the celebration of the Earth,
Congress adjourned its members, making appearances and speeches
to thousands of protestors across the country. The event cut across
political party affiliations and political ideologies. Even the godfather
of American political conservatism, Senator Barry Goldwater, sup-
ported the event, presenting a speech that day at Adelphi University
on Long Island.[413]

To bolster his argument, Nelson listed categorically the atrocities
committed against nature since the end of World War II. He named
the rivers, lakes, and streams ravaged by water pollution. He quoted
Dr. S. Dillon Ripley of the Smithsonian Institute, who projected by
the year 2000, nearly 80 percent of all wildlife on the planet would
face extinction. Sarcastically, he referred to our society as "Progress—
American style," then described in graphic detail the tons of garbage,
exhaust fumes, incinerator smoke, millions of gallons of raw sewage,
and industrial pollutants pouring into the natural world each year in
the United States. The Earth Day teach-ins Nelson envisioned were
only the beginning of the solution to the problem: What Nelson
demanded was nothing less than a complete reorganization of the

[412] Ibid.
[413] Ibid. and Christofferson, *The Man From Clear Lake*, p. 310.

federal regulatory system and a transformation of American culture, which translated into a change in human behavior.[414]

No less in demand as a keynote speaker, Stanford biologist Paul Ehrlich spoke that day in America's heartland at Iowa State University. Both Environmental Action coordinator Denis Hayes and Stanford student Stephanie Mills, the editor of Earth Times, had embraced Ehrlich's neo-Malthusian philosophy. Ehrlich preached eliminating pollution which depended on society's capacity to control the birth rate. As we have seen by Earth Day 1970, Ehrlich's book *The Population Bomb* had appeared on The New York Times best-seller list; Ehrlich had come to be highly regarded by American intellectuals and in great demand on the college lecture circuit. Crunching demographic numbers based on census data, Ehrlich projected population growth on Earth would exceed humanity's capacity to grow food; the human race would eventually occupy every square foot of the planet's land surface. Ehrlich's theory was compelling and sobering. His was a vision of an Easter Island scenario, a world where the quality of life would make living conditions intolerable for all humankind.[415]

Another academic who played an active role in raising the level of environmental consciousness, Barry Commoner lectured in the classroom and headed up the newly established Center for the Biology of Natural Systems at Washington University in St. Louis. Commoner, an outspoken critic of the federal government's environmental policy, had converted to environmentalism after joining with other scientists in a study to determine the effects of radioactive fallout from weapons testing. Subsequently, he believed the nuclear test-ban treaty of 1963, negotiated by President John Kennedy and Soviet Premier Nikita Khrushchev, to be the single most important act of diplomacy in United States history.[416]

Commoner, whom Time magazine called the Paul Revere of environmentalism, understandably opposed America's military involvement in Indochina. He accused the United States of wag-

[414] Ibid.

[415] David M. Rorvik, "Ecology's Angry Lobbyist," *Look*, 21 April 1970, p. 42.

[416] Barry Commoner, "Beyond the Teach-In," *Saturday Review*, 4 April 1970, vol. 50, p. 50.

ing what he called the "first ecological warfare" since the Europeans spread small pox to the indigenous people of North America. That pathogen had killed massive numbers of Native Americans in the western hemisphere.[417] Similar to Nelson and Ehrlich, Commoner called upon Americans to consume less and conserve more; he vented his frustration on an indifferent governmental establishment and what he described as the death grip of the "military-industrial complex on US policy."[418] Though not a neo-Malthusian, like Ehrlich, Commoner rose to the top of the list on the college lecture circuit and wholeheartedly embraced Nelson's teach-in concept as the Stanford biologist had. Teach-ins, Commoner explained, were symposiums, a gathering of intellectuals first proposed by the Athenians to facilitate the free exchange of ideas then embellished by student activist Tom Hayden in *The Port Huron Statement*. On April 22, Commoner's whirlwind itinerary included lectures at Harvard, MIT, Rhode Island College, and Brown University.[419]

Academics Ehrlich and Commoner would not be the only academics speaking that day. Venerable Margaret Mead lent her expertise in the study of primitive human cultures and society to the Earth Day discourse. Appearing at New York City's American Museum of Natural History, Mead called pollution a plague on humanity in existence since the discovery of fire, which provided light for the cave artists of Lascaux. In her speech, she told her audience, "The middle class have gone away to the suburbs. It's the poor who are affected." She explained her assessment of the task facing environmentalists describing their formidable undertaking as "comparable to efforts for the Protestant Reformation, the spread of Buddhism or the Industrial Revolution."[420] Mead offered her alternative to governmental intervention by calling for a religious faith. She proposed combining newly discovered scientific knowledge about nature and the Judeo-Christian ethic to create an eclectic "New Age" religion.

[417] Ibid., p. 52.

[418] Ibid., p. 50.

[419] Ibid.

[420] Israel Shenker, "In the Schools, Pollution Is a Dirty Word," *The New York Times*, 23 April 1970, p. 31.

Humanity would abandon its adversarial, exploitative, anthropocentric attitude toward the environment, embrace nature, and conceive in its consciousness a new found reverence for wildlife and the natural world.[421]

Ehrlich, Commoner, and Mead were academicians who supported Earth Day with appearances and speeches. Also lending his voice to the environmental cause, CBS News anchor Walter Cronkite began broadcasting a series of special reports "Can the World Be Saved?" on April 20. Approved by CBS News producer Ron Bonn, the series constitutes what environmental historian Douglas Brinkley calls "perhaps the most important, if unsung, part of Cronkite's legacy." Cronkite covered all the issues, subject matter which captured front-page newspaper headlines, which helped elevate the deteriorating condition of the environment to "the front burner of public discourse."[422] Lake Erie, auto exhaust emissions, Dow Chemical using Lake St. Charles and the Detroit River as its own corporate sewer for the dumping of toxic chemicals, beaches closed because of untreated sewage contamination, birds of prey on the verge of extinction caused by DDT contaminating their food supply, solid waste garbage piled as high as a two story house, and the Florida Everglades threatened by development, all converted Cronkite to man the parapets of environmentalism.[423]

An astute television journalist, Cronkite had picked up on the reporting of newspaperman and friend Gladwin Hill and Joseph Lelyveld. Brinkley indicates the Santa Barbara oil catastrophe also contributed to Cronkite's conversion, calling it "a rallying point for a new environmental awareness sweeping the land." When Hill wrote that the "environmental crises was eclipsing student discontent over the war in Vietnam in intensity," Cronkite paid attention, bringing the weight of CBS and his reputation as the most trusted man in America to bear on the environment. This led future head of the newly created Environmental Protection Agency, William

[421] Dr. Margaret Mead, "Five Who Care," *Look*, 21 April 1970, p. 37.

[422] Douglas Brinkley, *Cronkite* (New York: HarperCollins Publishers, 2012), p. 431.

[423] Ibid.

Ruckelshaus, to conclude Cronkite played a significant role in lifting the American public's consciousness to consider the enormity of the country's environmental crises.[424]

On Wednesday night, April 22, Cronkite assessed the state of America's environmental health with his CBS News Special Report. "Earth Day: A Question of Survival" featuring guest commentator Barry Commoner. Cronkite had been impressed with Commoner's book *Science and Survival* after reading it to prep for the news special. In his book, Commoner argued "against what happened when the industrial order spun madly out of control, when society so fully believed in technology that it arrogantly treated nature as its slave." The scientific community, Commoner believed, could shed light on environmental problems, but only political activism could solve them. Cronkite used Commoner's expertise during the special report much in the same way he consulted astronaut Wally Schirra to add commentary when CBS News covered the Apollo moon launches.[425]

The steady drumbeat of news coverage by Cronkite and the news media in general did not go unnoticed. On Earth Day, there were hundreds of appearances and speeches by elected officials representing a broad cross section of the political spectrum. Conspicuously absent in the mix was the president. Though his advisers recommended he make some sort of public announcement, Nixon deferred. Though he approved of Earth Day, Richard Nixon spent April 22 at the White House. United Press International photographed him that day sitting alone in the White House Rose Garden, a solitary figure appearing to be reviewing perhaps a presidential briefing on how the war was going in Southeast Asia. Nixon took the day to release to the press a plan to use federal assistance in natural disasters, issuing an executive order which created a new agency, the National Council on Federal Disaster Assistance, to assist state and local governments to cope with natural disasters. Nixon stated the reasoning for his decision, saying, "As we move into a new decade one of the nation's major goals is to restore a ravaged environment. But we must also be ready

[424] Ibid., pp. 431–432.
[425] Ibid., p. 433.

to respond effectively when nature gets out of control and victimizes our citizens."[426]

This factored into Nixon's decision. Seven months after Nixon's inauguration during the early morning hours of August 18, 1969, a category 5 hurricane made landfall on the Gulf Coast of Mississippi slamming ashore. Hurricane Camille's 175-mile-per-hour winds churned up a storm surge in excess of twenty feet, destroying beach front property and inundating the entire southern coast of the state, killing more than 140 people. Nixon's executive order would constitute the federal government's response to such a natural disaster, the precursor of the Federal Emergency Management Administration (FEMA). What Richard Nixon did pivoted on the hinge of political expediency. Providing federal assistance to the Mississippi Gulf Coast played an integral part in what political historians call Nixon's southern strategy. The quintessential Machiavellian, Nixon's decisions were carefully measured and calculated for maximum return in the form of a political dividend he received by bolstering his standing in the court of public opinion. In such a way, he vetted issues which resonated on more solid ground with American voters. The environment was one; the de-escalation and Vietnamization of the war in Southeast Asia another.

The number of beltway politicians who participated on Earth Day, whether speaking or merely putting in a personal appearances, cut across a broad swath of the political spectrum. Not the president. Nixon's press release read: "The president feels the activities show the concern of people of all walks of life over the dangers to our environment."[427] Political expediency, or what J. Brooks Flippen calls the "desire for partisan advantage," swayed Nixon's judgment, not concern for the natural world or nature.[428]

[426] "President Urges A Reorganization of Disaster Relief," *The New York Times*, 23 April 1970, p. 18.

[427] Richard Harwood, "Earth Day Stirs Nation," *Washington Post*, 23 April 1970, p. A20.

[428] J. Brooks Flippen, *Nixon and the Environment* (Albuquerque: University of New Mexico Press, 2000), p. 16.

On this point, the record is clear. Nixon approved the Alaskan oil pipeline without so much as an impact study of its environmental consequences. He broke ground for the Tennessee-Tombigbee Waterway opposed by environmentalists. He lobbied unsuccessfully for the production of the Supersonic Transport and the Cross Florida Barge Canal, both of which Congress killed by refusing to appropriate funding for. On the political side of the coin, it was generally understood Nixon's competition on the opposite side of the aisle in his run for reelection in 1972 would be either Maine Senator Edmund Muskie or Washington's Henry "Scoop" Jackson; both had made the environment a political issue, which Nixon ignored at his own peril. Though that political prognostication never materialized, Richard M. Nixon was a master at disarming and neutralizing the political opposition throughout his political career. Conversely, almost lost in the Nixon biography is his environmental legacy. In the environmental ledger he created the Environmental Protection Agency, a cabinet-level position with sweeping powers to bring the federal government to bear on environmental problems. The thirty-seventh president shored up the Clean Air Act and the Clean Water Act, giving the federal government greater regulatory authority. Nixon signed into law the Endangered Species Act, arguably one of his greatest achievements. And Nixon signed the National Environmental Policy Act, which mandated federal agencies to undertake environmental impact studies of federal construction projects. In addition, several members of Nixon's staff had an affinity for the environmental cause; their number included Russell Train, John Whitaker, and John Ehrlichman, a member of Nixon's inner circle, his Praetorian Guard.

As Philip Shabecoff characterized him, Nixon was often referred to as the "environmental president" but "no tree hugger."[429] Two incidents are indicative of Nixon's duplicity on this issue. In April of 1970, Sierra Club president Philip Berry visited Nixon in the Oval Office to discuss the president's possible support for funding population-control legislation. What happened during the negotiation

[429] Philip Shabecoff, *A Fierce Green Fire: The American Environmental Movement* (New York: Hill and Wang, 1993), p. 112.

is a clear indication of just what Nixon thought of environmental issues. Historian J. Brooks Flippen includes a brief excerpt from the exchange between the two in his book *Nixon and the Environment*. With Berry, "Nixon was blunt, beginning the meeting with a lecture: 'All politics is a fad. Your fad is going right now. Get what you can, and here's what I can get you.' As Nixon proceeded to explain that he thought the population problem was overblown, Berry seethed." For at least five minutes, the environmentalist and the president sparred, arguing about overpopulation until Nixon abruptly ended the conversation and adjourned the meeting.[430]

Here is another incident involving the environmental president. One year had passed since the first Earth Day. In a private meeting which took place in the White House between Nixon and automotive CEOs Henry Ford II and Lee Iacocca, their face-to-face discussion revolved around persuading the president to roll-back auto emission standards and relax mandated safety features, the result of lobbying by consumer advocate Ralph Nader. In the conversation which followed, Nixon acknowledged air pollution to be a serious problem; the president expressed his concern for consumer advocate Nader's "safety kick," as he called it. But then the thirty-seventh president launched into a tirade, the pent-up frustration getting the best of him. Exasperated, Nixon railed, "We can't have a completely safe society or safe highways or safe cars and pollution-free, and so forth, or...(we'll go back to living) like a bunch of damned animals..."[431]

[430] Letter, Philip Berry to Richard Nixon, Apr. 9, 1970, Folder "Population, 1970, Box 92, John Whitaker Files, WHCF, RNPMP, Memo, John Whitaker to Patrick Moynihan, Apr. 29, 1970, Folder "January–April, 1970, 4 of 4, April, 1970, Box 2, John Whitaker Files, WH/cf, RNPMP. Interview, J. Brooks Flippen with Philip Berry, June 19, 1998, as quoted in J. Brooks Flippen, *Nixon and the Environment* (Albuquerque: University of New Mexico Press, 2000), p. 102.

[431] National Archives Nixon Project, National Archives at College Park, College Park, Maryland, "Conversation Among President Richard M. Nixon, Lido Anthony Iacocca, Henry Ford II, and John D. Ehrlichman," the Oval Office, the White House, Washington, DC, April 27, 1971 (transcript, pp. 1–30) as quoted in Jack Doyle, *Taken For a Ride: Detroit's Big Three and the Politics of Pollution*, p. 76.

By his second term, as Flippen indicates, Richard Nixon had abandoned his environmental agenda altogether. With no political capital to be gained, Nixon turned his attention to deescalating American involvement and withdrawal from Vietnam.[432]

The point being the condition of a deteriorating environment in the United States held a low place on the list of presidential priorities by the spring of 1970. Tragically, eleven days later, that feeling of innocence and high-minded idealism of Earth protestors would come crashing to Earth and burn in one act of senseless violence. Coincidentally, Earth Day occurred on the same date the call by student radicals for a general strike on college campuses around the country in sympathy with the New Haven Fourteen. Black Panther Bobby Sale and ten other Panthers—three on lesser charges—had been indicted stemming from an investigation into the murder of police informant Alex Rackley.[433] All across the country, at Yale, Penn State, Kansas University, and Miami University in Oxford, Ohio, students cut class and laid siege to ROTC buildings and defied curfews. Then the crises on college campuses escalated on April 30 when President Nixon announced a new military offensive aimed at countering a Communist insurgency in Cambodia that he claimed threatened US troops in Vietnam. Student rage led to violence, which erupted on most major university campuses around the country. After four intense days of confrontation and demonstrations, Ohio National Guard troops opened fire on protestors at Kent State University, killing four students on May 4. On the campus of Jackson State University in Mississippi, a similar tragedy occurred.

As for the events of April 22, those issues which energized more than twenty million people did more than persuade Richard Nixon to propose environmental laws which improved America's environment. A nationwide trend in American education from the grade schools to the Ivy League added classes in ecology and environmental studies. A new genre emerged in the history profession: environmen-

[432] Flippen, *Nixon and the Environment*, pp. 159, 170–171, 186 (see Flippen's chapter "Get Off the Environmental Kick," pp. 189–219.)

[433] "80% Boycott Classes at Yale In Support of Black Panthers," *Washington Post*, 23 April 1970, A3.

tal history. Classes on the environment called Earth Science would be offered in curriculums at most institutions of higher learner even in high schools. Earth Day made a lasting impression in the education profession. Earth Day organizers capitalized on the anti-war sentiment as several off-Broadway productions of the rock musical Hair with its anti-war message performed around the country. Earth Day was not without its critics. Journalist I. F. Stone ridiculed it, calling Earth Day a "beautiful snow job" convinced the event was an elaborate ruse planned to deceive Americans by diverting their attention away from the war.[434] Though embracing Stone's theory, Chicago Seven defendant Rennie Davis summed up the feelings of most protestors on Earth Day when he shouted into the microphone, "'Let Nixon know that this is our perspective: an end to a system based on the prerogatives of private greed rather than social need.'"[435] Davis expressed the feelings of the Black Power movement and most African Americans living in blighted, dilapidated urban ghettos at the time. One year removed from April 22, 1970 a non-profit organization "Keep America Beautiful" ran television commercials featuring a Native American, his Hollywood name Iron Eyes Cody, canoeing down a polluted river, standing on a congested freeway, trash thrown at his feet. The commercial ended with the words, "People start pollution. People can stop it." Earth Day's cause had generated what became known as the "crying Indian" commercial.

Nonetheless, in many ways, the Kent State tragedy symbolized an end to the social revolution striving for social justice, racial and gender equality, and healing the environment in America. Academics, college students, and intellectuals sensed American society rapidly moving toward modernity in the nuclear age had become a culture of convenience more interested in materialism and the accumulation of wealth than in the deteriorating condition of the environment. Many felt their very survival and existence depended upon cleaning up America's air and water and reducing the birth rate. This

[434] "Area Holds Cleanup with Rally," *Washington Post*, 23 April 1970, A20.

[435] Rennie Davis, "Up Agnew Country," in National Staff of Environmental Action, Garrett Bell, ed., *Earth Day—The Beginning* (New York: Aron Press, 1970), pp. 87–88.

values system emerged and came to be reinforced by an American civilization seemingly obsessed with conspicuous consumption, by their latest new car purchase, by the barbecue pit and patio set, by the abundance of food treated with pesticides, and by the shining showroom floors where every household appliance could be had for a price. Earth Day, for a moment, hit the pause button in all of that when Americans began to think about the consequences of their generational binge at the expense of the natural world and nature.

Reflecting this new undertone of political and environmental awareness and a change in the American public's consciousness, most demonstrators on Earth Day believed in constructive social change; many were housewives, Girl Scouts, Boy Scouts, and high school students who did nothing more than pick up trash to beautify their neighborhoods. The same idealism that inspired Earth Day had motivated Michael Schwerner, James Chaney, and Andrew Goodman to register voters and teach African American children in freedom schools in Mississippi during the summer of 1964. In many ways, the Kent State tragedy signified an end to the high-minded idealism of that period in American history. As for the events of April 22, 1970, they too had a symbolic significance. America's conversion to environmental preservation seemed assured, but as to whether or not they would practice their newfound religion, that question remains unanswered, even to this very day.

Bibliography

Primary Sources

Carson, Rachel. *Silent Spring*. Reprint, Boston: Houghton Mifflin Company, 2002.

Carson, Rachel. Always Rachel: The Letters of Rachel Carson and Dorothy Freeman, 1952–1964. Edited by Martha Freeman. Boston: Beacon Press, 1995.

Douglas, William O. A Wilderness Bill of Rights. Boston: Little, Brown and Company, 1965.

Douglas, William O. The Three Hundred Year War: A Chronicle of Ecological Disaster. New York: Random House, 1972.

Easton, Robert. Black Tide: The Santa Barbara Oil Spill and Its Consequences. New York: Delacorte Press, 1972.

Eichel, Lawrence E., Kenneth W. Jost, Robert D. Luskin, and Richard M. Neustadt. The Harvard Strike. Boston: Houghton Mifflin Company, 1970.

Ehrlich, Paul R. The Population Bomb. Cutchogue, New York: Buccaneer Books, 1968.

Hickey, Joseph J. Editor, Peregrine Falcon Populations: Their Biology and Decline. Madison: The University of Wisconsin Press, 1969.

Lapp, Ralph E. The Voyage of the Lucky Dragon. New York: Harper, 1958.

Leopold, Aldo. A Sand County Almanac and Sketches Here and There. New York: Oxford University Press, 1950.

Longgood, William. The Poisons in Your Food. New York: Simon and Schuster, 1960.

National Staff of Environmental Action, Garrett DeBell, ed., Earth Day—The Beginning: A Guide for Survival. New York: Bantam Books, 1970.

Osborn, Fairfield. Our Plundered Planet. Beston: Little, Brown and Company, 1948.

Pinchot, Gifford. The Fight for Conservation. Reprint, Seattle, Washington: University of Washington Press, 1967.

Smith, Margaret Bayard. The First Forty Years of Washington Society: Portrayed by the Family Letters of Mrs. Samuel Harrison Smith. New York: Charles Scribner's Sons, 1906.

Stradling, David, ed. The Environmental Moment, 1968–1972. Seattle: The University of Washington Press, 2012.

Thoreau, Henry David. Walden and Civil Disobedience. Paul Lauter, ed. New York: Houghton Mifflin Company, 2000.

Veblen, Thorstein. The Theory of the Leisure Class. New York: The Viking Press Inc., 1931.

Vogt, William. Road to Survival. New York: W. Sloane Associates, 1948.

Wolfe, Linnie Marsh, ed. John of the Mountains: The Unpublished Journals of John Muir.

Osborn, Fairfield. Our Plundered Planet. Boston: Little, Brown and Company, 1948.

Secondary Sources

Bosworth, Patricia. Jane Fonda: The Private Life of a Public Woman. Boston: Houghton Mifflin Harcourt, 2011.

Cahalan, James M. Edward Abbey: A Life. Tucson: University of Arizona Press, 2001.

Christofferson, Bill. The Man From Clear Lake: Earth Day Founder Senator Gaylord Nelson. Madison: The University of Wisconsin Press, 2004.

Cohen, Lizabeth. A Consumers' Republic: The Politics of Mass Consumption in Postwar America. New York: Alfred A. Knopf, 2003.

Commoner, Barry. The Closing Circle. New York: Alfred A. Knopf, 1971.

Diggins, John Patrick. The Rise and Fall of the American Left. New York: W. W. Norton & Company, 1992.

Doyle, Jack. Taken For a Ride: Detroit's Big Three and the Politics of Pollution. New York: Four Walls Eight Windows, 2000.

Flippen, J. Brooks. Nixon and the Environment. Albuquerque: University of New Mexico Press, 2000.

Gitlin, Todd. The Sixties: Years of Hope, Days of Rage. New York: Bantam Books, 1990.

Gottlieb, Robert. Forcing the Spring: The Transformation of the American Environmental Movement. Washington, DC: Island Press, 1993.

Harvey, Mark W. T. A Symbol of Wilderness: Echo Park and the American Conservation Movement. Seattle: University of Washington Press, 2000.

Huffman, Thomas R. Protectors of Land and Water: Environmentalism in Wisconsin, 1961–1968. Chapel Hill: The University of North Carolina Press, 1994.

Jackson, Kenneth T. Crabgrass Frontier: The Suburbanization of the United States. New York: Oxford University Press, 1985.

Lear, Linda. Rachel Carson: Witness for Nature. New York: Henry Holt and Company, 1997.

Mann, Charles C. The Wizard and the Prophet: Two Remarkable Scientists and Their Dueling Visions to Shape Tomorrow's World. New York: Alfred A. Knopf, 2018.

Maraniss, David. They Marched Into Sunlight: War and Peace, Vietnam and America, October 1967. New York: Simon & Schuster, 2003.

Martini, Edwin A. Agent Orange: History, Science, and the Politics of Uncertainty. Amherst: University of Massachusetts Press, 2012.

Matusow, Allen J. The Unraveling of America: A History of Liberalism in the 1960s. New York: Harper and Row publishers, 1984.

McNeil, J. R. Something New Under the Sun: An Environmental History of the Twentieth Century World. New York: W. W. Norton and Company, 2000.

Miller, Richard L. Under the Cloud: The Decades of Nuclear Testing. New York: The Free Press, 1986.

Nash, Roderick. Wilderness and the American Mind. New Haven: Yale University Press, 1967.

Nelson, Gaylord, Susan Campbell and Paul Wozniak. Beyond Earth Day: Fulfilling the Promise. Madison: The University of Wisconsin Press, 2002.

Robertson, Thomas. The Malthusian Moment: Global Population Growth and the Birth of American Environmentalism. New Brunswick, New Jersey: Rutgers University Press, 2012.

Rome, Adam. The Genius of Earth Day: How a 1970 Teach-in Unexpectedly Made the First Green Revolution. New York: Hill and Wang, 2013.

Schulman, Bruce J. The Seventies: The Great Shift in American Culture, Society, and Politics. Cambridge, MA.: DaCapo Press, 2001.

Shabecoff, Philip. A Fierce Green Fire: The American Environmental Movement. New York: Hill and Wang, 1993.

Souder, William. On a Farther Shore: The Life and Legacy of Rachel Carson. New York: Crown Publishers, 2012.

Tanner, Thomas, ed. Aldo Leopold: The Man and His Legacy. Ankeny, Iowa: Soil Conservation Society of America, 1987.

Newspapers

Albuquerque Tribune
Chicago Tribune
Detroit Free Press
Detroit News
Lexington Herald-Leader
Los Angeles Times

EARTH DAY

New York Times
San Francisco Chronicle
Santa Barbara News Press
The Seattle Times
The St. Louis Post-Dispatch
The Washington Post

About the Author

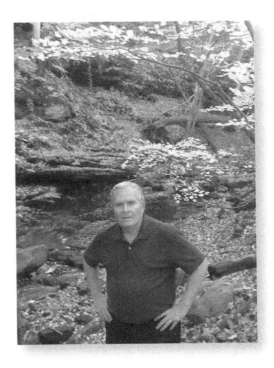

The author, Jean W. Griffith, is a contributor to the highly regarded Charles Scribner's Sons Encyclopedia of American Lives series. His online modern American history survey course, "Dawn of the American Century," is a Great River Technologies production. He has published historical editorials and social commentary in the Joplin Globe, a regional newspaper near his home in Carthage, Missouri. For the past two decades, he has worked as a college lecturer teaching history in Missouri and Kansas.

CPSIA information can be obtained
at www.ICGtesting.com
Printed in the USA
FSHW020952190820
73042FS